# THE DALÍ
# LEGACY

# THE DALÍ LEGACY

## HOW AN ECCENTRIC GENIUS CHANGED THE ART WORLD AND CREATED A LASTING LEGACY

CHRISTOPHER HEATH BROWN
and JEAN-PIERRE ISBOUTS

APOLLO
PUBLISHERS

ST. JOHN THE BAPTIST PARISH LIBRARY
2920 NEW HIGHWAY 51
LAPLACE, LOUISIANA 70068

The Dalí Legacy: How an Eccentric Genius
Changed the Art World and Created a Lasting Legacy
Copyright © 2021 by Christopher Heath Brown and Jean-Pierre Isbouts

All rights reserved. No part of this book may be used or reproduced in any
manner whatsoever without the written permission of the publisher, except
in the case of brief excerpts in critical reviews or articles. All inquiries should
be sent by email to Apollo Publishers at info@apollopublishers.com

Apollo Publishers books may be purchased for educational, business, or
sales promotional use. Special editions may be made available upon request.
For details, contact Apollo Publishers at info@apollopublishers.com.

Visit our website at www.apollopublishers.com.

Published in compliance with California's Proposition 65.
Library of Congress Control Number: 2020935787

Print ISBN: 978-1-948062-66-4
Ebook ISBN: 978-1-948062-67-1

Printed in the United States of America.

Dedicated to the memory of Michael Schwartz—
a dear friend, extraordinary art dealer,
and connoisseur of Dalí
and Modern Art.

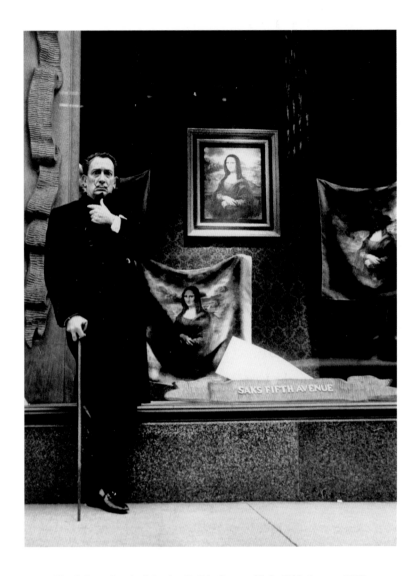

Fig. 1. Peter Basch, *Salvador Dalí in Front of Saks Fifth Avenue*, 1965

# CONTENTS

# FOREWORD

BY FRANK HUNTER,
DIRECTOR OF THE SALVADOR
DALÍ ARCHIVES

**I**n 2016 I received a telephone call from Dr. Christopher Brown, inquiring about prints by Salvador Dalí, especially early ones. He related how numerous people had told him that I was the Dalí print expert. "Well," I said, "I suppose that's not far from the truth. After all, I did publish a print with Dalí; I did work on *The Official Catalog of the Graphic Works of Salvador Dalí* (Salvador Dalí Archives, New York, 1996); and I am currently the director of the Salvador Dalí Archives."

The print I made reference to came about purely by happenstance. In 1974 I happened upon a small book titled *La Vita Nuova* (c. 1294) by Dante Alighieri. Paging through it, with original poems and sonnets on one page, and English translations on the opposite page, I was struck by the imagery portrayed in one particular sonnet, whose lines begin "*A ciascun' alma presa e gentil core* ..." (To every captive soul and loving heart ...). With

this sonnet, Dante relates a dream in which the personification of Love appears, holding Beatrice, Dante's obsessive love object, on one arm and on the other, Dante's burning heart, which Love feeds to Beatrice. Incredible, I thought; Dante was a proto-surrealist!

A short time later, I took the sonnet to Dalí's weekly Sunday salon at New York's St. Regis Hotel. I first met Dalí here in 1969, introduced by my friend, mentor, and Dalí's official archivist, Albert Field. My intention was to see if Dalí would agree with my plan to create an original etching based on the sonnet's imagery. Dalí was delighted. He agreed, and a year later, a shiny copper plate appeared, beautifully etched with the figure of Love holding Beatrice. After paying Dalí, the printer, and the paper supplier, we published the etching along with a facsimile of the sonnet from the editio princeps.

I tell this story to illustrate how Dalí was intrigued by Old Masters, not only artistic ones, but also literary ones. After all, he did produce one hundred paintings illustrating Dante's *Divine Comedy*, as well as many illustrations, paintings, and graphics based on Cervantes's *Don Quixote*.

The connection between the Old Masters and Salvador Dalí had its beginnings when the fifteen-year-old Dalí wrote an essay for *Studium*, a student magazine, describing Leonardo as ". . . the greatest master of painting, a soul that knew how to study, to invent, to create with ardor, passion, and energy . . ." Some years later, he wrote, "Begin by learning to draw and paint like the old masters. After that, you can do as you like; everyone will respect you." (*50 Secrets of Magic Craftsmanship*, Dial Press, New York, 1948.)

So it goes without saying that a book devoted to the secret of Dalí's legacy and success—including his respect of and admiration for the Old Masters—is a welcome addition to the field

of Dalí studies. Both Christopher Brown and Jean-Pierre Isbouts are well versed to tackle this intriguing subject; together they have written three books about the father of the Old Masters, Leonardo da Vinci: *Young Leonardo*, *The Mona Lisa Myth*, and *The da Vinci Legacy*.

Over the course of his long, creative life, Dalí paid homage to many of the Old Masters, including Velázquez, Vermeer, Rembrandt, Raphael, Leonardo, Michelangelo, Dürer, Cranach, and Goya, to name but a few. Dalí's pointed mustache was probably his greatest and most iconic tribute to Spain's Old Master, Diego Velázquez.

Dalí's reverence is evidenced in paintings, drawings, illustrations, sculptures, and graphic works. In 1971 Dalí created a series of fourteen original engravings titled *Hommage à Albrecht Dürer* (Editions Vision Nouvelle, Paris). A few years later, another tribute—a series of six paintings for a set of lithographs titled Changes in Great Masterpieces (Sidney Z. Lucas, New York)— paid homage to Velázquez, Vermeer, Rembrandt, and Raphael.

As the authors state early on, how pervasive was the influence of the Old Masters on Dalí's art, and how did these influences manifest themselves? These are but a few of the many questions this book attempts to answer.

Dr. Brown, who first approached me several years ago seeking information, has since become a friend, as well as an inveterate Dalí collector, and now scholar. As Dalí was apt to say quite often, "Bravo!"

# INTRODUCTION

*Begin by painting like the Renaissance masters.*
*After that, do as you wish. You will always be respected.*

Salvador Dalí

**W**ho was Salvador Dalí, and what is the secret of his endur-
ing popularity today? That is the question that inspired
this book. Why does Dalí still rank as one of the most celebrated
artists of the twentieth century, even though for much of his
lifetime he was both beloved and reviled for his uncompromising
genius, overt eroticism, and flirtations with megalomania? Indeed,
his controversial writings and outrageous behavior alienated not
only his critics but also many of his fellow Surrealists. So then,
who was this man who every morning experienced "an exquisite
joy—the joy of being Salvador Dalí"?

   This question is even more striking when we remember that
Dalí rapidly rose to prominence during the roaring twenties
of the artistic demimonde of Paris, when all sorts of new and

daring Modernist movements were tearing at the fabric of traditional European art. With his prodigious talent, Dalí was soon recognized as the public face, the universal brand of Surrealism. However, as his fame grew, so did his pursuit of celebrity and wealth, which, in the minds of many twentieth-century critics, overshadowed his reputation as an artist. Even as late as the 1960s, his provocative art continued to invite bewilderment, anger, and adoration, thus shifting the landscape of the art world and the nature of celebrity itself.

It is only in recent years that historians have begun to reappraise Dalí as one of the most influential artists of the modern age. Part of the reason, perhaps, is that his oeuvre includes not only paintings but also sculptures, films, theater sets, costumes, jewelry, clothing, and literary works, as well as a large number of drawings and graphics. Dalí expert Frank Hunter believes this output rose to as many as two thousand graphic works and fifteen hundred paintings—an incredible body of work for a twentieth-century artist.

Today, Dalí's popularity is greater than ever. In addition to the Salvador Dalí Museum in St. Petersburg, Florida, and the Dalí Theatre-Museum in Figueres, Spain, new Dalí exhibitions and ad hoc "museums" continue to pop up all over the world, including recent exhibits in St. Petersburg, London, Dubai, Madrid, and Dallas. His whimsical, even outrageous approach to subject matter, his fondness for nudes, and his consistent adherence to the canon of traditional figurative art continue to exert a magical appeal.

What is less understood, in both popular and scholarly literature, is the root of Dalí's enduring popularity. Is it his choice of mystical motifs? His unique ability to capture the sensuousness of the nude? Or his dogged devotion to the Western canon of realism, even as modern art continued to plumb the uncertain

depths of abstraction? And if that last is true, which styles of the past exerted the greatest influence on his work? Which Old Masters of the Renaissance and the Baroque served as his primary models? And to what extent was Dalí influenced by the exceptional realism of nineteenth-century artists—a movement usually referred to as "academic art," given that this style was taught at art academies throughout Europe?

This is a major gap in the study of twentieth-century art history. We know a great deal about Dalí's involvement with the Modernist currents of his time, but much less is known about his engagement with the Old Masters.[1] This grows in part from a certain prejudice that historians of modern art have long harbored against the oeuvre of Salvador Dalí. As long as Dalí stayed in the mainstream of interbellum modern movements, he remained a respectable and legitimate subject of research, but as soon as he ventured out on his own, using the discredited paradigms of realism, he lost legitimacy as a twentieth-century artist—at least in the eyes of these authors.

A factor that heavily influenced Dalí's reception in these critical circles of the 1950s and 1960s is that realism was the sole form of artistic expression tolerated in Nazi Germany, as well as Fascist Italy and Communist Russia. Those ideologies put an abrupt end to Modernist movements in their countries. So repulsive was the socialist realism of Nazi-era artists such as Arno Breker, Fritz Klimsch, Josef Thorak, and Adolf Wissel that for much of the twentieth-century postwar period, any form of representative art in Western Europe was considered ethically and aesthetically out of bounds.

Yet another reason why art historians have not grappled with the secret of Dalí's exceptional realism is more fundamental. Unlike most artists, Dalí did not pass through neatly

articulated phases of influence. The impact of Old Masters such as Hieronymus Bosch, Johannes Vermeer, and Diego Velázquez came and went with the ebb and flow of Dalí's mind, prompted to some extent by his intermittent exposure to these artists.

But what does that mean, the "influence" of one artist or style on another? Many of us may identify the idea of artistic influence with pure imitation of a particular style or technique. But there are many ways in which an artist can draw inspiration from a work of the past. In the medieval period, for example, a pupil was *required* to imitate the master in obeying key conventions for the depiction of sacred scenes, because most of the faithful during the Middle Ages were illiterate. It was therefore important to understand the established tradition of how these sacred scenes were painted, so that worshippers could recognize the tableaux and understand what was going on.

The Italian Renaissance completely upended that situation when the role of artistic influence became exactly the opposite, as a factor of change, rather than conformity. Artists were now eager to learn from one another *how far one could go* in the pursuit of new solutions. Thus, the young Florentine artist Masaccio was among the first to depict human beings as fully realized, three-dimensional bodies rather than as the stylized figures of Gothic art. Linear perspective, first documented by the sculptor and architect Brunelleschi, allowed painters to create a convincing optical illusion of space by placing objects on a geometric grid. Similarly, artists like Botticelli broke new ground with the choice of daring motifs, such as the female nude in the *Birth of Venus*—a theme that a generation earlier would have been denounced as pagan and possibly heretical.

The artist Leonardo da Vinci introduced another set of revolutionary ideas that would launch the art of the High

Renaissance, including the dramatic contrast of light and dark known as chiaroscuro; a more monumental treatment of the human figure; and the use of subtle atmospheric effects to suggest space and depth. These changes involved not only style and technique but also a radical rethinking of the relationship between a figure and the space it inhabits. Many of these innovations would cascade through the ages and inspire altogether new solutions, such as the theatrical light effects of Caravaggio, the tactile realism of Spanish Baroque painters, or the incredible virtuosity of seventeenth-century Dutch artists in the treatment of surface and texture. The late nineteenth century would usher in another set of radical new ideas, this time focused on the role of color, light, and framing, often inspired by the development of photography.

Throughout his life, Salvador Dalí was a keen student of these movements—not only in terms of style but also motif, composition, and technique—even if that influence is not always readily apparent at first glance. As we will see in this book, Dalí's use of Old Master material could take many forms. He could copy a particular element outright, or he could use it as a model for his own works—Raphael's elongated neck for a self-portrait, for example. He could also analyze a painting by, say Leonardo da Vinci, and then develop its principal motif to a point where the precedent was only dimly present—as in, for example, *Leda Atomica* or *The Sacrament of the Last Supper*. What's more, Dalí was a genuine Renaissance man in the truest sense of the word. He expressed his ideas not only in his drawings, graphics, and paintings but also in film, sculpture (including so-called "readymades"), stage designs, jewelry, and his voluminous literary output.

Our story will take us through all the main episodes of Dalí's remarkable life, not only to trace the seeds of his inspiration but also to uncover the secret of his enduring legacy.

# 1.
# BEGINNINGS

*I remained always the Catalan peasant, naïve and cunning,*
*with a king in my body.*

Salvador Dalí

**S**alvador **Domingo Felipe** Jacinto Dalí i Domènech was born in Figueres, Spain, in 1904, in a country that had become a mere shadow of its former great self. For centuries, Spain had been the dominant power in Europe, if not the world, and a bedrock of its security system. In the tenth century, when much of the Continent was still plunged in the Dark Ages, the Convivencia in Al-Andalus (today's Andalusia) had served as a beacon and refuge of Western civilization, sustained by not only Muslim but also Jewish and Christian scholars. Librarians from Córdoba scoured the bookshops of Alexandria, Damascus, and Baghdad in search of ancient tractates for the Library of Córdoba, which ultimately grew to four hundred thousand books. This included works by Plato, Aristotle, Archimedes,

and other Greek scholars that otherwise would have been lost to humankind.

From the early Renaissance onward, under the aegis of the Habsburg dynasty, Spain rapidly acquired territories in Hungary, the Low Countries, and Southern Italy, so that by 1700 its court had become the dominant power center in the world. When Portugal decided to send its fragile vessels south, toward Africa, Spain cast its trade routes westward into the Atlantic Ocean, in the hope of finding a new route to the East Indies. On August 3, 1492, an explorer named Cristoforo Colombo slipped the mooring lines at Palos de la Frontera, on the southwestern coast of Spain, and led his flotilla into the great Atlantic unknown. Five weeks after a victualing stop in the Canary Islands, he made landfall at the Bahamas, believing he had reached the East Indies. Instead, he had reached the New World. Just twenty years later, Juan Ponce de León sailed from today's Puerto Rico and discovered a landmass that he named Florida. One by one, Spanish colonial administrations suppressed and replaced the indigenous civilizations of Central and South America. Jesuit missions sprang up all over the continent as well as among the natives of North America, including today's Ontario, Quebec, Michigan, and New York.

But in the early nineteenth century, Spanish might began to crumble. From 1808 onward, indigenous revolts led to the loss of all of Spain's colonies in North and South America, except Cuba and Puerto Rico. In that same year, Napoleon invaded Spain, which led to a war of unprecedented violence, as captured in a famous series of prints by Francisco Goya. And finally, just six years before Dalí's birth, Spain experienced what became known as the Disaster of 1898, when war with the United States led to the loss of Cuba, Puerto Rico, Guam, and the Philippines. This catastrophic year ignited a deep and far-reaching polarization

between Spanish liberals and right-wing conservatives, laying the seeds for the Spanish Civil War.

Spain's history and its deep-seated traditionalism cast a heavy shadow over the early years of the twentieth century, particularly in Catalonia. This northern province had always been a thorn in the side of the Castilian monarchy, often siding with France against the ruling house in Madrid when the opportunity presented itself. In 1714, the victory of Philip V over the kingdom of Aragon had led to the wholesale elimination of all indigenous Catalonian institutions, including the Catalan language. The Catalonians never forgave Madrid for this infamy, and for the next two centuries the province remained a cauldron of seething resentment. What gave this resentment particular weight is that in the second half of the nineteenth century, Catalonia was also the first region to embrace the Industrial Revolution, boosting its economy and wealth to unprecedented heights. Barcelona, its nominal capital, became one of Spain's most developed cities, with universities and other cultural institutions to match.

If Catalonia was always the most European of Spain's provinces, then its easterly region of Empordà was certainly the most "French." Jutting into the Mediterranean with a coastline that abruptly carves inward, Empordà is dominated by a weathered and wind-beaten mountain range known as the Montgrí Massif, with summits rising to nearly one thousand feet. Here, in the sixth century BCE, the Greeks had established one of their first colonies—the root of the word Empordà is *empúries* or *empòrion,* meaning "markets" in Greek. By the early twentieth century, Figueres had become Empordà's most vibrant city, in contrast to the capital of Girona Province, the city of Girona itself, which was content to bask in the fading glory of its medieval beauty. Significantly, Figueres is closer to the French border at Perpignan

than to any other Spanish city—a mere thirty-seven miles, more than twice the distance from Barcelona. It is separated from the Mediterranean Sea, with its cluster of fishing villages, by the expansive stretches of the Empordàn plain, bordered on the horizon by the Albera mountain range. The vastness of this plain embedded itself in the imagination of young Salvador Dalí from an early age and returned in his canvases throughout his life.

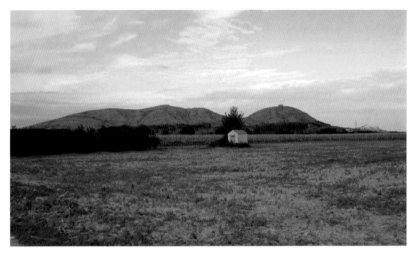

Fig. 2. The Empordà plain with the Montgrí Massif in the distance

That young Dalí was born in Figueres, rather than in the more cosmopolitan city of Barcelona, was not by design. In the early 1880s, Dalí's grandparents Galo Dalí and Teresa Cusí had decided to move from the fishing village of Cadaqués to Barcelona in the hope of securing a promising future for their children. Galo and Teresa, as it turned out, had had an affair that produced a daughter, Amicela, in 1871, long before they were married. It took the birth of a son, Salvador, in 1872 and a third child, Rafael, in 1874 to finally compel them to head to the altar, but the marriage was troubled and the couple even separated for a while.

Much has been written about the roots of the name Dalí, which appears to be neither Spanish nor French. In later years, the painter himself claimed an Arab pedigree, arguing in his autobiography *The Secret Life of Salvador Dalí* that "in my family tree my Arab lineage going back to the time of Cervantes has been almost definitely established."[2] According to some sources, Dalí even went as far as to claim that he was a descendant of the Moors who invaded Spain in 711. This, he would argue, explains "my love of everything that is gilded and excessive, my passion for luxury and my love of oriental clothes."[3]

Though no evidence for these claims has been found, there may be some truth to the idea of an Arab lineage, as the author Ian Gibson found by the simple expedient of browsing through telephone books in Tunisia, Algeria, and Morocco. From this, Gibson deduced that the Dalís may have been the descendants of Moriscos, Spanish Muslims who were coerced into converting to Christianity after the last Muslim territory in Spain was conquered by Ferdinand of Castile and Isabella of Aragon in 1492.

What happened to the Dalí bloodline over the next four centuries is ground for mere speculation. It appears that many members of the family were laborers, as attested by an entry in the 1688 register of Ller, a small town on the border of the Empordàn plain.[4] In the early nineteenth century, a man known as Silvestre Dalí Raguer decided to move his family from Ller to Cadaqués, shortly to be joined by his brother, the blacksmith Pere Dalí Raguer—the future painter's great-great-grandfather.

Some eighty-five years later, Galo Dalí père decided to reconcile with his wife, Teresa, and take the growing family to Barcelona, which at that time was experiencing an economic boom thanks to the rapid industrialization of Catalonia, particularly in the production of cotton. Whether the prospect of fortune

was the reason for Galo's move is not entirely clear; some sources claim that Galo simply couldn't tolerate the brutal winds blowing across the Empordà plain, known as the *tramontane* in Spanish and the *tramuntana* in Catalan (literally, "across the mountains"). Often blowing at more than sixty miles per hour, the wind is a fearsome phenomenon in this part of the Mediterranean even today, capable of toppling railroad cars and snapping television masts like matchsticks. In fact, the brutal force of these winds has often been cited as the reason why many people living in and around the Empordà plain are known for their somewhat volatile tempers. But other authors have maintained that Galo simply wanted a better future for his sons and realized that a degree from a Barcelona university would be a vital prerequisite at the dawn of the modern age.

Thus the Dalí family arrived in Barcelona at the peak of its prosperity—no fewer than sixteen new banks opened up in the city in 1881 and 1882 alone. Vast sums poured into the Llotja, the local stock exchange, prompting Galo to invest not only his own savings but that of others as well, acting, in a sense, as a quasi-stockbroker. For a while, life was good. The boys, Salvador and Rafael, were enrolled in the local schools, and Salvador soon matriculated in the local university, as his father had hoped. Nevertheless, the political tensions between Catalonia and Madrid were always simmering under the surface. Galo often found himself in court, defending himself or accusing others, assisted by a well-known political activist-attorney named Goncal Serraclara Costa.

This rather litigious nature came to haunt Galo in 1886 when the Barcelona stock bubble unexpectedly burst—as stock bubbles invariably do—and he suddenly found his savings and investments wiped out. Bereft of friends and allies, he did what many

such unfortunates do under these circumstances: he climbed over the third-floor balcony of his house on the Rambla de Catalunya and plunged to his death. Fortunately, his son-in-law—a young attorney named Josep Serraclara, Goncal's younger brother who had married Teresa's daughter Catalina—came to the family's aid. He ensured that the official death certificate did not identify suicide, thus permitting a Catholic burial. He also took in Galo's widow with her two sons, Salvador and Rafael, who remained in Serraclara's house until they completed their university degrees. Salvador (henceforth to be identified as Salvador Dalí Cusí, to distinguish him from his illustrious son) set his sights on becoming a notary—a position of some consequence in a culture where large segments of the population were illiterate, let alone educated. Rafael, meanwhile, decided to become a physician.

Barcelona had by now largely recovered from the 1886 crash and had pulled itself sufficiently together to host the 1888 Universal Exposition. Curiously, books about Salvador Dalí's early years often omit this event, but in fact the Universal Exposition would have a major impact on the creative environment in which Dalí's early talent took shape. Universal Expositions of this type were a particular product of the Industrial Revolution. They provided competing nations a platform to flaunt their perceived progress and modernity, usually by building lavish pavilions that were then stuffed with the latest, most advanced products. The international flavor of these vast exhibition grounds also fostered the illusion that by the end of the century, European countries had become so closely intertwined economically that any thought of an aggressive war was inconceivable. It is this idealism, presented with all the trimmings of belle epoque grandeur, that drew hundreds of thousands of visitors to the Barcelona Exposition grounds from all over Europe, and indeed the world. The event,

which featured pavilions from twenty-seven countries, ran from May 20 to December 9, 1888, in a sprawling 115-acre field that had been cleared of the city's old citadel walls.

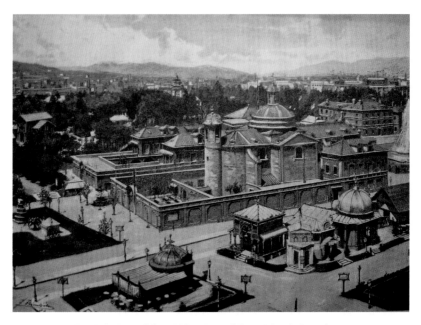

Fig. 3. A view of the 1888 Universal Exposition in Barcelona.

It drew a total of two million people—an astounding number at that time. Though only the entrance gate remains—the Arc de Triomf—the exhibition grounds extended into a city park known as the Parc de la Ciutadella, which remains to this day. Another visible remnant of the Exposition is the massive monument to Cristoforo Colombo that cruise ship passengers see as they disembark at the city's main cruise terminal.

For the purposes of our story, however, the 1888 Exposition had one major outcome: it established Barcelona as a new cultural center that could rival the art circles and avant-garde of Paris, London, and Berlin, not only in terms of painting but also

sculpture and architecture. As a result, Spain was once again able to claim the position of influential locus of contemporary art that it had occupied throughout the Baroque Era and only yielded in the early nineteenth century. Among its most prominent artists was the controversial Catalan architect Antoni Gaudí, who had designed the pavilion of the Compagnie Transatlantique and only two years later assumed responsibility for a major cathedral then under development, the Sagrada Família. As a corollary, Barcelona became an important center of art patronage, particularly with regard to modernist movements. One such patron was the Pichot family, Pitxot in Catalan, who lived on the Calle de Montcada 21 (the same street where today the Picasso Museum is located). At the time of the Exposition, this family ran one of the most fashionable salons in the city, while one of their offspring, Ramon Pichot, was destined to become a painter of some renown—and a mentor for the future artist Salvador Dalí.

In the meantime, Dalí Cusí had successfully completed his legal studies and was busy applying for various notary positions in Barcelona. Alas, the Disaster of 1898 affected Barcelona deeply, and job opportunities soon dried up. One Pichot family source, the young Antoni, later claimed that it was Ramon Pichot who persuaded Dalí Cusí to give up on Barcelona and return to the original family seat in Figueres.[5] Ramon had a personal motive for doing so. The Pichot family had extensive holdings in the Empordàn plain and would always need a local notary who could keep an eye on things and provide the necessary deeds, wills, and transfers sustaining the Pichot estates. Thus, it was largely through the patronage of the Pichot family that Dalí Cusí made the decision to return to Figueres, ensuring that his future son Salvador would grow up in an environment that would become a key motif in his art. At the same time, the Pichot family was also

destined to become a key catalyst in the development of young Salvador's art, and a principal gateway to the avant-garde movements then swirling around in Barcelona and art centers beyond.

Once established in Figueres, and ensured of a promising practice, the twenty-eight-year-old notary was finally in a position to marry the young woman to whom he had become engaged in Barcelona: twenty-six-year-old Felipa Domènech Ferres. Significantly, Felipa's maternal grandfather was an artisan named Jaume Ferres, who was well known in the area for his handsomely crafted combs, fans, and walking sticks. Many of these would come to populate the dressers and cubby holes of the Dalí family home; indeed, a carved walking stick would make its appearance in many of Dalí's earliest paintings and continue to serve as a mysterious motif for much of his subsequent oeuvre.

Felipa and Salvador Dalí Cusí were married on December 29, 1900, the cusp of the new century. Within weeks, Felipa announced to her husband that she was pregnant.

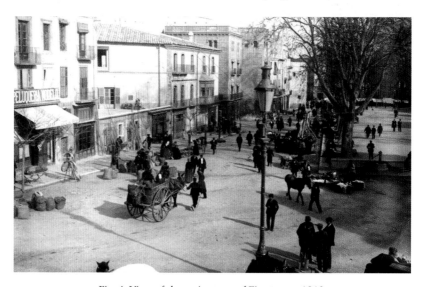

Fig. 4. View of the main street of Figueres, c. 1913

Fig. 5. Salvador Dalí, *Portrait of my Father*, 1925

Now twenty-nine, Salvador Dalí Cusí was gradually becoming an important personage in Figueres. Heavy-set, with a large head pierced by brooding eyes, he exuded some of the volatility and ferocity so often associated with the region. As a result, he was not an easy man to get along with. Prone to outbursts, he was used to having his way and impatient with anyone or anything that did not conform to his wishes. This image of a remote,

self-absorbed personality was captured in young Dalí's earliest memory of his father as he sat in his rocking chair listening to a phonograph record of Gounod's *Ave Maria*: "Standing in front of him, against the background of the music, I can see his leonine jaw coming and going above my head, full of its terrifying energy."[6] Such qualities did not bode well for a man facing the incipient responsibilities of fatherhood.

The first child of Felipa and Dalí Cusí was born on October 21, 1901. It was a boy, and consequently the parents named him after his father, Salvador. Little Salvador appeared for all the world to be a healthy child, but in 1903, when he was just twenty-one months, the toddler fell ill. As so often happened in those days before the development of antibiotics, he succumbed to an apparent stomach infection. Many myths have been spun around this sudden death, including the rumor that the child died as a result of a blow by his irate father, but no convincing evidence of this has been brought forward.

What we do know is that the death of her young son devastated Felipa, and to a lesser degree Dalí Cusí as well, casting a deep shadow over the marriage that was never fully lifted. Indeed, when nine months after the baby's death another son was born, the parents fatefully decided to name him Salvador as well, thus burdening this second child with an unfathomable source of guilt. It condemned the second Salvador to inferiority to a namesake who would gradually attain an inviolable and saintly status in the family. "I felt fear on every occasion when I entered my parents' room and saw the picture of my dead brother covered with fine lace," Dalí wrote later. "His beauty induced the extremely opposite reaction of me visualizing this ideal brother in the state of a final decay during the whole night while I was lying in my bed. I could only fall asleep if I was thinking about my own death."[7]

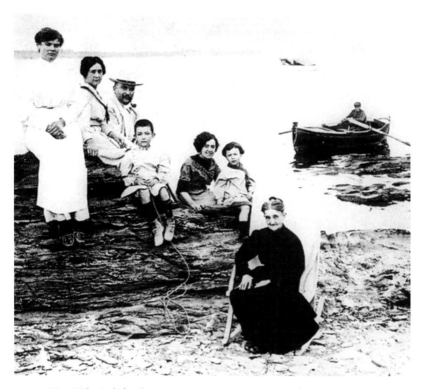

Fig. 6. The Dalí family in 1910: aunt Maria Teresa, mother Felipa, father Dalí Cusí, Salvador Dalí, aunt Caterina (later the second wife of the father), sister Anna Maria, and grandmother Anna (from upper left)

One does not need to be familiar with modern developmental psychology to know that this situation has the potential to inflict grave damage on a child—something of which Dalí himself was all too aware. "All the eccentricities which I commit," he wrote later, "all the incoherent displays of the tragic fixity of my life" were rooted in the fact that he found the urgent need "to prove to myself that I am not the dead brother, but the living one. As in the myth of Castor and Pollux, in killing my brother I have gained immortality for myself."[8] In an interview with the French

literary critic Alain Bosquet, Dalí went further and said, "Every day, I kill the image of my poor brother, with my hands, with kicks, and with dandyism. Today, I made him take flowers to the cemetery. He is my dark God, for he and I are Pollux and Castor: I am Pollux, the immortal twin, and he is the mortal one. I assassinate him regularly, for the 'Divine Dalí' cannot have anything in common with this former terrestrial being."[9]

An interesting parallel can be drawn with the Dutch Postimpressionist artist Vincent van Gogh, who was likewise named after a baby who was stillborn just one year before his own birth. In Albert Lubin's 1972 biography of Van Gogh, he argues that the burden of inhabiting a dead sibling would haunt Van Gogh for much of his career as an artist, as expressed in various drawings and paintings of pairs of male figures.[10] It may also have contributed to the deep depression with which Van Gogh struggled in the final years of his life.

Three years later, in 1907, Dalí's mother gave birth to a baby girl, Anna Maria. This completed the Dalí family, which not only included Dalí's parents but also Felipa's mother, Maria Anna Ferres, and her younger sister, Caterina (known as Tieta, or "Aunt"), who worked as a milliner. As a result, Salvador grew up surrounded by older, often overpowering women—a situation that was bound to have a further impact on his development as a young man. Worse, Dalí's mother liked to dress him in girls' clothes, since she had been fervently hoping for a girl after the birth of her first son. This experience, and the growing intimacy between young Salvador and his mother, may be factors in the sense of sexual ambiguity and fear of aggressive female sexuality that would inform so many of Dalí's early works. It has even prompted some authors to argue that his attraction to androgyny was fueled by an innate homosexuality and feelings of sexual

inadequacy. There is no evidence that Dalí was gay, though the poet Federico García Lorca once claimed he tried to seduce Dalí, apparently to no avail.

A more persuasive argument can be made that Dalí was genuinely terrified of heterosexual intercourse. Dalí himself blamed these feelings on the fact that his father had prominently placed a graphically illustrated book about venereal diseases on the piano in the living room. In his book *The Tragic Myth of Millet's Angelus,* Dalí went as far as to claim that fear of sexual intimacy informed his entire life, producing a neurotic impotence that could only be alleviated through masturbation.[11]

As deep as his affections for his mother were, just as fraught was his relationship with his father. The result was a near-Oedipal rivalry that prompted various acts of rebellion, such as wetting his bed "for the sheer fun of it," as he wrote, or hiding feces in corners of the house. He once returned home late, explaining that he had "shit himself," which elicited a thunderous response from his father. The experience would inform his work *The Lugubrious Game* (1929).[12]

Another distinct feature of Dalí's early childhood was his penchant for violent temper tantrums, which inevitably prompted his doting mother to try to placate him—thus encouraging the child to persist in this type of behavior. As a result, Dalí grew up as a rather spoiled and sheltered child who was always in search of new ways to get people to pay attention to him. "I was the absolute monarch of the house," he wrote later.[13]

In one particularly disturbing event, Dalí remembered walking at age five in the countryside, accompanied by a young boy who was puttering along on a tricycle. At one point they found that they had to cross a bridge that was still under construction and therefore not yet equipped with guardrails. "Suddenly," Dalí

33

wrote, "as most of my ideas occur, I looked behind to make sure no one was watching us and gave the child a quick push off the bridge." The little boy landed on a pile of rocks and was seriously injured. Dalí ran home to breathlessly report the news of the accident. For the remainder of the afternoon he sat contentedly as women rushed back and forth with "bloodstained basins," secure in the knowledge that the child had suffered "a badly injured head." As Dalí sat on a rocking chair, eating cherries, the scene put him "in a delightful hallucinatory mood," without "the slightest feeling of guilt."[14]

This incident reveals a pattern that would run as a basso continuo through the fabric of Dalí's extraordinary life: the never-ending thirst to be the agent of his destiny, to be at the center of things, to be seen and admired, to be talked about and revered. Even in his dying days, as he lay in his bed in Barcelona's Hospital Quirón, he insisted on watching the daily news bulletins on television reporting on his health.[15]

In sum, the experiences of Dalí's youth almost certainly inculcated a number of complex psychopathological symptoms, which Zoltán Kováry described as a mixture of "affective disorders, sexual problems, narcissistic symptoms, and . . . prodromal psychotic signs."[16] Taken together, these symptoms would form a fertile basis for the work of a Surrealist artist.

# 2.
# THE EARLY YEARS:
# 1922–1926

*Intelligence without ambition is a bird without wings.*

Salvador Dalí

**W**hen Dalí was five years old, he was enrolled in the local primary school but soon proved to be an unwilling student. At times, he had to be dragged kicking and screaming to the classroom. When this behavior persisted, he was placed instead in the Hispano-French School of the Immaculate Conception in Figueres, an experiment that likewise failed badly. The one positive outcome of this attempt was the fact that the school taught French, thus giving Dalí an initial grounding for the language that he would speak—with a strong Spanish accent—and write for much of his adult life.

Around this time, at age six, Dalí painted his first picture. He had discovered, in Ralf Schiebler's words, that "drawing and

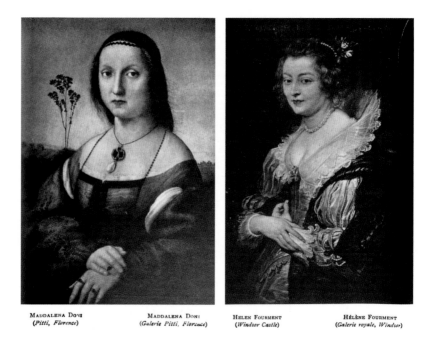

MADDALENA DONI
(*Pitti, Florence*)   MADDALENA DONI
(*Galerie Pitti, Florence*)   HELEN FOURMENT
(*Windsor Castle*)   HÉLÈNE FOURMENT
(*Galerie royale, Windsor*)

Fig. 7. A page from Gowans & Gray monograph *The Masterpieces of Raphael,* featuring Maddalena Doni (left), and a page from the monograph on Rubens, illustrating the portrait of Hélène Fourment (right)

painting would be the most effective vehicles for [his] urge to impress others and win their admiration."[17] At this point, his exposure to art had been limited to a series of art monographs, known as the Gowans's Art Books and published by the British publishing house Gowans & Gray between 1905 and 1907. Each monograph contained a series of sixty moiré-patterned black-and-white photographs, taken from the oeuvre of a particular Old Master. There was no text or narrative to speak of. The focus of these pamphlets was simply to provide a collection of an artist's principal works in black-and-white pictures, with only short captions in English, French, and German.

Even so, the books enjoyed wide distribution throughout Europe; in Spain, the distribution was in the hands of a Portuguese representative, Ferreira & Oliveira, based in Lisbon. "On hot days," Meredith Etherington-Smith, author of *The Persistence of Memory: A Biography of Dalí*, relates, "Dalí would sit in the laundry tub, fill it with cool water, and prop the issue of *Art Gowans* he was studying on a plank put across the tub," paying particular attention to the nudes.[18] The Gowans's Art Books, Dalí would later write, "produced an effect on me that was one of the most decisive in my life. I came to know by heart all those pictures of the history of art, which have been familiar to me since my earliest childhood, for I would spend days contemplating them."[19] Thus, the young boy was introduced to the world of the Old Masters from a very early age, and in purely visual terms. Consequently, Dalí imbibed the images and stored them in the recesses of his fertile imagination, there to serve as a repository of ideas for the remainder of his life.

The fourth volume in this series was *The Masterpieces of Raphael,* and it is this book that perhaps made the biggest impression on the young Dalí.[20] His autobiography is filled with allusions to Raphael and the Raphaelesque. "If I look towards the past," he wrote later, "beings like Raphael appear to me as true gods; I am perhaps the only one today to know why it will henceforth be impossible even remotely to approximate the splendors of Raphaelesque forms." His wife and muse, Gala, is described as "as well painted as a Raphael," while one of his first paintings, a 1921 self-portrait, is entitled *Self-Portrait with Raphaelesque Neck.*[21] The rather awkward composition, in which he portrays himself with an elongated neck, cut off at the shoulders, is reminiscent of Raphael's *Self-Portrait* of 1504–1506, albeit in reverse. In his interview with Alain Bosquet, Dalí averred that "I adore three old masters: Velázquez, Raphael, and Vermeer."[22]

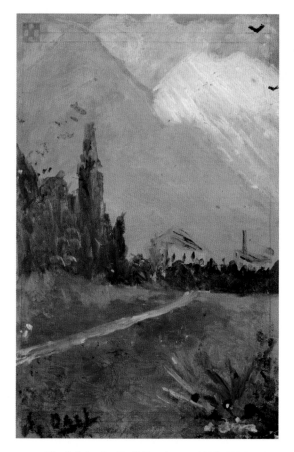

Fig. 8. Salvador Dalí, *Landscape*, 1910–1914

Of course, in expressing his admiration for the work of Raphael (which was featured in the fourth volume of Gowans's Art Books), Dalí was hardly unique. The interest in Raphael as the ideal of Old Master art had been a staple of academic painting for much of the latter part of the nineteenth century. Entire schools of European art, particularly those working in genres such as history painting, biblical scenes, or Greco-Roman mythology, modeled themselves on Raphael as the highest benchmark of

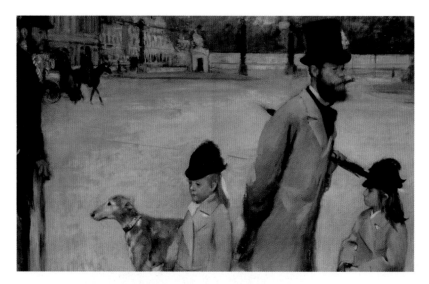

Fig. 9. Edgar Degas, *Place de la Concorde*, 1875. Impressionist artists were fascinated by the challenge of creating a spontaneous, snapshot-like image of modern Parisian life.

artistic expression. In France, this movement was centered on the Académie des Beaux-Arts, which schooled an entire generation of artists, including William-Adolphe Bouguereau, Ernest Meissonier, and Thomas Couture, in the classicist hyperrealism that was all the rage in the official salons of the latter part of the nineteenth century. By the time Dalí came into contact with this genre, avant-garde circles derisively referred to these artists as *les pompiers* (meaning, "the firemen," after the quasi-classical helmets worn by French firemen at the time). Reactionary and conservative though their subject matter may have been, there was no denying the tremendous technical skill with which these artists executed their visions, often under influence of High Renaissance artists such as Raphael and Leonardo da Vinci. In many instances, their astonishing optical realism relied heavily on the use of photography, even if they were not prepared to admit it.

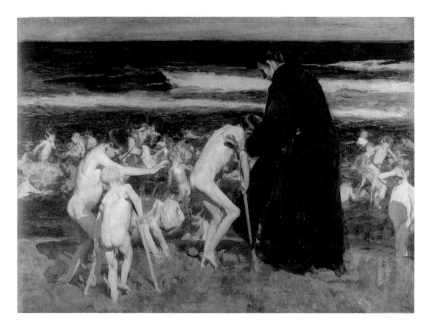

Fig. 10. Joaquín Sorolla, *Sad Inheritance*, 1899. Although the rapid
brushstrokes and sharp light effects are elements of the Impressionist
ethos, the composition and draftsmanship remain firmly traditional.

So pervasive was the academic infatuation with Raphael
that early on, a reaction broke out in England that referred to
itself, tellingly, as the Pre-Raphaelite Brotherhood. Founded
by Dante Gabriel Rossetti, John Everett Millais, and William
Holman Hunt, this group devoted itself to finding the original,
unmannered spirit of the Renaissance, before the art of Raphael
and da Vinci became canonized as fixed doctrine. In France, the
rule of the Academy would elicit another reaction, that of the
Impressionists, who instead sought inspiration in the motifs and
social ills of modern life.

Indeed, the influence of Raphael on Dalí's young mind would
swiftly be overtaken by other, more modern artists, including the

Impressionists. As it happened, Dalí père had purchased a modest vacation home in Cadaqués, the same fishing village where the Pichot family owned a lavish villa. It was here that Ramon Pichot discovered the stirrings of an artist in young Dalí and introduced him to the family's collection of paintings. This included not only Pichot's own works but also those painted by his friends, who invariably hewed to the Impressionist or Pointillist vernacular. Not surprisingly, Dalí's very first work is a landscape in the Impressionist style, entitled *Landscape,* executed with a flair that is quite astonishing for a six-year-old.

When it first emerged in the 1860s, Impressionism was the focus of a group of highly individual French artists who referred to themselves as the Gang of the Batignolles—the quartier in Paris where many of them lived. Stylistically, these artists did not have much in common. What they did share was a deep interest in the spontaneous framing and lighting of a particular scene without any intervention by the artist, almost as if they had used a photo camera to take a snapshot of something caught on the street. This, of course, was a deliberate reaction to the careful lighting, staging, and framing taught by official art circles.

To do so, Impressionists often painted *en plein air,* that is, outside, in full view of their subject, rather than in the confines of a studio as landscape painters had done up to this point. In addition, their art was usually characterized by quick, bravura brushstrokes that militated against the polished detail of the prevailing academic style. Most importantly, however, the French Impressionists broke new ground with their choice of subject matter: washerwomen, prostitutes, and other figures marginalized by the modern urbanization of Paris, rather than the lofty mythological or historical themes preferred by official art.

41

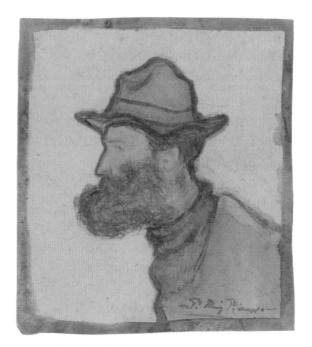

Fig. 11. Pablo Picasso, *Ramon Pichot*, 1900

Though originally conceived as a reaction, Impressionism rapidly spread through Europe in the 1880s and 1890s and eventually replaced the academic style as the official canon of artistic instruction. Spain was no exception, since many Spanish artists spent time in Paris and inevitably became infatuated with the Impressionist vernacular, both as a style and as an instance of social activism.

One of the foremost Spanish Impressionists was Joaquín Sorolla, who absorbed Impressionist and Postimpressionist impulses during his sojourn in Paris in 1885, before returning to his native Valencia in 1888. Though he embraced the Impressionist palette, Sorolla remained faithful to academic principles of composition and draftsmanship, in a manner typical

for many European Impressionists working outside of France around the turn of the century. This made sure that they remained inside the commercial mainstream of the prevailing art salons, as evidenced by Sorolla's *Sad Inheritance* (1899), depicting young polio patients bathing on the beaches of Valencia. This earned Sorolla a Grand Prix and Medal of Honor at the 1900 Universal Exhibition in Paris.

In other words, Impressionism in Spain and other areas, notably Italy and the United States, was a far less radical movement than its French progenitor, largely preoccupied as it was with the treatment of light and brushwork, rather than any particular subject matter or theoretical idea. In this, however, Ramon Pichot was arguably an exception. Nine years older than Picasso, he became close friends with his Spanish compatriot. In 1900, the two artists traveled to Paris together to imbibe the many new art currents then flowing through the city.

Eight years later, Ramon married a model and former lover of Picasso's, Laure Gargallo, known as Germaine. Together they ran a restaurant near Picasso's studio at the Bateau-Lavoir, called La Maison Rose. As a result, Ramon had a front-row seat for the various movements then emerging in the French capital, such as Fauvism, and Cubism. During trips back to the family estate at Cadaqués, Ramon would often spend time with young Dalí and—we may assume—regale him with the latest developments he had observed in Paris. It is possible that these conversations, illustrated by Ramon's own sketches and paintings, persuaded Dalí to pursue a career as an artist himself. "The paintings that filled me with the greatest wonder," Dalí recalled, "were the most recent ones, in which deliquescent impressionism ended in certain canvases by frankly adopting, in an almost uniform manner, the *pointilliste* formula."

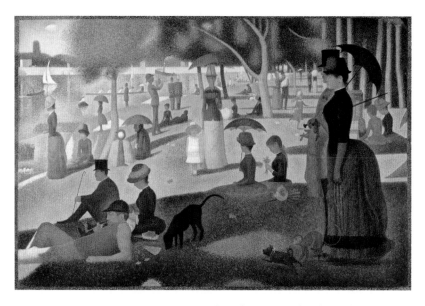

Fig. 12. Georges Seurat, *A Sunday Afternoon on the Island of
La Grande Jatte*, 1884–1886. This masterpiece of Pointillism uses tiny, juxtaposed
dots of multicolored paint, which the human eye perceives as tones.

Pointillism had been developed by Georges Seurat and
Paul Signac in the late 1880s as an extreme development of
Impressionism, in which the attempt to simulate the fall of light
was achieved by small spots of complementary colors, which—it
was believed—the human eye would synthesize and interpret as
a subtle range of tones. Often known as Divisionism (although
strictly speaking, Divisionist painters would approach their
work with a greater scientific focus on the mixing of primary
colors rather than by pure impression), this peculiar form of
painting captured much of the Paris art world in the last two
decades of the nineteenth century, only to be abandoned just
as quickly at the turn of the century. Many noted artists expe-
rienced a Pointillist phase (the term was derisively coined by

art critics, in much the same way that the term Impressionism was a result of a scathing review), including Pissarro and Van Gogh. But by the time young Dalí became immersed in the latest currents of modern art, Pointillism had already run its course.

More importantly, perhaps, Ramon became a key catalyst in convincing Dalí's father that his son had a genuine talent and that this talent should be nurtured and encouraged. This went directly against the plans that Dalí senior himself may have had for his son, which undoubtedly envisaged a career as a notary or a lawyer.

But the opinion of the Pichot family counted, not least because so much of Dalí père's notarial business depended on them. "My parents had already undergone the influence of the personality of the Pichot family before me," Dalí wrote in his autobiography. "All of them were artists and possessed great gifts and an unerring taste. Ramon Pichot was a painter. Ricardo a cellist, Luis a violinist, Maria a contralto who sang in the opera. Pepito was, perhaps, the most artistic of all."[23] Against such an overpowering influence, Dalí's stubborn resistance was bound to crumble.

**In 1914, however,** war suddenly broken out in Europe, disrupting the growing international contacts among artists from London, Berlin, Paris, Milan, and Barcelona. What prompted the war was the fact that on June 28, 1914, the heir to the throne of Austria-Hungary, Archduke Franz Ferdinand and his morganatic wife, Sophie, were assassinated by Serbian-trained terrorists in Sarajevo. Kaiser Wilhelm II of Germany, brimming with indignation, demanded that Austria exact revenge against Serbia, lest her passivity be mistaken for weakness. By the time Austria finally issued an ultimatum to Serbia, the Russian czar,

the traditional protector of the Slavs of Serbia, had also begun to rattle his sword. This, in turn, forced France to join the fray, for France and Russia had recently concluded a joint defensive pact. This was the great tragedy of early twentieth-century Europe: Its kingdoms were locked in the grip of treaty obligations that were supposed to secure the peace yet only served to thrust the continent into war.

The sheer barbarity of World War I, the first war to be conducted on an industrial scale, left the world bereft of many of its cherished beliefs—including the comforting Victorian concept of standing at the pinnacle of Christian civilization. This also destroyed the underpinnings of academic painting with its fondness for elaborate historical or mythological subject matter, creating an artistic and intellectual tabula rasa on which many new ideas could flourish.

Spain had resolutely declared its neutrality in the conflict, but the scale of the war—and its extraordinary duration, four years— was bound to expose the latent tensions in Spanish society. While the deeply conservative upper classes generally favored the cause of the so-called Central Powers, Germany and Austria-Hungary, the lower classes and intellectuals, particularly in Catalonia, strongly favored the French side. Many Catalans decided to volunteer in the French armies, ultimately numbering nearly two thousand men. Significantly, the war boosted the economy of Catalonia, which had already enjoyed a far greater level of industrialization than any other part of Spain. Massive wealth poured into the region as the Allies were desperately looking for a great variety of goods, not only wool and foodstuffs but also arms and other materiel, including steel. This did not go unnoticed by the German Kriegsmarine, and some 140,000 tons of Spanish shipping were lost to German U-boats. Nevertheless, by 1915 so much food had

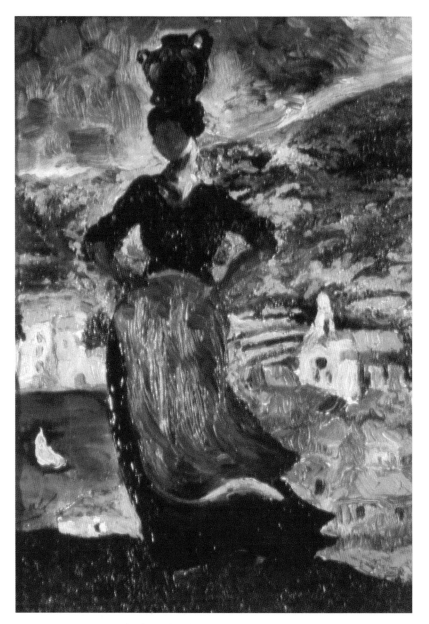

Fig. 13. Salvador Dalí, *The Woman with the Pitcher*, c. 1918

been shipped out of Spain that food riots erupted in some Spanish cities, ultimately toppling the conservative government in favor of a new liberal administration. As a result, World War I served to deepen the social and political divisions in the country, even though it was not itself a belligerent in the war.[24]

The Great War made a deep impact on artists throughout Europe. Rejecting academic art and its penchant for photographic naturalism, they embarked on developing new, reductive ideas that sought a more authentic form of artistic expression. This prompted not only a late flowering of Fauvism and Cubism, but also new movements such as Dada, Surrealism, Futurism, and German Expressionism. It was in this volatile mix of new ideas that Salvador Dalí came of age.

Indeed, one of Dalí's first paintings, *The Woman with the Pitcher*, painted around 1918, is a remarkable work for a sixteen-year-old, particularly in the treatment of the light caressing the young woman's neck and face. The painting betrays the influence of Ramon Pichot's paintings and indirectly that of Postimpressionists such as Gauguin and Cézanne, particularly in the portrayal of the village and mountains in the background.

The following year, while still at the Figueres grammar school, Dalí joined with school friends to start a magazine entitled *Studium*, conceived as an outlet for his first literary endeavors on the world of art. *Studium* was published as a monthly review from January to June of 1919 and featured contributions by Jaume Miravitlles, a Catalan politician and activist; Joan Turró, a local physician; Ramon Reig, an art professor with a particular interest in Catalan poetry; and the pharmacist Joan Xirau, who wrote articles on the history of the Empordà. Its publication coincided with a groundswell of civic pride and cultural fervor in Figueres. Among other sequelae, this produced the opening of a

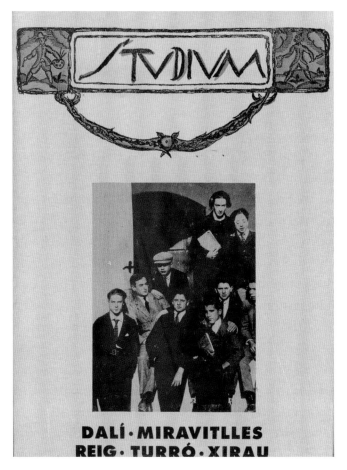

Fig. 14. The cover of *Studium*, published between January and June 1919.
Dalí is shown at top right.

large municipal park, the start of a public library, the creation of a main shopping street, the Rambla, and the inauguration of a rail service between Figueres and La Jonquera, on the French border.

The magazine is of particular interest for our subject because its six issues featured a series of full-length articles, written by Dalí, under the header "The Grand Masters of Painting." The

featured artists included Goya, El Greco, Dürer, Leonardo da Vinci, Michelangelo, and Velázquez. These reveal that even at the tender age of fifteen, Dalí was already immersing himself in the art of the most prominent artists of the Italian and Spanish Renaissance. He described Leonardo as "the greatest master of painting, a soul that knew how to study, to invent, to create with ardor, passion, and energy, which was how he lived his whole life. . . . His paintings," Dalí added, "reflect his constant love, dedication, and passion for his work."[25]

The quality of the articles suggests that Dalí had made an effort to consult sources beyond what was available at his grammar school or the local Municipal Drawing School, where he attended classes taught by Juan Núñez. Indeed, the closest examples of actual Old Master paintings that Dalí could have seen at that time were to be found at the Museu Municipal de Belles Arts, then housed in the Palau de Belles Arts, built in Barcelona for the 1888 Universal Exhibition. This collection, which in 1934 was transferred to the Palau Nacional, a huge neo-Baroque concoction built in 1929 on Montjuïc Hill, is rich in Romanesque and Gothic art but noticeably poor in the work of Old Masters. Indeed, the small group of works by sixteenth- and seventeenth-century artists on display was largely the result of a bequest by the nineteenth-century Catalan collector Francesc Cambó, which included works by Titian, Tiepolo, Rubens, Goya, and Fragonard.[26]

Regardless of his interest in Old Masters, young Dalí's artistic output in this period remained deeply beholden to the Postimpressionist models introduced to him by Ramon Pichot. Ramon's paintings made "the deepest impression of my life," he wrote later, "because they represented my first contact with an anti-academic and revolutionary aesthetic theory."[27]

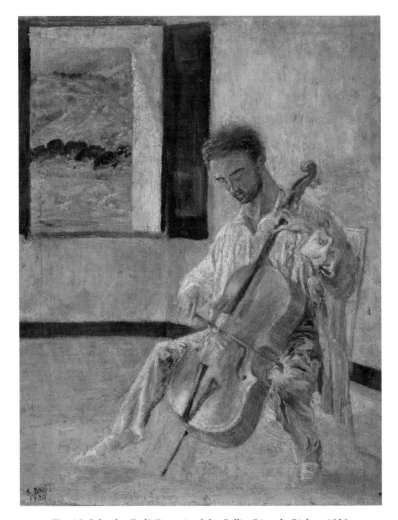

Fig. 15. Salvador Dalí, *Portrait of the Cellist Ricardo Pichot,* 1920

The following year, in 1920, Dalí secured the reluctant permission of his father to eventually go and study art in Madrid, at the Real Academia de Bellas Artes de San Fernando, on condition that he would also earn a degree that would qualify him as a teacher. Thus emboldened, Dalí produced several remarkable

51

works before his move to Madrid, including a painting of Ramon's brother Ricardo, entitled *Portrait of the Cellist Ricardo Pichot* of 1920. What is significant about this painting is not only the confident treatment of light on the cello or the bravura brushwork on the figure of Ricardo but also the idea of placing the musician in a room that is noticeably bare, save for the large window looking out on the hills of Cadaqués. This restraint, so unlike that of the exuberant treatment of nature by the Postimpressionists, must have its roots in the work of the Dutch seventeenth-century artist Johannes Vermeer. Inspired by his interest in geometry, Vermeer often studied the effect of placing a solitary figure in a tightly defined, almost monochrome domestic interior, with a strong emphasis on horizontals and verticals so as to enhance the gravitas of the person portrayed.

Even more remarkable is the fact that Dalí executed this work in the midst of a frenzy of experimentation with other forms of French avant-garde ideas, including Fauvism and Cubism. This shows that the young Dalí was able to clearly compartmentalize his survey of prevailing movements and investigate them with objectivity, ready to absorb whatever he deemed of use before moving on to the next endeavor.

Indeed, another important work from 1920 is the imposing portrait of his father, with his brooding, Churchillian bulk in sharp contrast to an enflamed sky behind him. Here, the inspiration is not so much Postimpressionism but Fauvism, a movement that broke away from Impressionism and Pointillism in the pursuit of strident colors as an expression of emotion, rather than the calculated effects of optical science.

Espoused by Henri Matisse, Maurice de Vlaminck, and André Derain, Fauvism flared briefly in the years before World War I, thus releasing artists from whatever figurative formalism remained in

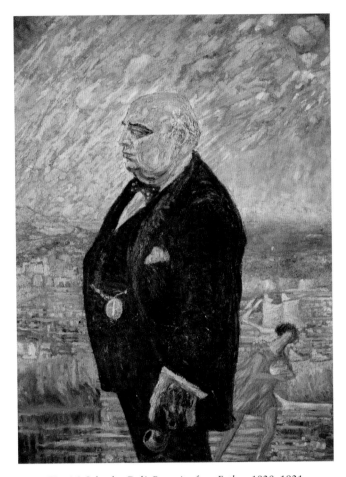

Fig. 16. Salvador Dalí, *Portrait of my Father*, 1920–1921

Impressionism and its associated movements. *Les fauves* (literally, the "wild beasts," a term coined by the art critic Louis Vauxcelles) delighted in dissolving the prevailing rules of form and depth in a shrill contrast of bright colors, thus presaging the abstract movements of the twentieth century. That same delight in color for color's sake animates Dalí's *Self-Portrait* of around 1921, in which he appears in the now-familiar Raphaelesque pose in front of

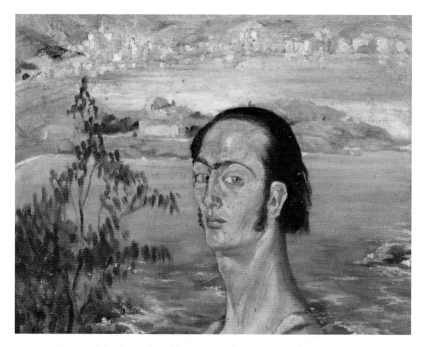

Fig. 17. Salvador Dalí, *Self-Portrait with Raphaelesque Neck*, c. 1921

his beloved bay at Cadaqués. Unlike in his previous self-portrait, though, any sense of depth and shadow in the landscape has been dissolved in a riot of Fauvist colors, stacked like a japonaiserie without any concern for linear or atmospheric perspective.

Dalí delighted in the wild, untrammeled chromaticism of *les fauves* as seen through the prism of Divisionism. In particular, the jarring contrasts of orange, violet, and white fascinated him (as in *Cadaqués from the Back*, 1921) to the point that he walked around with a carafe stopper in his pocket, shaped as a crystal, which made the world look "impressionistic" whenever he peered through it.[28]

# The Early Years: 1922–1926

**On February 6, 1921,** tragedy struck. After a six-month struggle with cancer, Dalí's mother, Felipa, died at age forty-seven. Her death affected the young artist deeply. Felipa had always served as a loving bulwark against the remote authoritarianism of his father. Dalí had become so used to her soothing acquiescence to his father's volatile behavior that he felt as if one of the key pillars of his life had been torn asunder. The fact that his father was having an affair with Felipa's sister, Catalina, during this time didn't help things; indeed, as soon as decorum allowed him, Dalí's father proposed to Catalina, and they were married. This further widened the already considerable gap between father and son and drove young Dalí ever closer to his sister, Anna Maria, who was now thirteen.

All these developments served to accelerate Dalí's plans to move to Madrid and enroll in the Academy of Fine Art. Now nearly five feet eight, he began to dress conspicuously as a Parisian flaneur, wearing a dandy's hunting jacket with baggy breeches buttoned to the knee. He also let his hair and sideburns grow long, which gave him the nickname Señor Patillas. "I had let my hair grow as long as a girl's," he later wrote, "and looking at myself in the mirror I would often adopt the pose and melancholy look that so fascinated me in Raphael's self-portrait, and whom I should have liked to resemble as much as possible."[29] At long last, in 1921, he packed his valise and traveled to Madrid.

The Real Academia de Bellas Artes de San Fernando (the Royal Academy of Fine Arts of San Fernando) had been established in 1744 by the Spanish king following the example of King Louis XIV of France in order to foster the development of an indigenous Spanish art tradition. In its long history it had counted Francisco Goya as one of the directors and since the 1760s had been housed in a lovely Italianate palace on the Calle

de Alcalá, Madrid's longest street. The palace had originally been designed by José Benito de Churriguera for a prominent Spanish family, the Goyeneche.[30] According to a 1908 Baedeker Guide, by the early twentieth century it was commonly known as the Real Academia de Bellas Artes, or the Real. Students entering the building at that time would have found a small picture gallery on the first floor with paintings by Murillo, Zurbarán, Goya, and Ribera, though the best works in the Academy's possession had by that time been transferred to the Prado Museum.

Fig. 18. The Royal Academy of Fine Arts in Madrid

By 1921, Madrid had become a magnet for young middle-class students seeking a degree from any of the capital's prestigious universities. This is why just twelve years before Dalí's arrival, the Spanish Board for Advanced Scientific Studies and Research,[31] created in 1907, had decided to develop a large residence hall, the Residencia de Estudiantes, on the model of Oxford or Cambridge

student dormitories, to accommodate the city's growing student population. For anywhere between 185 and 240 pesetas a month, a student could choose to live in a dormitory or a small private room and enjoy full bed and board. In 1915, the Residencia had moved into a complex of neo-Mudejar buildings on the Hill of Poplars, designed by Antonio Flórez. From that point on, it very quickly became an incubator of Spanish intellectual and creative talent. Noted poets and authors including Manuel de Falla and José Ortega y Gasset would live here, as well as foreign artists and scholars, including Albert Einstein, Igor Stravinsky, Walter Gropius, and Le Corbusier. Coming from the placid pace of Figueres, the plunge into this hotbed of creative frenzy must have been exhilarating.

Fig. 19. The Residencia de Estudiantes in Madrid

Indeed, Dalí quickly developed friendships with other students then living in the Residencia, including the poet and playwright Federico García Lorca, the author and intellectual José "Pepín" Bello, the writer Rafael Alberti, and the aspiring film director Luis

Buñuel. Lorca, Bello, and Alberti would later become members of
the Generation of '27, a leading literary group in pre–Civil War
Spain that sought to harmonize traditional Spanish forms and
folklore with European avant-garde styles. It was a heady group
of people to be involved with, not least because here, for the first
time, Dalí found himself in the company of intellectuals who more
than matched his own incipient talent. This may have tempered
his rather tempestuous nature, as observed by the Residencia's
founder, Jiménez Fraud, who often invited students to dinner:

> Federico [García Lorca] came a lot, played the piano, and
> lectured on popular music. Dalí came with Federico and didn't
> talk! He was then very simple and natural. One day I found
> him sitting in an armchair absorbed in looking at my drawing
> room—a room so different from the surrounding he had
> then painted.[32]

Exciting as the student milieu may have been, Dalí was not
impressed with the curriculum taught at the Academy. He found
that the faculty was at least twenty years behind the times—as
art academies often are—given that its faculty had come of age in
an era besotted with the "traditional" Impressionism of Joaquín
Sorolla and was loath to abandon it. As a result, the school was
both too traditional, and not traditional enough. On the one
hand, Dalí expected to be taught the latest in avant-garde art,
particularly movements like Cubism, to which Ramon Pichot
had introduced him; and on the other, he staunchly believed that
no matter how Modernist an artist might be, his work should
always be rooted in the precise academic draftsmanship of the
nineteenth century, and particularly that of the French artist Jean-
Auguste-Dominique Ingres. Back in the days of his childhood,

while pouring over the Gowans monographs, Dalí had decided that Ingres's *Golden Age* was "the most beautiful picture in the world and I fell in love with the naked girl symbolizing the fountain."[33] Even at the Municipal Drawing School in Figueres, his art teacher, Juan Núñez, emphasized the importance of drawing as the essential foundation of art. Dalí had readily adopted that maxim as his own gospel, and so he had expected the Madrid Academy to help him improve his technique. Alas, the opposite was true; only one professor, José Moreno Carbonero, taught a class in traditional drawing. The others were too absorbed in the Impressionist freedom of the brush, light, and plein air.

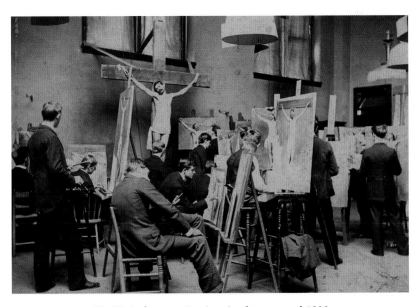

Fig. 20. A class at a Fine Arts Academy around 1900

In response, Dalí drew in on himself, rarely going out other than to attend classes or to hop on a tram to go to the Prado Museum. "Avoiding the groups who foregathered in the Residence," he wrote later, "I would go straight to my room

where I locked myself in and continued my studies." This behavior, reported to his father back in Figueres, caused some consternation. While Dalí père was obviously pleased that his son took his studies seriously, he was worried that the still impressionable young man might turn into an ascetic. "My father wrote me on several occasions that at my age it was necessary to have some recreation, to take trips, go to the theater, take [a] walk about town with friends," Dalí wrote; "nothing availed."[34]

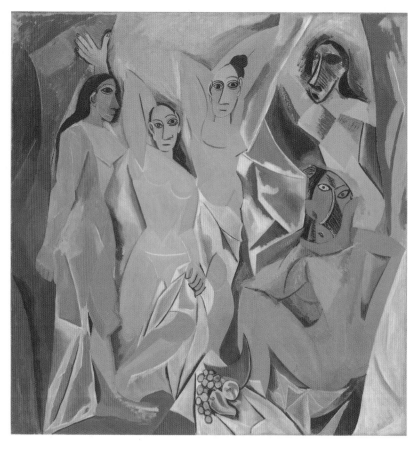

Fig. 21. Pablo Picasso, *Les Demoiselles d'Avignon*, 1907

In fact, the studies that now preoccupied Dalí so whole-heartedly had little to do with completing class assignments but with mastering the mysteries of the Cubist technique, using the work of Juan Gris as a model. A close friend of Georges Braque, Fernand Léger, and Henri Matisse, Gris was a Spanish artist who had moved to Paris in 1906 and embraced the approach to Cubism then propagated by Picasso. Gris idolized Picasso, even dedicating a painting to him, *Hommage à Pablo Picasso,* but the affection was not mutual; according to Gertrude Stein, "Juan Gris was the only person whom Picasso wished away."[35]

Inspired by the artworks of Paul Cézanne, Cubism sought to reduce three-dimensional illusion to a collage of elementary forms. This meant that objects—such as a human figure, or a musical instrument, or a landscape—could be broken down into highly abstracted forms and then reassembled into a collage, sometimes as seen from multiple vantage points. Picasso's *Les Demoiselles d'Avignon* from 1907 is often considered a foundational work of Cubism, as is Georges Braque's *Baigneuse* of 1908.

What distinguished Gris's approach to Cubism from that of Braque and Picasso, however, was his insistence on greater geometric clarity and a certain exactitude of form and line. This struck a chord in Dalí, who at that time was trying hard to improve his own drawing technique, notwithstanding the Academy's lack of interest in this subject. Another important feature of Cubism was a tendency to reduce the color palette to just a few, almost monochromatic tones. Gris, by contrast, tended to deploy bright, clashing colors, although his palette became more muted in the 1920s.

This influence is readily apparent in Dalí's paintings from 1922 and 1923, including *Figueras Gypsy, Landscape in Cadaqués,* and *Cubist Self-Portrait.* The latter in particular is a close citation

of Picasso's and Braque's work, executed in somber tones of gray, black, purple, and sienna. Here, Dalí's mask-like head, located in the center, is engulfed by a cascade of abstract shards of color, similar to Picasso's treatment of *Portrait of Amboise Vollard* (right) of 1910. It once again reveals Dalí's amazing fluidity in absorbing and applying modernist trends in his incessant desire to be fully au courant with new ideas.

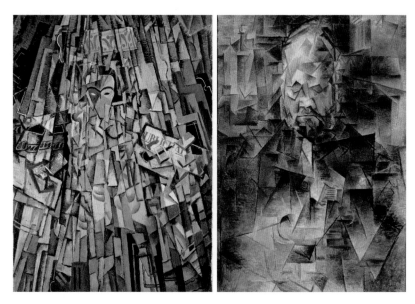

Figs. 22–23. Salvador Dalí, *Cubist Self-Portrait* (left), 1923, and Pablo Picasso, *Portrait of Amboise Vollard* (right), 1910

As part of his quest, he became an avid reader of *l'Esprit nouveau*, a French magazine published between 1920 and 1925 that chronicled the various modernist movements in the wake of World War I, not only in art but also in architecture; among its contributors was the architect Le Corbusier. And then, almost in the same breath, Dalí could do a volte-face and produce a stunning beach scene with nude female bathers, the *Bathers of Es*

*Llaner,* in a perfect Pointillist style. Once again, Dalí was absorbing, practicing, and distilling the flood of new ideas flowing down from France, like a diner at a banquet filled with different exotic dishes. But he was not yet ready to commit himself.

Indeed, in cataloging the various impulses that Dalí received in these formative years, we should never forget that the most powerful source of inspiration in Madrid was the Prado Museum. And yet some books about Salvador Dalí omit this crucial fact, as if the young artist was solely interested in modernist trends. As he himself wrote, at every opportunity he would jump on a streetcar and make the three-mile journey to the Prado. Opened to the public in 1819, the Prado brought together virtually all of the works that the Spanish Crown (and particularly the art-loving Emperor Charles V) had diligently accumulated from the territories under its sway. This included works by Hieronymus Bosch, Rogier van der Weyden, and Peter Paul Rubens from the Low Countries; paintings by Mantegna, Raphael, and Titian from its Italian possessions; and masterpieces by Diego Velázquez, El Greco, and Francisco Goya from its home territory. At the time of Dalí's visit, the museum held no fewer than sixty works by Velázquez, which imprinted themselves on Dalí's imagination as no other Old Master ever would. So comprehensive is this collection that it represents the art of Velázquez in all phases of his life, covering every genre he touched: portraiture, landscapes, and historical scenes, as well as biblical and mythological themes. This includes an early mythological work, *Triumph of Bacchus* (1629), as well as a scene from the Eighty Years' War with the Netherlands, *The Surrender of Breda* (1635). One work that captivated Dalí in particular is the enigmatic *Las Meninas,* an almost surrealistic work that juxtaposes the artist with members of the Spanish court in snapshot fashion.

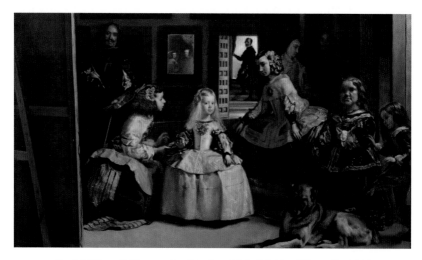

Fig. 24. Diego Velázques, *Las Meninas* ("The Maids of Honor"), 1656

At the center is the Infanta, the six-year-old Princess Margarita Teresa, surrounded by her chaperones and maids of honor. But the largest figures, placed prominently in the foreground, are two dwarfs, a German named Maria Barbola and an Italian man named Nicolas Pertusato, whose foot is stirring a large mastiff from his slumber. Meanwhile, the real power couple of this court, King Philip IV and his consort, Mariana of Austria, appear to be present as well, but this is an illusion; their portrait is reflected in a mirror placed in the background.

It is very difficult for us to imagine the impact that these and other Old Master paintings must have made on Dalí. Today, we are used to seeing art reproductions from around the world in high definition and vibrant, high-fidelity colors, whether in illustrated books or on the screens of our laptops and computers. But none of these technologies existed in the 1920s. Most art books published in the early decades of the twentieth century reproduced illustrations in black and white, often using rudimentary

techniques such as pasting a print on a blank page with glue. Others used elaborately crafted steel engravings, which served as the dominant form of printed illustrations in the nineteenth century. So the encounter with an actual work of art, in all of its true color and scale, was a far more intense experience than that which museumgoers have today. Indeed, the contrast between seeing these Old Master works in all of their awe-inspiring presence and perusing the black-and-white prints of modernist works in the journals of the day must have been striking.

In 1922, Dalí had his first exhibition. He was invited to participate in a group exhibition of the Catalan Student Association at the Galeries Dalmau in Barcelona. Josep Dalmau had become an influential dealer in modern art in part because many foreign artists had fled to Barcelona in the preceding decades to escape the fighting of World War I. Thus, Dalí made his formal entrée in Barcelona's art circles.

But back in Madrid, his tenuous relationship with the Academy went from bad to worse. A vacancy had opened up in the faculty, and numerous painters applied for the position, each being given the opportunity to exhibit two works. Dalí visited this exhibit and immediately decided that none of these artists appeared to be familiar with modern movements such as Cubism or Fauvism, instead working in an insipid imitation of the tired Impressionist vernacular. This led to a student demonstration in which Dalí, as one of the leaders, loudly expressed his dissatisfaction. He believed that an artist named Daniel Vázquez Díaz should be given the position. In the investigation that followed, Dalí was swiftly singled out as the instigator of this "riot" and suspended for one year, together with several other students.

But more punishment awaited him upon his return to Figueres. Economically, Spain struggled to recover from the aftermath of

World War I, which also marked the end of its profitable business with the war's principal belligerents. Endemic unemployment and poverty spread, prompting numerous strikes as a result. Then, in 1921, the Spanish Army suffered a grave defeat at the hands of Berber insurgents in Spanish Morocco, stunning the Spanish parliament, the Cortes Generales. This played into the hands of certain right-wing circles in the Spanish military, who had been waiting for a pretext to stage a coup.

Fig. 25. A mounted officer announces the 1923 coup d'état by Miguel Primo de Rivera.

In 1923 these officers, led by a general named Miguel Primo de Rivera, toppled the constitutional government and seized power in Spain. Having established a junta of eight senior officers, de Rivera immediately launched a crusade against anyone suspected of socialist or communist sympathies, while also suppressing the separatist movements in Catalonia and the Basque country. As

it happened, Dalí's deep engagement with the avant-garde—and his father's well-known sympathies for the Catalan cause of independence—led to young Dalí's being put on a blacklist. He was arrested on May 14, 1924, and sent to prison in Girona. Fortunately, de Rivera sensed that his witch hunt had gone too far and declared a general amnesty in June. The young Dalí was released on June 12 and soon thereafter joined his family for the traditional summer retreat in Cadaqués. This is when he painted his Pointillist *Bathers of Es Llaner*, showing twenty-four nude girls from different angles.

Fig. 26. Salvador Dalí, *Bathers of Es Llaner*, 1923

But in the fall, Dalí grew bored with life in Figueres and decided to return to the Residencia in Madrid, even though he was not yet allowed to resume his studies at the Academy. As a result, he was able to spend more time with his author friends,

particularly García Lorca, as well as a writer named Ramón Gómez de la Serna, who ran a literary salon of sorts in the Café Pombo. This kindled a desire in Dalí to do likewise, and to express himself with the pen rather than just with the brush. He set to this task with his usual determination, which marked the beginning of a vast corpus of writing that in time would include art critiques and ruminations on art history, manifestos of various kinds, poetry, prose, autobiographies, and even film scripts, many of which have become available in the English language only in recent years.[36]

For García Lorca, this was likewise a special time when he greatly cherished his friendship with Dalí. In 1926 he wrote a poem entitled "Oda a Salvador Dalí," inspired by a vacation they took together in Cadaqués:

> *¡Oh Salvador Dalí, de voz aceitunada!*
> *No elogio tu imperfecto pincel adolescente*
> *ni tu color que ronda la color de tu tiempo,*
> *pero alabo tus ansias de eterno limitado.*

> O Salvador Dalí, with an olive-smooth voice,
> I'll not extol your imperfect adolescent brush
> nor your color that flatters the color of your time;
> I'll rather sing of your anxieties of external confinement.[37]

Fig. 27. Julio Moisés Fernández de Villasante, *Portrait of a Lady*, 1928

In the meantime, Dalí busied himself by attending a "free Academy" taught by an artist named Julio Moisés Fernández de Villasante. At first glance, this was a rather surprising choice, for Fernández de Villasante was a traditional artist who served Madrid's high society by painting portraits of the elite in a thoroughly academic style. Modernity had no appeal for the thirty-six-year-old painter, who understood the taste of his clientele and their desire for portraits that were both realistic and endowed with classicist grandeur. In fact, that is why de

Villasante was commissioned to paint the portraits of several members of Spain's royal family, including King Alfonso XIII and Queen Victoria Eugenia, who were certainly not looking for any avant-garde treatment.

But a close observation of de Villasante's style reveals why Dalí was so attracted to this artist. Despite their conformity, his portraits are based on careful and highly realistic observation of his sitters, executed with a superb mastery of the pen and brush. In other words, de Villasante offered Dalí a rigorous instruction in the art of drawing in the classicist tradition of Ingres. This once again underscored the essential duality of Dalí's educational ambitions in this period: while he wanted to imbibe all the new modernist styles emanating from Paris, he was also determined to master the technique of traditional figurative painting, exemplified by the Salon art of the late nineteenth and early twentieth centuries.

His visits to the Prado and the classes taught by de Villasante were both fundamental factors that enabled him to produce his first masterpiece. This is the *Figure at a Window* of 1925, which depicts Dalí's sister, Anna Maria, leaning out a window to gaze at the bay of Cadaqués—a vista that, as we will see, would return time and again in his work. Painted during one of the Dalí family's summer vacations in Cadaqués with the Pichot family, the portrait reveals an astonishing confidence with the human figure.

Unlike the Impressionistic treatment of the *Portrait of the Cellist Ricardo Pichot*, this painting is executed in the sharply delineated realism that would become the hallmark of Dalí's style. What's more, its composition is not angled, as in the case of *Cellist Ricardo Pichot*, but painted directly facing the wall. It begs us to ponder what has captured Anna Maria's interest, or what thoughts may be occupying her as she stares at the scintillating bay on the horizon. This sense of quiet contemplation is

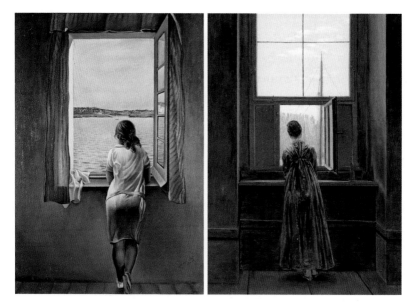

Figs. 28–29. Salvador Dalí, *Figure at a Window* (left), 1925, and
Caspar David Friedrich, *Woman at the Window* (right), 1822

reminiscent of several paintings by Johannes Vermeer as well as
the German Romanticist artist Caspar David Friedrich, including
his *Woman at the Window* of 1822—likewise a portrait of the
artist's relative, in this case his wife, Caroline. When Dalí's paint-
ing was exhibited in November of 1925 as part of his first one-
man show, once again held at the Dalmau Gallery in Barcelona,
Pablo Picasso dropped by and thought that *Figure at a Window*
was his best work.[38]

But this foray into academic realism didn't mean that Dalí's
engagement with Modernism was at an end. There were other
movements that were slowly trickling down to Madrid, notably
from Milan, where a group of Italian artists, poets, and musicians
had developed a movement called Futurism. More of a political
manifesto than an aesthetic doctrine, Futurism resolutely rejected

all of the traditional forms of the past in favor of an art form that was always modern, dynamic, and experimental, driven by anything that promised speed and disruption—such as a car, an airplane, or even a gun.

At the same time, the art of Picasso loomed ever larger in Dalí's artistic universe. In 1925, the year he was finally allowed to resume his classes at the Academy, Dalí painted the *Large Harlequin and Small Bottle of Rum,* which is a close homage to Picasso's *Statue from Nothing,* published in the January 1925 edition of *La Révolution Surréaliste.*

Meanwhile, the response to Dalí's one-man show at Dalmau's turned out to be surprisingly positive—so positive, in fact, that Dalí's father offered him a great gift: the chance to take a trip to Paris, the mecca of modern art. Dalí was ecstatic, and soon thereafter embarked for Paris, accompanied by his stepmother and sister, sensing that this was where his ultimate destiny would lie. "In 1925, Paris was far from Figueres, far away, mysterious, and big," he later remembered. "I landed there one morning with my sister and my aunt [sic] to judge its distance and size, as a boxer does during a round of studying his opponent." He knew that this was the city he "ultimately had to conquer."[39] The highlight of this trip was a visit to Picasso's studio, which had been arranged by a Cubist artist and friend, Manuel Angelo Ortiz. The experience of meeting the legendary Pablo Picasso moved Dalí deeply, "as if," as he later wrote, "I was having an audience with the Pope."

The first thing he told Picasso upon arrival at his studio was that "I have come to see you before visiting the Louvre." Picasso nodded and said, "You're right."

For the next two hours, Picasso showed him all the canvases in his studio. When he was done, he asked Dalí, "You get the idea?"

"I get it!" was the reply.[40]

Did Dalí get it? The evidence suggests that he did. From the fresh canvases he saw in the artist's studio, it was clear that Picasso had turned his back on Cubism and instead had embraced a new and highly individual neoclassical style that sought to blend traditional classicism and Postimpressionist influences. A factor in this change, some authors suggest, was a major retrospective of the work of Ingres in the Salon d'Automne in 1905. This exhibit featured, among others, Ingres's work *The Turkish Bath*, which may have been the inspiration for Picasso's *Les Demoiselles d'Avignon*.

Needless to say, Picasso's turn to classicism, with its undertone of Ingres-type meticulous modeling, immediately struck a chord in Dalí, as evidenced by his *Venus and Cupids* (1925) and *Figure between the Rocks* (1926). *Venus and Cupids* in particular is a homage to Picasso's neoclassicist works such as *Two Women Running on the Beach* (1922), but executed in the vernacular of Ingres; the nude bather in front, seen from the back, is an echo of Ingres's *La Grande Baigneuse* (1808; see page page 230). As such it perfectly captured Ingres's famous dictum, which Dalí had noted for his exhibition at the Dalmau Gallery: "Form is beautiful when it is both firm and full, and when the details do not impair the overall impact of the large body mass."

In 1926 Dalí was finally readmitted to the Academy, but it almost didn't matter. Things had not improved in the classroom, and if anything, Dalí was less impressed with the quality of the faculty, and their teachings, than before. Furthermore, he was beginning to be acknowledged as an artist in his own right; in January of 1926, the magazine *D'aci i d'allá* had proclaimed him as a promising artist, breathlessly stating that "rarely does a young painter make his appearance on the scene with the audacity and aplomb of Salvador Dalí from Figueras." It went on to address those who questioned the need for the artist to find inspiration in

France, rather than in his native Catalonia, asking "What does it matter if Dalí, in order to fan his own flames, uses the pencil of an Ingres or the rough-cut wood of Picasso's Cubist work? . . . [It's] because his God-given talent as an artist still needs to mature."[41]

When Dalí was finally expelled, for the second time, on June 14, it almost felt like a relief. From this point on, he would forge his own career—and that career would be increasingly influenced by another wave that was surging through Paris and beyond: a movement called Surrealism.

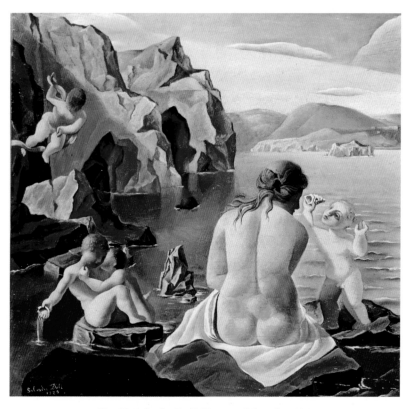

Fig. 30. Salvador Dalí, *Venus and Cupids*, 1925

# 3.

# THE YEARS IN
# THE WILDERNESS:
# 1926–1929

*You have to systematically create confusion,*
*it sets creativity free.*

Salvador Dalí

**T**he period between Dalí's expulsion from the Academy and his encounter with Gala was a difficult time, spent in the claustrophobic atmosphere of the parental home in Figueres. Naturally, Dalí's father was furious that notwithstanding the money he'd spent on Dalí's education at the Madrid Academy, his son had failed to get a degree, or indeed any form of qualification that could have secured him a position of some sort. The short-lived success at the Dalmau Gallery was in the past. In his father's eyes, Dalí now needed to prove that he could carve out a career for himself—any career, as long as it allowed him to make a living.

Fig. 31. Luis Meléndez, *The Afternoon Meal,* 1772

Dalí may not have noticed, as he was still busy absorbing all of the avant-garde movements then throbbing in art circles throughout Europe. For example, though in October 1926 his exhibition at the Autumn Salon in Barcelona featured a canvas called *Girl Sewing (Portrait of Anna Maria)*, inspired by Johannes Vermeer's *The Lacemaker*, three months later Dalí's works at the Galeries Dalmau included paintings in the Cubist style, notably *The Neo-Cubist Academy*.

An even greater surprise was a mystical still-life, *The Basket of Bread*, painted with a near-photographic realism and sense of texture that reflected the influence of an entirely different source: the Spanish Baroque, including artists such as Zurbarán, Murillo, and Meléndez. During the many hours spent at the Prado, Dalí had grasped how each of these Baroque artists could transform an object from daily life, such as a loaf of bread, into a motif of

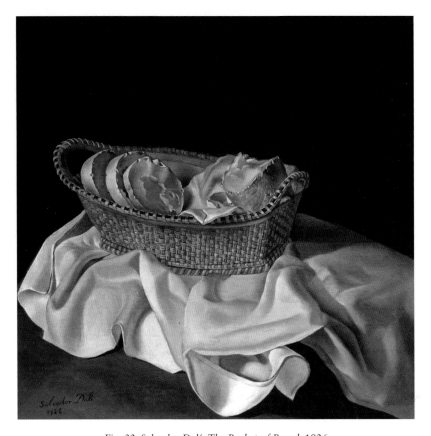

Fig. 32. Salvador Dalí, *The Basket of Bread*, 1926

great significance through not only a scrupulous adherence to detail but also the dramatic use of light and dark.

Bread would always play a major part in Dalí's oeuvre, as we will see, not only because of his penchant for interpreting ideas and emotions in terms of food but also because bread had a particular spiritual resonance for Catholic Spain. Jesus called himself "the bread of life" and broke bread with his Apostles during the Last Supper, thus instituting the Eucharist, the focal event of the Catholic Mass.

What's more, the Baroque in both northern and southern Europe had introduced the still life as a new motif in art. Elaborate arrangements of foods on the verge of decay, such as bread, meats, grapes, or oysters, were a popular motif, not only because of their decorative value but also because they breathed the *vanitas* motif so revered in the seventeenth century. *Vanitas* works, targeted to wealthy aristocratic and mercantile elites, served to remind their audience that no matter how prosperous they might be, the pleasures of life were fleeting, and a mere moment in the preparation for eternal life.

This idea strongly resonated with Dalí. It would inspire a number of paintings in the 1920s and early 1930s that explore the decay and putrefaction of living things, as well as his meditations on another favored *vanitas* motif, the skull, in a later period. The correlation between life and death is strongly implied in the French term for still life, *nature morte,* or "dead nature." As Dalí wrote many decades later, "the painting of a still life . . . is a way of rectifying the real by the creation of an entropy clear to all." At the same time, the contrast between the hard crust and the soft dough in *The Basket of Bread* also heralds Dalí's interest in the symbolic meanings of "hard" and "soft"—or the way an artist could manipulate our understanding of such objects, as in the melting watches of *The Persistence of Memory.* That idea could also acquire a sexual dimension, as in the *Catalan Bread* of 1932, where the bread assumes a phallic shape.

He worked furiously, almost without letup. He knew that following the expulsion from the Madrid Academy, he had to prove himself—not only to his father and his family but more importantly to his own sense of self as an artist. "I would awake at sunrise," he wrote later,

and without washing or dressing sit down before the easel which stood right beside my bed. The first image I saw on awakening was the painting I had begun, as it was the last I saw in the evening when I retired. . . . I spent the whole day seated before my easel, my eyes staring fixedly trying to "see," like a medium (very much so indeed), the images that would spring up in my imagination.[42]

Sometimes, the imagery would emerge spontaneously from his mind, "exactly situated" on the canvas in front of him, but at other times, "I would wait whole hours without any such images occurring."

Surrealism came to his rescue, or so it seemed. The idea that spontaneous dreams, visions, or hallucinations could serve as principal motifs for figurate art is what animated the Surrealists. They believed that the subconscious and the irrational held the keys to the next transformative stage in Western art. With its name coined by the French poet Guillaume Apollinaire in 1917 and later adopted by André Breton and Philippe Soupault, Surrealism was motivated by the idea that an overreliance on rationalism, shaped by bourgeois values, had led to the outbreak of World War I.[43] It followed that redemption lay in the opposite: in a world of spiritualism and the spontaneous. Surrealists called it *l'automatisme*, the unrepressed, intuitive thought or vision, whether expressed in poems, novels, music, or paint, that could liberate the unconscious.

Or, as Breton put it in 1924:

Surrealism is based on the belief in the superior reality of certain forms of association heretofore neglected, in the omnipotence of the dream, and in the disinterested play of

thought. It leads to the permanent destruction of all other psychic mechanisms and to its substitution of them in the solution of the principal problems of life.[44]

Of course, Sigmund Freud's discovery of the power of dreams in the human psyche served as a major tonic for this movement, because it legitimized the subconscious and unconscious minds as fertile sources of inspiration. But Freud questioned the Surrealist claim that their art was a pure and unadulterated expression of the unconscious, for the very act of reproducing a dream in any form, whether art, music, poetry, or film, is bound to be a deliberate and conscious act. Nevertheless, both Surrealism and Freud struck a deep chord in Dalí, for they helped him to channel ideas and impulses that he had nurtured for a very long time.

By the 1920s, the Surrealist movement was increasingly concentrated in Paris around artists that included not only André Breton but also Tristan Tzara, one of the founders of Dada in Zurich; the Spanish Symbolist painter Joan Miró; the German artists Paul Klee and Max Ernst; and even (albeit for only a short period) Pablo Picasso. A group portrait entitled *Rendez-Vous of the Friends*, painted by Max Ernst in 1922, brings some of these artists together, not unlike the way Henri Fantin-Latour had immortalized the Impressionists in *A Studio at Batignolles* some fifty years earlier.

What set the movement apart from other Modernist currents of the moment, however, is that Surrealism was not really a "style" at all. It was an ideology, a manifesto, rather than a recognizable way of depicting things on canvas. As a result, Surrealists such as Giorgio de Chirico, Max Ernst, Joan Miró, and René Magritte differed strongly in the way that they actually expressed their hallucinating visions.

Fig. 33. Giorgio de Chirico, *Song of Love*, 1914

Giorgio de Chirico is a case in point. Raised in Greece, he attended the Athens School of Fine Arts, was thoroughly immersed in classical art, and then moved to the Fine Arts Academy in Munich, a city that was rapidly becoming a center of Germany's avant-garde. From there, he traveled down to Venice and Florence. One day, while walking on the piazza facing the Santa Croce in Florence, he experienced a powerful epiphany that would inspire much of his subsequent work, including *The Enigma of an Autumn Afternoon* (1910), and particularly *Song of Love* (1914), now in the Museum of Modern Art (MoMA)

in New York. In many ways, *Song of Love* would establish the canon of Surrealist figurative art: brooding landscapes or classical piazzas, painted in late-summer sienna tints under blue skies, with various, seemingly incongruous objects strewn about. These are motifs that would return, time and again, in the art of Salvador Dalí—particularly de Chirico's use of classical statuary and his penchant for substituting eggs for human faces.

In this, de Chirico showed himself to be a staunch disciple of classical figurative art. It is true that the Surrealists had never rejected the Old Masters and neoclassicism as fervently as other avant-garde painters had done; in Ernst's group painting, even Raphael has pride of place. But in the eyes of the Paris Surrealists, de Chirico went too far in his wholehearted embrace of Leonardo da Vinci, Raphael, and even Rubens. They were particularly affronted when the artist published an article, "The Return of Craftsmanship," which called for an end to modernist experiments and a return to the traditional methods and iconography of European art.[45] Of course, Dalí would make the same argument even more emphatically some twenty years later.

By contrast, artists such as Joan Miró rejected traditional figurative art out of hand. Miró felt that true Surrealist art should adopt the illogical, playful vocabulary of dreams themselves: as "poems of color," using a fluid interplay of lines, shapes, and colors.[46] Like Dalí, Miró was a Catalan; he was born in Barcelona in 1893 and grew up in the city's Barri Gòtic neighborhood, a dense warren of medieval alleys framed by beautiful Gothic ornamentation. Also like Dalí, he had his first one-man exhibition at Dalmau's, in 1918, but unlike Dalí's, his work was ridiculed and widely criticized. Undeterred, Miró moved to Paris and around 1924 he joined the nascent Surrealist camp. Next, the artist dispensed with all forms of academic conventions

Fig. 34. Joan Miró, *Horse, Pipe and Red Flower*, 1920

regarding composition and perspective and instead arranged his objects as two-dimensional collages, as in his *Horse, Pipe and Red Flower* of 1920.

Eventually, these abstractions became so cryptic that Miró had to provide an iconographic dictionary of sorts. Yet the artist insisted that these images were still the product of an unfettered mind. He later described his method, which bears a striking

similarity to Dalí's in this time period: "How did I think up my drawings and my ideas for painting? Well I'd come home to my Paris studio in Rue Blomet at night, I'd go to bed, and sometimes I hadn't any supper. I saw things, and I jotted them down in a notebook."[47]

Over the next decade, many different artists would move in and out of the Surrealist stream, including Victor Brauner, Paul Delvaux, Wolfgang Paalen, Kurt Seligmann, and Richard Oelze. This signaled that as an artistic movement, Surrealism never had a real cohesive manifestation; it was merely, in Herbert Read's words, a "local and temporary concentration of forces."[48]

The exception was Dalí. Later, Dalí would write that his parents had named him Salvador ("Savior") because "he was the chosen one who had come to save painting from the deadly menace of abstract art, academic Surrealism, Dadaism, and any kind of anarchic 'ism' whatsoever."[49] Indeed, whatever one thinks of Dalí, he remained a Surrealist at heart for the remainder of his life, just as Monet would always remain loyal to classical Impressionism and Van Gogh would remain the consummate Expressionist until the end.

Infused with these new ideas, young Dalí began to paint in the Surrealist vein. Works such as *Study for "Honey Is Sweeter than Blood"* (1926), *Apparatus and Hand* (1927), and *Senicitas* (1928) clearly reflect the influence of Miró's works of this period. "Miró liked my things very much, and generously took me under his protection," Dalí would later write. But Miró's greatest influence on Dalí's life lay elsewhere, in whether he could persuade Dalí père to let his son move to Paris, the hotbed of all that was new and exciting, and live there. Dalí senior had serious misgivings, though at the same time he was not unaffected by what the magazine *D'aci i d'allá* had written not too long ago, that "if

Salvador now has his eye on France, it is because it lies within his scope, and because his God-given talent demands the opportunity to prove itself."[50] And to drive that message home, Miró wrote a follow-up letter from Paris, telling Dalí's father, "I am absolutely convinced that your son's future will be brilliant!" That letter was the tipping point. Dalí would be allowed to move to Paris.

The idea was as exciting as it was daunting. How would young Dalí acquit himself among such titans as Picasso, Breton, and Miró? To prepare himself for this great intellectual test, Dalí decided to join a Barcelona salon of intellectuals around a magazine called *L'Amic de les Arts* (*The Friend of the Arts*). As he later recalled, he soon found that he could manipulate this group "as I wished." As such, the experience served as an experiment of sorts, one that "would be useful in giving me an exact sense of the degree of effectiveness of what I already at the time called my 'Tricks.'" It also suggests that at this early age, Dalí was already becoming adept at manipulating the people around him, in order to secure their devotion and admiration. "I have always had the gift of manipulating and of dominating with ease the slightest reaction of people who surround me," he admitted quite freely in his 1942 book, while marveling at the "voluptuous pleasure" of having admirers "at constant 'attention' to my capricious orders."[51]

Of course, such conceits may have worked in the salons of Barcelona but not in the supercharged intellectual atmosphere of Paris cafés; and indeed, Dalí's arrival in the French capital was far from the triumph he was hoping for. Joan Miró had tried to prepare him for that, by warning him that "between you and me, these people of Paris are greater donkeys than we imagine." And now, as they sat together in a Paris brasserie, his mentor advised him, "It's going to be hard for you, but don't get discouraged."

Fig. 35. The infamous scene in *Un Chien Andalou* in which a man prepares to slice the eye of a young woman with a razor. Dalí was disappointed when this and other scenes did not produce the shock effect he'd been hoping for.

But discouraged Dalí was, particularly after he saw the edit of a film that Buñuel had asked him to get involved with. Entitled *Un Chien Andalou (An Andalusian Dog)*, the picture was conceived as a true Surrealist work by stitching together a series of seemingly random scenes, some quite shocking, which Buñuel hoped would amount to the cinematic equivalent of a Surrealist hallucinatory painting.

Among other scenes, this film features the now-notorious one of a man slicing the eye of a young woman with a razor (in reality it is the eye of a dead calf, but the rapid cutting suggests it is the woman who is mutilated).

According to the film's mythology, the idea for the film was born when Buñuel and Dalí sat in a restaurant, and Buñuel described a dream in which he saw how "a cloud sliced the moon in half 'like a razor blade slicing through an eye.'" Dalí then

said that he'd had a dream of a hand crawling with ants. They then decided that these, and other spontaneous "products of the psyche," would make for a wonderful film, and off Buñuel went. The seventeen-minute silent film, which was financed by Buñuel's mother, eventually ran out of funds, forcing Buñuel to edit the film himself in his kitchen.[52] Nevertheless, when it was first screened at the Studio des Ursulines, scores of prominent figures decided to attend, including Le Corbusier, Picasso, André Breton, Christian Bérard, and other Surrealist painters. Buñuel was ecstatic. Dalí, however, had hoped that the audience would erupt in shock and outrage at some of the scenes and was deeply disappointed when it didn't. Nevertheless, he was gratified by what the Spanish writer Eugenio Montés had to say about the film: "Buñuel and Dalí have just placed themselves resolutely beyond the pale of what is called good taste, beyond the pale of the pretty, the agreeable, the epidermal, the frivolous, the French."[53]

**In the months** that followed, Dalí faithfully followed Miró and other Surrealists in plumbing his inner subconscious as thematic material for his paintings. But soon, Paris got on his nerves and he fled back to Catalonia, to bask in the intense sun and light of Cadaqués. Like Vincent van Gogh in Provence, he worked in a frenzy, sometimes painting several works per day, pausing only for "spasmodic explosions of laughter." His art in this period ranged from the montage-like visions of Miró to a more academic depiction of objects, even if the objects themselves were strange, amorphous constructs inspired by his dreams or subconscious. Frequently these dreams mined the terrain of disturbing childhood memories, such as in *The Enigma of Desire—My Mother, My Mother, My Mother* (1929), while at other times he sought

absurdist material in the depiction of animals, such as in *The Spectral Cow* (1928) or *The Stinking Ass* (1928).

At the same time, Dalí was increasingly driven by his autoeroticism, partly inspired by his reading of Freud's *The Interpretation of Dreams*.[54] He was by all accounts still a virgin, even though in Paris he had once asked a taxi driver, "Do you know any good whorehouses?" The driver had dutifully taken him to a few establishments, but in each Dalí remained the voyeur, content to revel in his "libidinous fantasies," as he called them. "Surrealism," Dalí declared, paraphrasing Breton, "no longer involves the representation of the external world, but that of the intimate and personal world of the artist."[55]

Fig. 36. Salvador Dalí, *The Spectral Cow*, 1928

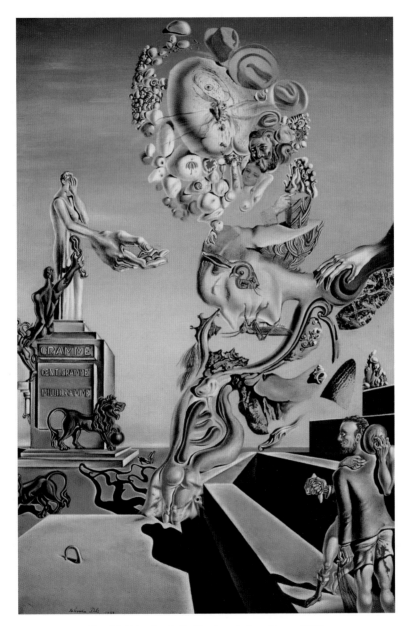

Fig. 37. Salvador Dalí, *The Lugubrious Game*, 1929

And like Breton, Dalí felt the need to develop a theoretical basis for his work—one that would authenticate his troubled psyche and fevered fantasies as valid inspiration for his art. The result was a construct that he called his "paranoiac-critical method." Unlike the human *automatisme* of Breton, Dalí declared that only a paranoiac such as himself had a unique, paranormal sensitivity for hidden visuals and emotional meaning, precisely because of his "systematic delusion of interpretation." This, he argued, was distinct from pure hallucination. The paranoiac process involved two different perceptive dimensions that, together, amounted to "clairvoyance" or, as he put it, "the depiction of an object, that without the least physical or anatomical change is simultaneously the depiction of another wholly different object."[56] In other words, beyond what seem to be ordinary figures and objects on his canvases, there is a secret meaning that explains their role in the hidden drama.

Be that as it may, for the next few years Dalí's paranoiac process remained preoccupied with fetishist obsessions, including masturbation and his fear of heterosexual sex. This culminated in a disturbing work known as *Le Jeu Lugubre* (*The Lugubrious Game* or "The Dismal Sport"), which is both an oil painting and a collage on cardboard. The painting shows a floating portrait of himself being demonized by "a veritable anthology" (Ian Gibson) of his fetishes and obsessions, including a grasshopper (which he abhorred), crawling ants (associated with putrefaction), and various intimate parts of a woman, while the statue at left has an enlarged hand to facilitate masturbation. Observing this scene is a man in the foreground whose pants are soiled by excrement. Not surprisingly, the work caused consternation among his close circle of friends for its blatant use of scatological imagery and references to obsessive masturbation. Georges Bataille wrote

about the "terrible ugliness" of Dalí's paintings, which made him "grunt like a pig before his canvases."[57] But the painting was also admired. When the work was exhibited during Dalí's show at the Goemans Gallery in November of 1929, it was purchased by the Vicomte de Noailles.

Either way, few authors have remarked on the fact that with this painting, Dalí appears to have entered a new and deliberate phase in his work. Despite its shocking attributes, the scene is depicted with a conventional realism and perspective that echoes the work of Giorgio de Chirico. Though the figures may have an awkward, rubbery quality, they are nevertheless fully realized, three-dimensional beings, with none of the fragile abstractions of Miró or Braque. It is perhaps the first example of the figurative Surrealist style that would rule Dalí's work from this time forward.

As it happened, Dalí was still working on *The Lugubrious Game* when he was visited in Cadaqués in July of 1929 by several Surrealist artists including Paul Éluard. In fact, it was Éluard who, spotting the painting on Dalí's easel, suggested the title *Le Jeu Lugubre*. But what mattered most is that Paul had brought along his comely wife, the Russian Elena Ivanovna Diakonova, also known as Gala. Ten years older than Dalí, Gala was perhaps not beautiful in a conventional sense, but she did have a strong charisma, with striking, deep-set eyes that radiated sensuality (and, as time would tell, a healthy interest in sex). Paul and Gala had met as seventeen-year-old teenagers in a Swiss sanatorium, where both were being treated for tuberculosis. They fell in love, and Gala quite naturally assumed the role of Paul's strong-willed muse, encouraging him to pursue a career as a poet. The outbreak of World War I intervened before that could come to pass, and Paul was briefly enlisted in the French army while Gala was sent back to Moscow. But Paul's poor health disqualified him for

service as a poilu in the French infantry. Instead, he landed a desk job behind the front, while Gala convinced her parents that she wanted to study at the Sorbonne, war or no war. Eventually she got her way, as she always did, and—remarkably—was able to make her way across war-torn Europe to Paris. They were married on February 20, 1918, while the war was still raging.

Fig. 38. Gala as photographed by Carl van Vechten in 1934

For all the world they seemed like soul mates, inseparable for life. But in 1921 the couple met another Surrealist, the German artist Max Ernst, who soon thereafter decided to move into the Éluards' Paris apartment. Not long thereafter, Gala became Ernst's lover, perhaps because she craved a bedmate more vigorous than Paul, whose health remained delicate. And Ernst was not the only one to be seduced by her charms; other Surrealists, including Louis Aragon and André Breton, seemed bewitched by her—so much so that Breton later wrote that she was a "destructive influence" on the artists she met.

Outwardly, Paul seemed to agree to the ménage à trois between himself, Ernst, and Gala, but he became depressed, started drinking heavily, and eventually disappeared. Using money drawn from his father's bank account, he decided to flee the betrayal of his marriage and seek solace in faraway places. One would have expected Gala to feel chastened by this development, and perhaps make an attempt to save her relationship with her husband, but the opposite appears to be the case; she decided to follow Ernst to Germany instead. It was only when Paul wrote to her from Saigon in French Indochina in 1924, begging her to return to him, that Gala agreed to travel to Vietnam—but only if Paul's father put up the money for her fare, and if Max Ernst could accompany her as well. This obviously did not improve an already fraught situation. Indeed, upon his return to Paris, Paul made it clear that Ernst was no longer welcome in the Éluard household. Unfortunately, the episode had also affected Gala's feelings for Paul. She channeled her frustrations into becoming a "Surrealist groupie," as Etherington-Smith put it. "Gala knew what she wanted," André Thirion remembered:

The pleasures of the heart and the senses, money, and the companionship of genius. She wasn't interested in politics or philosophy. She judged people by their efficiency in the real world and eliminated those who were mediocre, yet she could inspire the passions and exalt the creative forces of men as diverse as Ernst, Éluard, and Dalí.[58]

Paul realized that his marriage to Gala was irretrievably damaged, and it affected him deeply. He suffered another bout of tuberculosis and spent the winter of 1928 at the same sanatorium where he and Gala had met fourteen years earlier. In 1929 the couple decided to travel to Spain, where they had their fateful visit with Salvador Dalí. They found Dalí in the company of René and Georgette Magritte as well as the gallery owner Camille Goemans.

The encounter with Gala marked the principal turning point in Dalí's life and career as an artist. He finally had met the woman who, he believed, had been a constant presence in his erotic fantasies. "She was destined to be my Gradiva," he wrote later in *Secret Life*, "the one who moves forward, my victory, my wife." As Descharmes wrote, "She was the personification of the woman in his childhood dreams," a woman whom serendipitously he had named "Galuchka," and who bore an uncanny resemblance to the female type that populated his paintings and drawings up to this point. In Dalí's mind, her arrival was simply ordained. He later described his first impressions of her in almost clinical detail:

Her body still had the complexion of a child's. Her shoulder blades and the sub-renal muscles had that somewhat sudden athletic tension of an adolescent's. But the small of her back,

on the other hand, was extremely feminine and pronounced, and served as an infinitely svelte hyphen between the willful, energetic, and proud leanness of her torso and her very delicate buttocks which exaggerated the slenderness of her waist and rendered her even more desirable.[59]

Gala's body would become the single most important constant in Dalí's art from here onward, including a late portrait known as *Gala Nude, Seen from Behind, Looking in an Invisible Mirror* (1960). Indeed, nude depictions of her remarkably fit body would appear as late as the 1970s, when she was approaching seventy. For Dalí, Gala was quite simply a godsend—not only as a model but also as his business partner and constant companion. She was his Hélène Fourment, his Camille Claudel, his Dora Maar.

Not so for Paul, obviously. For him, there was little choice but to return to Paris alone.[60] That is not to say that Dalí and Gala instantly became lovers. Struggling hard to overcome his innate shyness and sexual anxiety, Dalí took Gala on long walks along the coast of Cadaqués, during which his nervousness would invariably prompt hysterical fits of giggles and laughter. Gala, always alert to a man's weaknesses and desires, seemed to have sensed his deep-rooted gynophobia. At one point, she simply took him in her arms and whispered, "My little boy! Don't worry, we shall never leave each other."

That seemed to calm him. However, the question if, and when, Gala and Dalí actually consummated their relationship is still a hotly debated topic in art historical circles today. That Gala was a woman with a strong libido is attested by the history of her affairs, but Dalí's sexual experience up to that point had been limited to frequent, even obsessive masturbation. The grotesque pictures of diseased genitalia that his father insisted on showing

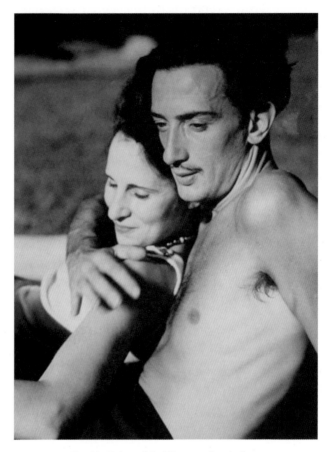

Fig. 39. Gala and Dalí in an undated photo

him in childhood may have irreparably damaged his ability to make love to a woman. Dalí himself believed that his father was responsible for his apparent impotence, and indeed, diseased, putrescent bodies figure prominently as motifs throughout his oeuvre. When the poet García Lorca, who had tried to seduce Dalí in the 1920s, heard that Dalí had fallen in love with a woman, he exclaimed, "It's impossible! He can only get an erection when someone sticks a finger in his ass."[61]

That masturbation remained Dalí's preferred method of sexual release is well documented in Dalí's autobiography, where he admits that he liked pleasuring himself in front of a mirror—often as much as four times a day. Later, he would watch as Gala had sex with other men. Some historians believe that Dalí and Gala never actually had intercourse but learned how to pleasure each other in other ways. Indeed, the first major work to follow their encounter in 1929 is a large canvas that is appropriately named *Face of the Great Masturbator.*

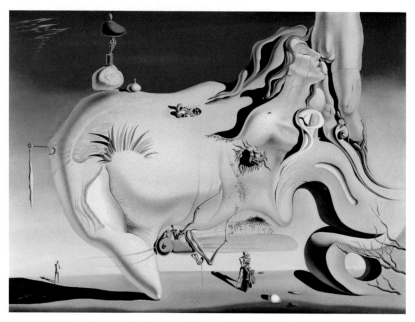

Fig. 40. Salvador Dalí, *Face of the Great Masturbator,* 1929

It is an important work for several reasons, not the least of which is that the painting marks the beginning of Dalí's mature style. People and objects are shaped as classical, three-dimensional forms, even though the scale is deliberately inconsistent. The principal organizing motif is the downward-looking, distorted

face that previously appeared in *Portrait of Paul Éluard, The Enigma of Desire*, and *The Lugubrious Game.* This strange shape has been alternatively identified with a passage in Hieronymus Bosch's *Garden of Earthly Delights,* which Dalí must have seen in the Prado in Madrid, or with a rock at Cullero on Cap de Creus, or with a whale that Dalí found stranded on the beach. A very similar shape would appear two years later in Dalí's groundbreaking work of this period, *The Persistence of Memory.*

Below the face is the now-familiar grasshopper, covered with ants (two symbols of Dalí's gynophobia), while a woman resembling Gala rises from the back of the head to kiss the crotch of a man. This man, whose upper torso is not visible, has bleeding contusions on the knees, which could suggest that he has just performed oral sex on the woman. Below, in the foreground, is an egg, the symbol of fertility. Seen together, the painting appears to be an autobiographical portrait of the artist's erotic hopes and dreams at the dawn of his first romantic relationship with a woman.

As Dalí explains, it documents the encounter between "reality and the sublime," inspired by the rock in the bay of Cadaqués:

> My mystical paradise begins in the plains of the Empordà,
> is surrounded by the Alberes hills, and reaches plenitude in
> the bay of Cadaqués. This land is my permanent inspiration.
> The only place in the world, too, where I feel loved.
> When I painted that rock that I entitled *Face of the Great
> Masturbator,* I did nothing more than render homage to one
> of the promontories of my kingdom, and my painting was a
> hymn to one of the jewels of my crown.[62]

*Face of the Great Masturbator* firmly marks the end of Dalí's frenetic wandering through the chaotic vocabulary of early twentieth-century art, and the beginning of his unfettered embrace of traditional realism, based not only on Spanish Baroque art but also twentieth-century academic realism. Or perhaps "magic realism" is a better term, for Dalí's use of the classicist grammar always went hand in hand with the emotional charge of Symbolism. As the French critic André Lhote put it, "Salvador Dalí is at once the Lalique and Gustave Moreau of oneirocriticism."[63]

It is, however, that very classicist idiom that, together with de Chirico and Magritte, set him apart from the rest of the Surrealist movement. While all of his contemporaries moved forward into the mists of an uncertain abstract future, Dalí remained wedded to realism, to the palette and technique of the Old Masters as well as nineteenth-century academic artists, so as to better explore Surrealist ideas. This perhaps explains his famous dictum: "The difference between the Surrealists and me is that I am a Surrealist."[64]

(faint illegible stamp text)

# 4.

# THE PERSISTENCE OF MEMORY: 1929–1934

*People love mystery,*
*and that is why they love my paintings.*

Salvador Dalí

The next phase of Dalí's life as an artist opened with what should have been a triumph: his one-man show at the Galerie Goemans, which included a lavish advance negotiated by Dalí's father. But two days before the opening of this pivotal exhibition, Gala persuaded Dalí to elope to Spain for an impromptu honeymoon in Sitges, a popular beach resort south of Barcelona. Gala had bewitched Dalí, just as she had bewitched and enslaved Éluard, Ernst, and other men in the Surrealist circle with her teasing eroticism. Dragging Dalí away from what might well have been the most important event in his career was her way of testing his utter devotion to her whims.

ST. JOHN THE BAPTIST PARISH LIBRARY
2920 NEW HIGHWAY 51
LAPLACE, LOUISIANA 70068

The couple spent a month in Sitges, burning through the money from the Goemans advance, "too preoccupied with our bodies to think about our exhibition," as Dalí wrote later. However, Dalí did recognize it was time to come clean with his father, who had pinned his hopes on the success of the Goemans exhibition and was desperate for news of what may have transpired in terms of sales. While Gala left for Paris, he returned to Figueres and sat down with his father to face the music. Dalí senior demanded to know what was left of the Goemans advance. By way of response, Dalí searched his pockets and could come up with only three thousand francs. His father then grilled him about his relationship with Gala, whose reputation had preceded her to Figueres. As it happened, this was just the moment when Buñuel appeared on the scene, dropping in just as the family argument reached a pitch:

> At first, all I could hear were angry shouts, then suddenly the door flew open and, purple with rage, Dalí's father threw his son out, calling him every name in the book. Dalí screamed back while his father pointed at him and swore that he hoped never to see that pig in his house again.[65]

But in fact, Buñuel was the bearer of good news: the Goemans exhibit had been a smashing success. All of Dalí's paintings had been sold for prices ranging from six thousand to twelve thousand francs, including *Le Jeu Lugubre*. This work was now hanging amid various Old Master paintings in the private collection of the Vicomte de Noailles in Paris, uncomfortably perched between a Watteau and a Lucas Cranach.

Dalí's relationship with his father, however, had reached a point of no return. When the latter read an article by the Spanish

art critic Eugenio d'Ors to whom his son had reportedly shown a lithograph of the Sacred Heart, purchased in Figueres, on which he had written, "Sometimes I spit with pleasure on the portrait of my mother," his indignation was boundless. That Dalí was articulating a key tenet of Surrealism—namely, that moral conflict must ensue when dreams go against the grain of a person's deepest feelings—hardly seemed to matter.[66] Dalí père wrote to his son, telling him that he should now consider himself disinherited and that he would never again be granted access to his family.

The younger Dalí was upset as well. Despite the fraught relationship with his father, the homes in Figueres and Cadaqués had served as refuges to which he thought he could always return in times of need. Now those anchors had been removed, and there was little for him to do but return to Paris in the hope of building a life with Gala. Having arrived in the French capital, Dalí discovered that Gala had moved into her apartment that she had shared with Paul, while ordering her former husband to move into a nearby hotel—which he meekly did. "Thus began the period of my life which I consider the most romantic, the hardest, the most intense, the most breathless, and also the one that 'surprised' me the most," Dalí wrote later; "now began the battle that I was to wage against life."

It was decided that he should return to the region that had always been his primary inspiration, Cadaqués, and instead set himself up in a little house of his own. He found such a home—little more than a shack, really—in the fishermen's village of Port Lligat and set himself to launching the next phase of his oeuvre as an artist. He felt the same intense pressure that every aspiring artist, poet, or author feels after initial success: the need to deliver even greater, even better work. Indeed, the stunning success of the Goemans exhibit had set a very high bar. Thus he settled once

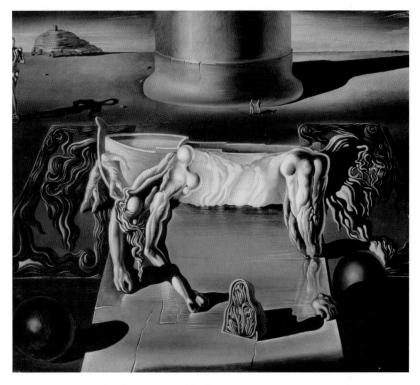

Fig. 41. Salvador Dalí, *Invisible Sleeping Woman, Horse, Lion,* 1930

more into the simple life of Cadaqués, "where instead of being the son of Dalí the notary," as he wrote later, "I was now the disgraced son, disowned by his family and living with a Russian woman to whom I was not married."[67]

The result was a series of paintings that not only conveyed his growing self-confidence, free from the distractions of Paris Modernist movements, but also his dawning understanding of what could become his own individual style. A first major theme was his continued exploration of androgynous and other ambiguous beings, such as *The Invisible Man* (1929) and *Invisible Sleeping Woman, Horse, Lion* (1930).

Of these, *Invisible Sleeping Woman, Horse, Lion* is perhaps the first to define the quintessential features of what today we recognize as the Dalínian style: the highly realistic modeling of a woman's body; the sharply delineated features of her hair and other objects, drawn with photographic precision; the deep, infinite vistas blending with the orange sky; and above all, a new sense of monumentality that departs from the cluttered and chaotic compositions of the preceding period. A number of preparatory drawings suggest the care with which Dalí set out to develop this composition. Later in his life, Dalí would describe this new style, at once modern and yet steeped in traditional technique, as "hand-painted color photography of super-fine images of concrete irrationality."[68] This newfound confidence continued with *Premature Ossification of a Railway Station* (1930), with its echoes of both de Chirico and Magritte.

Indeed, there is no question that there are significant parallels between Dalí and Magritte, not only in terms of their art but also their backgrounds and development as artists. The son of Belgian parents, living in the francophone region of Hainaut, Magritte had also experienced the tragedy of losing his mother, at age thirteen. In Magritte's case, however, the mother committed suicide by drowning herself in the Sambre River. When she was found, her dress covered her face—an image that would return in several of Magritte's paintings, where people's faces are covered with a cloth.

In 1920, Magritte met *his* Gala: a young woman named Georgette Berger, who would become both his muse and favorite model. He exhibited his first Surrealist works, *The Threatened Assassin* and *The Lost Jockey,* in 1927. After these were savaged by Belgian critics, Magritte and Georgette moved to Paris, where he became an active member of the Surrealist group. Unfortunately, his gallery, the Galerie Le Centaure, closed in 1929, depriving

Magritte of his main source of income. He moved back to Brussels and found work in advertising but remained active as an artist due to the patronage of the same man who would support Dalí for many years: Edward James.

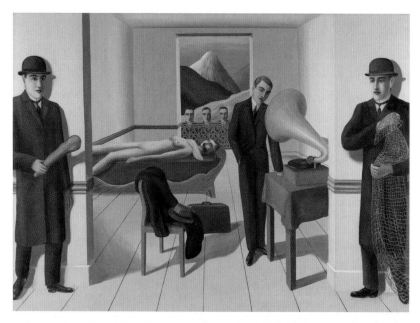

Fig. 42. René Magritte, *The Threatened Assassin*, 1926

Like de Chirico and Dalí, Magritte often placed objects in an unusual, even dreamlike context, rendered in a precise, realist style. But unlike Dalí, Magritte derived inspiration not from the turmoil of an inner subconscious but from a love for irony, contradiction, and the absurd—qualities that can endow ordinary objects with new and provocative meaning. Magritte's art is a search for mystery and the unfathomable. "Indeed," he wrote, "when one sees one of my pictures, one asks oneself this simple question, 'What does that mean?' It does not mean anything, because mystery means nothing either, it is unknowable."[69]

Dalí, on the other hand, remained preoccupied with the torment of erotic fulfillment, as vividly shown by the paintings from the early 1930s. *The Enigma of William Tell,* for example, shows the figure of William Tell, an expert marksman with a crossbow, with a phallic extension of such size that it must be supported by a crutch. The frequent use of the crutch motif, often used to support a human limb or organ (as, in this case, a large phallus), has sometimes been identified as Dalí code for his innate impotence. It signaled that his intensely erotic craving could not be fulfilled naturally but needed additional support to achieve full satisfaction. The Belgian psychiatrist Jean Bobon, writing in 1957, believed that "Dalí's crutch symbolizes first and foremost reality, an earthbound relation to the real, which checks and balances the hyper-development of an intellectualized sexuality and of an imaginative and sexually-laden intellect." Based on memories of his childhood, Bobon argued, "the crutch, for Dalí, stands for fame, love, and death."[70]

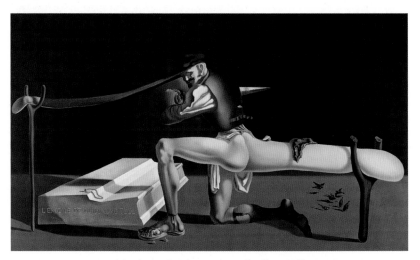

Fig. 43. Salvador Dalí, *The Enigma of William Tell,* c. 1933

In the 1938 book *Abbreviated Dictionary of Surrealism*, edited by André Breton and Paul Éluard, Dalí offered another explanation, describing it as a "wooden support derived from Cartesian philosophy, generally used for the support of soft, tender parts." In *Secret Life,* published four years later, Dalí related how deeply struck he was when he first beheld a crutch. "I immediately took possession of the crutch," he wrote, "and I felt that I should never again in my life be able to separate myself from it, such was the fetishistic fanaticism which seized me at the very first. . . . This object communicated to me an assurance, an arrogance even, which I had never been capable of until then"[71]—a clear allusion to Dalí's struggle with heterosexual performance.

The works of this period also show Dalí's deepening interest in another Dalínian motif, the juxtaposition of "hard" and "soft" objects. Typical hard objects are the cliffs of Cap de Creus, the rocks that thrust into the bay of Cadaqués, or the oyster shell that protects the softness of the flesh inside. Soft things are objects that can be bent, fondled, or shaped at will, such as a woman's breast or a freshly cut slice of Camembert cheese. It is the contrast of these properties, and our expectations of them, that fascinated Dalí—and would produce his most famous painting.

Dalí describes the genesis of this work in his 1931 book *The Secret Life,* under the entry entitled "The Vision of Reality as A Dichotomy in *The Persistence of Memory.*" As he describes it, Gala and Dalí had finished their dinner, which included various cheeses for dessert, when Gala announced her intention to see a movie with some friends. Dalí pleaded a headache and opted to stay home. After she left, he later remembered, he "remained seated at the table for a long time, meditating on the philosophic problems of the 'supersoft,' which the cheeses presented to my

mind." These ruminations were prompted by a few slices of some "very strong Camembert" that had been left on the plate.

At last he got up and walked to his studio, as was his wont, in order to take one last look at his easel before going to bed. This would remind him of the problem that he was working on at that moment, so that his mind could stew on it while he was asleep. The picture that happened to sit on his easel that night, he later wrote,

> . . . represented a landscape near Port Lligat, whose rocks
> were lit by a transparent and melancholy twilight; in the
> foreground an olive tree with its branches cut, and without
> leaves. I knew that the atmosphere which I had succeeded
> in creating with this landscape was to serve as a setting for
> some idea, for some surprising image, but I did not in the least
> know what it was going to be.[72]

When he moved to turn off the light and go to bed, he "instantaneously" saw the solution to the problem he'd been struggling with. "I saw two watches," he wrote, "one of them hanging lamentably on the branch of the olive tree." Though he was still suffering from a headache, he grabbed his palette, prepared his paints, and set to work. As he wrote,

> When Gala returned from the movie theater two hours later,
> the painting, which was to be one of my most famous, was
> completed. I made her sit down in front it with eyes shut:
> "one, two, three, open your eyes!" I said. "Do you think
> that in three years you will have forgotten this image?" Gala
> replied, "No one can forget it once he has seen it."

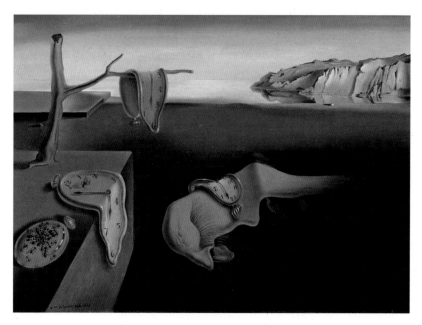

Fig. 44. Salvador Dalí, *The Persistence of Memory*, 1931

This comment inspired the painting's eventual title, *The Persistence of Memory*—a painting that would seal Dalí's reputation and propel him to worldwide fame. It was purchased by a man whom Dalí likened to "a bird with large black wings," the twenty-five-year-old American art dealer Julien Levy, who had just set up his own gallery of modern art at 602 Madison Avenue in New York. In 1932, Levy showed the work in an exhibition that also included the work of Picasso, Duchamp, and Ernst, in order to introduce Surrealism to American audiences. *The Persistence of Memory* was then bought in 1934 by Mrs. Stanley Resor for the New York Museum of Modern Art, which had been established just five years earlier. In this manner, the art of Dalí was introduced to the country where he would make his fortune in the decades to come.

Much has been written about this painting, and it fittingly serves as the first and perhaps most important work in Dalí's canon. At the center is the soft, anthropomorphic shape that we recognize as Dalí's profile self-portrait from *Face of the Great Masturbator*. Some have associated this shape with a passage in Hieronymus Bosch's triptych *The Garden of Earthly Delights*. The long eyelashes suggest that the face is sleeping, thus reinforcing the painting as a dream. The face is furthermore adorned with a melting pocket watch, similar to the watches draped over the bare olive tree and the table in the left foreground. At the far left is another watch, face down, shown with a cluster of ants that serves as a Dalínian motif of decay. The background is a vista of the rocks of Cap de Creus that appeared in his previous works. In contrast to the bright light that bathes the rock formation with the setting sun, the foreground is cast in a dark, almost ominous shadow.

What dreamlike vision does this painting represent? The almost ubiquitous references to autoeroticism that distinguish his other works from this period are nowhere in evidence. Are the melting watches simply the spontaneous product of Dalí's idiosyncratic imagination, or should we look for a deeper meaning, some form of code by which Dalí's intent could be unlocked? British art historian Dawn Adès, a major authority on the work of Dalí, has argued that the watches are an unconscious symbol of the relativity of space and time, a "Surrealist meditation on the collapse of our notions of a fixed cosmic order."[73] Einstein's relativity theory, first published in 1915, argues that time is not fixed but is relative to its position in space. Therefore, man-made pocket watches are essentially powerless against the complex majesty of the universe.

At first glance this argument is compelling; in 1930, one year before he painted the work, Dalí himself referred to Einstein's

relativity theory in the chapter "The Sanitary Goat" for the book *La Femme Visible*. "When Einstein points out the differences between the meter as a measuring unit, and the material meter that we must use, thereby giving rise to the possibility of a physical geometry," he wrote, "he achieves, on a very special plane of thought interferences the brutal rupture of psychological constants, which are creative, in this case, of great symbols and abstract, non-physical simulacra."[74] Allowing for its rather Rococo vocabulary, this paragraph seems to suggest a key by which the mystery of *Persistence* could be unlocked. But many years later, when Dalí himself was queried about this theory by the Russian physicist Ilya Prigogine, the artist scoffed that the painting represents the Surrealist perception of a Camembert cheese melting in the sun, and nothing else.[75]

This brings us back to Dalí's famous quote that "the secret of my influence has always been that it remained secret." It is certainly no secret that Gala served as Dalí's muse and that she may have pushed him toward classicism, rather than Surrealism, in the belief that he would always be in conflict with the other Surrealists—for not only purely aesthetic but also political reasons. Our argument, however, is that the "secret" that Dalí is referring to is the impact that the Old Masters would have on his oeuvre, starting with his encounter as a young man with Leonardo da Vinci in 1919. In our view, this is particularly apparent with two da Vinci works, *The Baptism of Christ* and *The Adoration of the Magi*, and the role they play in *The Persistence of Memory*.

The coauthor of this book, American art expert Christopher Brown, a prominent collector of Dalí art, has analyzed the position of the hands on each of the clocks, which he interprets as a timeline. The clock balanced over the edge of the table is set at 5:58; the clock draped over the tree branch points to 6:00; and

the clock that drips over the face in center may be set at 6:02. We could therefore imagine that the painting represents the past, the present, and the future. As such it reinforces Dalí's interest in the *vanitas* motif—the idea that the watch, as a measure of our own mortality, is itself subject to inevitable decay.

Figs. 45–46. Leonardo da Vinci, *The Adoration of the Magi* (left), 1481, and Andrea del Verrocchio, *Baptism of Christ* (right), 1475. The angel at far left is painted by Leonardo da Vinci.

Such a timeline is frequently deployed in the work of Old Masters such as Leonardo da Vinci. *The Adoration of the Magi*, Leonardo's large unfinished panel from 1481, now in the Uffizi in Florence, is also organized in three distinct panels of time: in fact, it illustrates the transition from paganism to Christianity. The old philosopher at the far left represents the past; the young man at the far right (which may be a self-portrait of Leonardo himself) is the future, while the present, an infinite, timeless constant, is the figure of the newborn Jesus. Another putative link to the Old Masters is Andrea del Verrocchio's *Baptism of Christ* completed in 1475, to which Leonardo contributed several passages (see also the Essays in the final chapter of this book).

Other scholars see the melting shape of the clocks as Dalí's argument that the value of time is being eroded by the increasingly hectic nature of modern life, and the apparent inability of the twentieth century's elites to control this phenomenon. Though pocket watches are today mere curiosities, in the 1920s and 1930s they were an attribute of the professional class, including bankers, notaries, and lawyers, who represented a staunchly conservative bloc in mid-century society. As we will recall, Surrealism was a reaction to a rational, ordered society with its inflexible social layers and psychological inhibitions. Art historian Robert Radford, in contrast, believes the key lies in the putative association between the concepts of memory and time. "It is not unreasonable to associate the watches in *The Persistence of Memory* with ideas about the passage of time and the relation between actual time and remembered time," Radford wrote, "but probably the dominant fascination for Dalí was the paradox of rendering the hardest, most mechanical of objects into its present soft, wilting form."[76]

Many years later, when Dalí was invited to give a lecture at the Museum of Modern Art and was pressed to explain the painting, his response was rather laconic. The public should stop worrying about the challenge of understanding his work, he said, "because I myself don't know what it means either."

**The overt use** of autoerotic motifs in Dalí's paintings, and his penchant for shock effect, had begun to wear on some of the members of the Paris Surrealist circle. While they accepted that eroticism was a potent theme in the language of dreams, they continued to believe that *automatisme* should be just that: spontaneously produced hallucinatory imagery that mined the subconscious in an authentic and truthful way. To many, it seemed that Dalí was

simply using his art to project his sexual frustration. Another factor in the shifting alliances was that artists in the Surrealist mainstream were choosing sides in the growing political polarization of France during the interbellum, with many aligning themselves with Communism. In a manifesto published in 1925, the so-called Centrale Surréaliste, a Surrealist salon of sorts around the figures of André Breton and Louis Aragon, openly declared their support for revolutionary ideology. They even pronounced their allegiance to the leader of a Moroccan revolt against French colonial rule, Abd-el-Krim, stating that "we place our energies at the disposal of the revolution, of the proletariat and its struggles." By the early 1930s, the growing shift to Communism even led Breton to collaborate with Leon Trotsky on a declaration called the *Manifesto for a Free Revolutionary Art*.

As a son of Catalonia, Dalí had grown up with a strong sense of Catalan identity that chafed against Castilian rule and longed for liberation. During his school years in Figueres, his head was full of revolutionary ideas, inspired by Lenin, Trotsky, and local political firebrand Martí Vilanova, who published a magazine named *Renovació Social*. In 1921, Dalí had even written an article for this magazine that extolled Soviet art. Indeed, after the fall of Imperial Russia in 1917, the Soviet Union initially proved to be fertile ground for modern art. Russian avant-garde artists such as Vasiliy Kandinsky, Vladimir Tatlin, Alexander Archipenko, and Kazimir Malevich experimented with Suprematism, Productivism, and Constructivism from a uniquely Russian perspective, which in some ways went beyond similar movements in the West. But in the 1920s, the Soviet government began to signal that these experiments were going too far, and by 1932, the Soviet Communist Party had imposed a soulless socialist realism on all artistic activity in the USSR.

In 1924, as we saw, Dalí had been briefly imprisoned because of some vague seditious activity. Four years later, Dalí affirmed to the newspaper *La Publicitat* that he sided with "the Communist position," while declaring himself to be "absolutely and profoundly anti-religious."[77] Nevertheless, when push came to shove during the growing political polarization of 1930s France, Dalí backed down and insisted that Surrealism was essentially apolitical. This did not sit very well with his fellow Surrealists. When Breton asked him to join a campaign to rebuff the growing far-right movement in France, which drew its inspiration from fascism, Dalí declined because, as he said, "I do not believe in it." To defend his position, Dalí sought refuge in literary obfuscation, arguing that "all the drama we are living through doesn't stem from political or tactical errors, but essentially from a colossal ideological deficit of the parties of the left."[78] This, of course, was bound to widen the schism between him and the rest of the Surrealist group around André Breton, who had firmly allied themselves with the Communist cause.

As the years wore on and Dalí began to say some positive things about Adolf Hitler, the new chancellor of Germany, a rupture was inevitable. But the truth is that, at heart, Dalí was never interested in politics. He could ally himself with a political idea if it served a greater purpose: to provoke, to stir outrage, or to attract attention. A case in point was his 1929 speech to the building workers' union in Barcelona, after their strike had all but crippled the city. A perceptive newspaper critic, F. Serra, looked on as Dalí climbed on the platform and loudly declared his support for the striking workers and the Catalan Left, while observing how his audience responded to his provocative slogans. "The public that turned up to hear Salvador Dalí," he wrote in *L'Hora*, "could be classified in many different ways."

There was a bourgeois public that laughed at his tomfoolery.
... There was an ingenuous public that went along in good faith,
convinced that behind this tomfoolery there would be ideas,
intelligence, and critical depth. There was also the public that were
present, with even stronger faith, in order to get angry. And then
there was that part of the public, mainly youngsters, who were
simply great fans of coarse language and eccentricity.[79]

But the real source of Dalí's alienation within the Surrealist
movement was not politics. It was his fundamentally different
approach to expressing Surrealist ideas in art. Starting with *The
Lugubrious Game* and *Face of the Great Masturbator*, Dalí had
followed Magritte's development of a more narrative approach to
painting, executed in flawless realism, and in a deliberate breach
with the poetic abstractions that other artists were pursuing.

Thus, at the beginning of the 1930s, Dalí was turning his back
on the modernist movements of the day, in order to return to the
Old Master models at the Prado in Madrid. As Fèlix Fanés has
observed, there is a distinct echo of Titian's *Worship of the Goddess
of Love* in the composition of *The Lugubrious Game*, with its
orgiastic scene unfolding in front of a classical statue—in this case,
the goddess Venus—with an outstretched hand. Such paintings
appealed to Dalí not only for their technique, composition, and
virtuosity of color but also because they depicted ancient myths,
the sixteenth-century equivalent of the surreal and the irrational.

Similarly, the woman turning to the crotch of a man facing
her in *Face of the Great Masturbator*, as if to perform fellatio,
may be inspired by the portrait of a woman in ecstasy, known
as *Beata Beatrix* (1863) by Dante Gabriel Rossetti, which was
much admired in Art Nouveau circles in Barcelona.[80] Indeed, it
is the narrative quality of Dalí's work, the desire to tell an often

autobiographical story in a conventional artistic vocabulary that audiences could understand, that offended his Surrealist colleagues, precisely because such constructs violated the principle of *l'automatisme.*

Old Master citations are also present in *The Memory of the Child-Woman,* where the *Mona Lisa* appears behind a tableau of a Greco-Roman ruin, and below an image of Gala and Dalí's childhood hero, Napoleon, carved from a phallus-like tower resembling the rock formations of Cap de Creus. In the distance, close to the horizon, is the peasant couple from Jean-François Millet's *The Angelus,* bent in prayer.

Of all nineteenth-century works, *The Angelus* would exert an almost magical attraction on Dalí, after he first saw this iconic painting as a child in his classroom. Painted between 1857 and 1859, the work depicts the noontime hour in rural France when the village church bell would be rung and farmers in surrounding fields would stop their work to say the Angelus prayer. In the mid-nineteenth century, many Catholics—and particularly the rural classes—still observed the daily cycle of obligatory prayers first established in the Middle Ages: at sunrise at 6:00 a.m.; at noon; and again at 6:00 p.m., at sunset. As such Millet's *Angelus* depicts a nostalgic image of faithful devotion that was then rapidly disappearing from the growing industrialized cities of France.

The painting shows a peasant couple bowing their heads in prayer, no doubt summoned by the bells of the church in the distance, for which Millet used the church of Chailly-en-Bière in the Île-de-France as a model. Moments before, they had been busy at work harvesting their modest potato field, as shown by the pathetically small basket at their feet. Though it fetched only a small sum at the Salon of 1860, the work became wildly popular in the 1870s and eventually would be one of the most

Fig. 47. Jean-François Millet, *The Angelus*, 1859

widely replicated images of the nineteenth century. Originally purchased for one thousand francs, it fetched as much as half a million francs just thirty years later, as a result of a bidding war between the Louvre and the American Art Association.

While some interpreted *The Angelus* as a religious work, as an expression of simple and humble piety, others saw it as a socialist statement, in which Millet was supposed to have paid homage to the growing worker movement in France. It is unlikely that Millet intended either; as he later said, the picture was inspired by a childhood memory in which "my grandmother, hearing the church bell ringing while we were working in the fields, always made us stop work to say the Angelus prayer for the poor departed."

Dalí was fascinated by the picture. Like Vincent van Gogh,

Fig. 48. Salvador Dalí, *Archaeological Reminiscence of Millet's Angelus*, c. 1934

he used it as inspiration for his own work, including a series of paintings in the early 1930s entitled *The Architectural Angelus of Millet and Gala and the Angelus of Millet Preceding the Imminent Arrival of the Conical Anamorphoses*. He explained his fascination with the *Angelus* in an essay entitled "The Tragic Myth of Millet's Angelus," in which he revealed that "In June 1932 appears in my mind all of a sudden, without any recent recollection nor any conscious association that lends itself to an immediate explanation, the image of Millet's *L'Angelus*." It made a strong impression on him, he continues, because for him it is "the most enigmatic, the most dense, and the richest in unconscious thoughts ever to have existed."

In fact, the painting did not strike Dalí as a rural image of

devotion at all but as a source of great inner disquiet and a perfect example of what the paranoiac-critical process could discern that others didn't. What he saw was a man "who stands hypnotized—and destroyed—by the mother. He seems to me to take on the attitude of the son rather than the father. One could say that the hat which he holds, and said in the language of Freud, signifies sexual excitement, in order to demonstrate the shameful expression of manhood."[81]

Dalí then continues to describe various "delirious phenomena" that the painting stirred in him, including the arrangement of two upright stones that evoked "the couple of Millet's *Angelus*" on the craggy surface of Cap de Creus.

These and other ideas led him to declare that the peasant couple in Millet's painting are not praying the Angelus but rather, are burying their child; the basket with potatoes is actually a coffin. This suggestion was met with some derision, until many years later, Dalí discovered that Millet had originally considered depicting a rural couple at a simple burial but then rejected the idea because he thought it would be too maudlin. Dalí insisted that the Louvre conduct an X-ray examination of the painting, which did reveal a painted-over outline of a coffin.[82] That sealed the matter. As Dalí triumphantly declared, *The Angelus* was not a scene of simple devotion but the portrait "of two beings in a desolate, crepuscular, and deadly environment . . . with a pitchfork plunged into the real and substantial meat that the plowed land had been for man through all time."[83] In a later interview, Dalí went further by saying that "I've made cuckolds of everybody, especially the people who stayed with the first pictures of Surrealism. Only my latter-day paintings, and they alone, have an imperial ambition from an artistic point of view, and it's only in them that I've integrated everything. This summer, I met the

principal Pop and Op painters; in my last painting, I annexed everything new in these two forms of art, and at the same time I've rendered the tragic myth of Millet's *Angelus*. From now on I shall never stop painting and repainting Millet's *Angelus*."[84]

Fig. 49. Arnold Böcklin, *The Isle of the Dead*, third version, 1883

Another acclaimed nineteenth-century work that came in for a paranoiac-critical interpretation was the Symbolist work *Die Toteninsel (The Isle of the Dead)* by Swiss artist Arnold Böcklin. A tall, rocky outcropping, not unlike the formations of Cap de Creus, rises from a dark expanse of water to welcome the graves of the dead. A small boat carrying a single mourner, a tall figure clad in white, has just arrived to deliver another coffin for burial.

Critics interpreted this figure as a representation of Charon, the mythological figure who carried the souls of the deceased to the underworld. But Böcklin always insisted that the painting had no meaning as such—even the title, *The Isle of the Dead*, had been conferred by an art dealer, Fritz Gurlitt—and that it was simply a "dream picture" in the best Symbolist tradition. Nevertheless, the setting bears some resemblance to the islet of Pontikonisi near

Fig. 50. Salvador Dalí, *The Real Painting of the "Isle of the Dead" by Arnold Böcklin at the Angelus Time*, 1932

the island of Corfu, Greece, as well as the islet of Saint George near Perast in Montenegro. Whatever its precedent may be, when the painting was first exhibited in 1880, it caused a sensation, inspiring scores of prints, books, and even symphonic poems. Delighted with his success, Böcklin went on to develop at least five different versions of the painting between 1880 and 1886. According to Vladimir Nabokov's novel *Despair*, a reproduction of the Böcklin work could "be found in every Berlin home."

Dalí reinterpreted the work by conceiving it as the now-familiar rock of Cap de Creus, with a dark slab on the right foreground, and a cup pierced by a staff on the left. He explained his interest in these ubiquitous nineteenth-century works as a response to the "frenzy over Surrealist works," in that he painted "a few apparently very normal paintings, inspired by the congealed and minute enigma of certain snapshots, to which I added a Dalínian touch of Meissonier." Like so much of Dalí's work, it was essentially a provocation to see how the public, worn down by the "continuous cult of strangeness," would respond to something so gratifyingly figurative and conventional. And, as he continues in his autobiography, they "instantly nibble[d] at the bait. Within myself I said, addressing the public, 'I'll give it to you, I'll give you reality and classicism. Wait, wait a little, don't be afraid.'"[85]

Another, quite different form of provocation was the incongruous use of objects—such as Dalí's famous use of a lobster as the hearing piece of a phone or as a garment covering the pubis of a female model. This sprang in part from a collaboration with his friend Marcel Duchamp. With the exception of a single portrait painted in 1918, Duchamp had foresworn painting altogether in 1914 in order to become an anti-artist, an *anartiste*. "Can one," he asked, "make works that are not works 'of art'?"

Fig. 51. Salvador Dalí, *Retrospective Bust of a Woman*, 1933

The answer was the development of so-called *tout fait objets,* or "readymades." Essentially, these were everyday objects displayed in an unconventional or provocative context. For example, for the first Independents Exhibition in New York of 1917, Duchamp decided to submit a porcelain urinal—though he was careful to do so under a pseudonym, R. Mutt. This prompted outrage, and the urinal was refused. Duchamp then took it to the studio of

photographer Alfred Stieglitz, where it was photographed as a work of art. The point Duchamp tried to make is that he didn't make the object; he *chose* it, and that was its significance.[86]

Dalí followed suit by creating similar improbable constructs that were part artwork, part readymade, such as *Retrospective Bust of a Woman*, exhibited at the 1933 Surrealist Exhibition at the Galerie Colle in Paris. Here, Dalí took a bust of a man-nequin, of the type used in jewelry showrooms, and adorned it with a baguette and an inkwell featuring the figures from Millet's *L'Angelus*. The bust also wore a necklace consisting of a zoetrope strip and cobs of corn. Meanwhile, the now-familiar group of ants was painted on the woman's cheek, suggesting putrefac-tion. Dalí referred to these readymades as objects "functioning symbolically," in other words, constructs where context and the combination of disparate elements gave the work psychological power. In this case, the purpose of the exercise was to present a woman as an object to be consumed.

**In the midst** of this creative frenzy, new shores were beckoning. Dalí's work had been exhibited at the first surrealist exhibition in the United States, hosted by the Wadsworth Atheneum in Hartford in 1931, followed by the one-man show at the Julien Levy Gallery in New York in 1933. Even though these shows had not produced many sales, Dalí was struck by the overwhelmingly positive critical reviews. Translated from English into French, the clippings "revealed a comprehension a hundred times more objective and better informed of my intentions . . . than most of the commentaries that had appeared in Europe about my work," he said. Though in Paris everything and everyone was seen through the prism of the writer's own agenda, Dalí continued,

no such bias was as yet evident in America. "Far from the battle" of modernisms that had raged in Europe, Dalí believed, Americans could be trusted to "be lucid and see spontaneously what made the most impression on them." And that, of course, was "precisely myself—the most partisan, the most violent, the most imperialistic, the most delirious, the most fanatical of all."[87] This sentiment was underscored when he received an honorable mention for *Enigmatic Elements in the Landscape* at the 1934 International Exhibition of Paintings held by the Carnegie Institute in Pittsburgh. Clearly, to America he should go.

Alas, that was easier said than done, for Dalí's always-precarious finances were now more precarious than ever. He had spent most of his funds on the house in Port Lligat. "I thus found myself at a moment when I was simultaneously at the height of my reputation and influence," Dalí later wrote, "and at the low point of my financial resources."[88] Worse, the Pierre Colle Gallery was not in a position to renew his contract or to advance him any funds, for it was itself in financial difficulty. "I want to go to America!" Dalí exclaimed and in desperation began to knock on the doors of everyone he knew, in an effort to borrow money.

This stratagem worked. In the end, it was Pablo Picasso who gave him the money with which to purchase passage on a ship. After a solo exhibit at the Zwemmer Gallery in London, he embarked with Gala for his first Atlantic crossing to the United States.

Fig. 52. Salvador Dalí, *Enigmatic Elements in the Landscape*, 1934

# 5.

# NEW HORIZONS: 1934–1945

*Gala is never, never wrong.*

Salvador Dalí

**Before the advent** of airplanes with the range to cross the Atlantic Ocean, ocean liners were the only way to travel from Europe to North America. In fact, the period from the 1920s to the 1930s has often been called the "second golden age of the ocean liners," for with the recovery of the European economy after World War I came a new impetus for transatlantic voyages. France, Britain, Germany, and Italy all competed in offering the fastest, most luxurious vessels in which passengers—even those in second and third class—could make the crossing in comfort. But fare prices took a steep dive after the United States sharply reduced the annual quota of immigrants in 1926, and the Great Depression of 1929 took a further toll on the world economy.

In Great Britain, this forced the Cunard Line and the White Star Line (of *Titanic* fame) to merge. Undaunted, France launched the SS *Normandie* in 1935, the largest and fastest passenger ship yet built at that time. Decorated with lavish art deco interiors designed by Roger-Henri Expert, the ship soon beat all of its competitors in attracting the European elite.

The *Normandie* was modeled on a ship that had been built for the French line just three years earlier, known as the SS *Champlain*. Though less famous than her younger sister, the *Champlain* was the first truly modern ocean liner, fast and comfortable, with interiors designed by René Prou, who had previously designed the interiors for the Venice Simplon-Orient Express luxury train. As it happened, this was the ship that would carry Dalí and Gala. But the beauty of its appointments was utterly lost on Dalí, who suddenly faced the prospect of traveling across an ocean for five days. He confessed that he was terrified by the idea of being lost in a limitless "ocean space." "I had never in my life sailed out of sight of land, and the creaking of the ship appeared to me more and more suspect," he wrote and began to look on the officers of the ship as "my executioners."

What was more, the sheer size of the ship did not inspire much confidence. "I felt that the boat was too large and too complex to be able to make the crossing without a catastrophe," he remembered. He made sure to attend all of the boat drills and always appeared ahead of time, "with my life-belt strapped on," and then kept his vest on as he retired to their cabin to read—just in case. His neurotic behavior made Gala laugh so hard that tears rolled down her cheeks.

Of course, his fertile imagination was working overtime, and it occurred to him that he should ask the captain to have the largest possible loaf of bread baked for him. As we have seen, bread held

Fig. 53. The SS *Champlain*, the first truly modern ocean liner,
on which Dalí and Gala traveled to New York

a lifelong fascination for the artist. "Bread has always been one of the oldest subjects of fetishism and obsession in my work," Dalí wrote, "the first and the one to which I have remained the most faithful." It also had a particular resonance for the American public, because his youthful work *The Basket of Bread* (1926) had made its way to the Philadelphia Museum of Art. But Dalí had other plans for the huge loaf he hoped to get from the *Champlain*'s kitchens. He intended to distribute pieces of it to the journalists, who were no doubt waiting for him on the New York quay. Whereas other celebrities on board plotted to avoid the press upon their arrival, Dalí eagerly looked forward to talking to them. "I love getting publicity," he admitted, "and if I am lucky enough to have the reporters recognize me, I will give them some of my own bread to eat"—just as St. Francis did with his birds.[89]

Fortunately, the crossing was made without mishap. Before long, Manhattan rose like a mirage out of the mists, "verdigris,

pink, and creamy white—like an immense Gothic Roquefort cheese." And as Dalí had hoped, there was the requisite crowd of American correspondents waiting for him. But they were less interested in the massive loaf that the ship's kitchen had baked for them than in another of Dalí's gastronomical exploits. Is it true, they asked, that Dalí had painted a portrait of his wife with a pair of fried chops balanced on her shoulder? Why, Dalí answered, "certainly, except that they were not fried, but raw."

"Why raw?" they asked.

Because, Dalí replied, "my wife is raw too."

But why then put these chops together with your wife?

"Because," Dalí said, "I like my wife, and I like chops, and I saw no reason why I should not paint them together."

Having thus satisfied the New York press corps, he and Gala checked into the Hotel St. Moritz and soon thereafter began to do the rounds of cocktail parties. This allowed him to visit some of the city's swankiest apartment buildings. Dalí was stupefied to see the proliferation of period styles in these upper-crust places, with splashes of "Gothic, Persian, Spanish Renaissance, and Dalís."

With the artist himself in town, the exhibit at the Julien Levy Gallery was bound to be a great success. Most of the paintings were sold, although the final celebratory party before the couple's return to France ended on a sour note. This last soirée had been organized by the American publisher and arts patron Caresse Crosby, who had come up with the idea to make it a "Surrealist ball." Consequently, everyone was invited to dress up as wildly exotic as possible. "Society women," Dalí later remembered, "appeared with their heads in bird cages and their bodies practically naked." In the center of the Coq Rouge, the restaurant where the party was held, a bathtub swung from the ceiling, looking as

if it might drop down on the guests below at any moment. Guests had tried to outdo each other in their choice of costumes, and so had Gala, who was dressed as an "exquisite corpse." On her head, Dalí wrote, she had fastened "a very realistic doll representing a child devoured by ants, whose skull was caught between the claws of a phosphorescent lobster"—a motif that was entirely in keeping with Dalí's penchant for the absurd.

Unfortunately, little did the Dalís know that at that moment, America was still in the grip of the Lindbergh baby trial, in which Bruno Hauptmann stood accused of having kidnapped the twenty-month-old son of famed aviator Charles Lindbergh. Every day, newspaper headlines provided updates on the trial, which the columnist H. L. Mencken called "the biggest story since the Resurrection." One French reporter who had been assigned to cover the trial was tipped about Gala's unusual choice of head-wear at the party and immediately saw an opportunity. He cabled his newspaper, *Le Petit Parisien,* that Gala had shocked New York society by walking around with a replica of the Lindbergh baby on her head. As it happened, none of the guests at the ball had made the connection, but that particular detail was conveniently omitted. By the time Dalí and Gala returned to Paris, they found themselves at the center of a brewing scandal, and the artist dis-covered that publicity can sometimes be a mixed blessing.

**Once back in** Paris, Dalí plunged into work. He did so know-ing that he wouldn't need to worry as much about his financial condition as before. A small group of collectors, known as the Zodiac, had pledged to support Dalí with a modest allowance in return for the choice of either one large painting or a small work with several drawings.

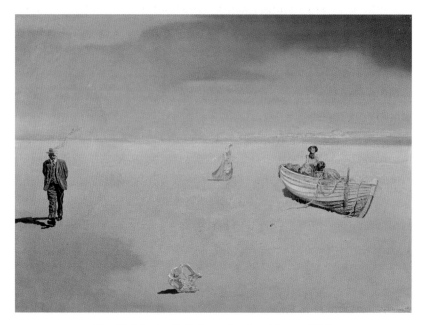

Fig. 54. Salvador Dalí, *Paranoiac-Astral Image*, 1934

At the same time, something far more important was happening. A new phase in Dalí's work was emerging—a phase in which the artist moved away from the bizarre and often incomprehensible collages of people and objects to a more cohesive narrative form. This was accompanied by a more consistent use of scale and a greater monumentality of his figures, as if Dalí was searching for a more accessible way of framing his story, even if the story itself was not always entirely clear. In a sense, Dalí was returning to the Baroque models of his youth, though such models were now executed with a far superior command of the brush, of color and tone, and of light and shadow. At the same time, there was a notable decline in the role of fetishist erotic material, no doubt because of the stabilizing influence that Gala brought to his life as both his lover and manager of his chaotic

household. A key example is the *Paranoiac-Astral Image* (1934), showing a man strolling on a deserted beach while a woman and her child find themselves stranded in a rowboat on the opposite side. The scale of the figures is consistent throughout, while the sharp sunlight evokes the work of Meissonier.

That is also true for *Atavistic Vestiges after the Rain* (1934) and *Enigmatic Elements in the Landscape* (1934). With their brooding, ochre-cobalt skies and sharply drawn figures, these are works that presage the postwar work of the mature Dalí.

Another revealing work from this period is *The Angelus of Gala* (1935), which at first glance is as conventional as a Dalí painting could ever get. However, the sitter, in this case Gala, is seen twice: both from the front and from the back, as if she were immersed in conversation with herself. On the wall behind her is a picture of a couple in the act of praying, loosely inspired by *L'Angelus.* They are placed in a wheelbarrow, however, which may carry some erotic undertones, and the juxtaposition of the two Galas mimics this pose in detail; in fact, the Gala facing us is sitting in a wheelbarrow as well. The garments of the sitter, as well as her hair, are rendered with the sense of detail that was the hallmark of Dutch seventeenth-century painters such as Vermeer.

Another work from this period is Dalí's *Apparition of the Town of Delft.* Here, Dalí has faithfully re-created Vermeer's *View of Delft* (1661) in the background (albeit in mirror image), while the foreground is populated by a group of skeleton-like figures, one brandishing a halberd, seated before a rusting automobile impaled on a tree. The irrational clash of different period motifs, one of the unifying principles of Surrealism, is still in evidence, but the visualization of these motifs is entirely classical, in a clear break with the abstractions that the rest of the French Surrealist movement was pursuing.

Fig. 55. Salvador Dalí, *The Angelus of Gala*, 1935

As we have seen, that alienation was long in coming. It had begun in the late 1920s with Dalí's obsessive use of scatological and disturbingly erotic imagery. Gala had tried to temper the blatant use of such sexual themes, arguing that such was tolerated within the group as long as it was done with taste. Dalí rejected such "tampering" with the paranoiac-critical method, scoffing that "a little crap was all right. But just crap was not on. Depicting genitals was approved, but no anal fantasies." Another growing bone of contention was the subject of religious motifs, which the Surrealists considered verboten. Dalí, who at times could be both

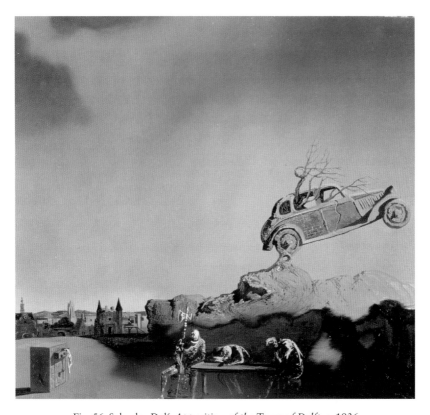

Fig. 56. Salvador Dalí, *Apparition of the Town of Delft*, c. 1936

atheist and lapsed Catholic, disagreed. "One could have sadism in dreams to one's heart content," Dalí wrote, "but no religion on any account, not even if it was of a mystical nature." To have erotic fantasies about Raphael's Madonna, for example, was "strictly prohibited."

What ultimately precipitated the break between Dalí and French Surrealism, however, was Dalí's disturbing interest in Adolf Hitler. In 1933, Hitler had been asked by German president Paul von Hindenburg to form a government as chancellor, following the inconclusive results of the 1933 elections. But after

the Reichstag fire and just before Hindenburg's untimely death, Hitler pushed through the 1934 Ermächtigungsgesetz ("Enabling Act"), which gave him full dictatorial powers. This allowed him to use legislation to marginalize Jews in all levels of German society. He also suppressed any artistic avant-garde movements, including German Expressionism. And yet, Dalí was intrigued with this character, who at the time was admired in many right-wing circles throughout Europe for the way he had stabilized the German economy. "I was fascinated by Hitler's soft, fleshy back, which was always so tightly strapped into the uniform," Dalí confessed.

But the Surrealists were outraged. Called by Breton to defend himself in front of his Surrealist colleagues, Dalí appeared with a thermometer in his mouth and proceeded to discard his clothing, piece by piece, while arguing that his obsession with Hitler was strictly paranoiac in nature and fundamentally apolitical. In other words, Hitler appealed to Dalí as a motif, precisely because of the Führer's innate irrationality. "Hitler interested me purely as a focus for my own mania," he later wrote, "and because he struck me as having unequaled disaster value."[90]

Curiously, however, Dalí continued to be invited to participate in Surrealist exhibitions, for Breton knew all too well that Dalí had become a celebrity and that the movement needed his brand if its exhibits were to have commercial success. Even Breton could see that the reason for Dalí's growing popularity was his instant accessibility for a public that had grown weary of modernist experiments. The blend of provocative erotic material with a realism that defiantly harked back to France's beloved Pompiers—Meissonier, Bouguereau, Couture—endowed his works with an irresistibility that other Surrealists could only dream of. As Dalí once told an admirer, "I was the only one who

moved in society and was received in high-class circles," precisely because he was proud to be a flaneur, a snob. "Snobbery consists in going to places that others are excluded from—which produces a feeling of inferiority in others," he wrote later. "That was my policy where Surrealism was concerned."[91]

And indeed, of all the Surrealists it was Dalí who steadily rose to become the most visible artist of his era—not only in Paris but also in London, which in 1936 hosted the International Surrealist Exhibition at the New Burlington Gallery. This was followed by the famous exhibit at the Museum of Modern Art, entitled "Fantastic art, Dada, Surrealism" in December of that year.

**What neither Dalí** nor the Surrealists could control, however, was that outside their rarified artistic circles, the world was rapidly changing, not only in France but also in Spain and the rest of Europe. As we have seen, a coup led by General Miguel Primo de Rivera in 1923 had established a Spanish military junta, but even this dictatorship failed to quell the growing social and political tensions in the country. In 1931, King Alfonso II was finally compelled to call for an election. Held on April 12, this led to a landslide victory of socialist and liberal republicans. Soon thereafter, the monarchy was abolished in favor of the Second Spanish Republic. King Alfonso fled the country, as did many noblemen and wealthy conservatives. In exile, they bided their time. They did not have long to wait for the events that would reshape Spain.

The next few years saw a steady escalation in clashes between liberals and republicans on the one hand, and right-wing monarchists on the other. Many of the latter had joined a

party called the Falange Española y de las JONS, or Falange for short. Prime Minister Manuel Azaña was powerless to stop the violence or to prevent large segments of the armed forces from being infiltrated by Falange sympathizers. A new government, led by Prime Minister Santiago Quiroga, responded to the Falange threat by sacking or reassigning many senior officers, including the chief of staff, a general named Francisco Franco, who found himself demoted to the Balearic Islands. This only served to make Falange officers more determined to strike back and take control of the country. The fact that Franco had been exiled to the Balearic Islands allowed him and his fellow conspirators to plot their coup away from the prying eyes of the Madrid government. In July of 1936, the Spanish Civil War erupted when Falangist officers seized control of Spanish Morocco and used the territory as their base for a full-fledged invasion of Spain.

At first, the Madrid government seemed to underestimate the threat that the Falange posed. Indeed, after Franco and his Moroccan troops—grandiosely dubbed the Army of Africa—landed on Spain's southern coast, the rebels were able to secure only a few cities. Falange sympathizers in Madrid and Valencia were quickly rounded up and imprisoned. But things started to change when over half of Spain's armed forces, as well as the Guardia Civil and metropolitan police forces, declared for the rebels, who now styled themselves as the Nacionales (Nationalists). This was meant to convey the narrative that as Spanish Christians they were the legitimate representatives of the Spanish state, in contrast to the anticlerical socialists and international anarchists who made up the Republican government. It was a smart ploy, for it prompted the Roman Catholic Church to choose the Nationalist side, given that the Republican Constitution had abolished the Jesuit order in 1931.

Through much of 1936, as Dalí worked in his cabin in Port Lligat, both sides tried frantically to build up their forces as well as their arms, from simple rifles to heavy artillery, from whoever was willing to sell. Soon, however, the initiative shifted to the Nationalists, largely because of Hitler's decision to order German air and armored forces to intervene on the side of the Falange. Since the rest of Europe had declared strict neutrality in the conflict, that meant that the momentum of the Nationalists was bound to grow, even though the USSR pledged to supply the Republicans, with uneven results.

Fig. 57. Pablo Picasso, *Guernica*, 1937

Of course, with Madrid heavily engaged in the Civil War, separatists in both the Basque provinces and Dalí's native Catalonia saw an opportunity to agitate for independence. The central government had little choice but to acquiesce to these demands, and thus, for the first time, both regions gained a large measure of autonomy as a result. Needless to say, this did not go down very well in the eyes of the Falange. In response, Franco asked the German Condor Legion, an expeditionary force of Luftwaffe fighters and bombers, to attack a Basque village by the name of Guernica, just twenty-two

miles east of the northern town of Bilbao. For the Luftwaffe, this was a perfect opportunity to practice the doctrine of coordinated terror attack that later would become a major feature of World War II. The bombing was carried out on Monday, April 26, 1937—a market day—and killed around three hundred people. It inspired Picasso's best-known masterpiece, *Guernica*, which he completed just two months later in his Paris studio.

When the Italian fascist leader Benito Mussolini was prodded to come to the aid of the Falange as well, the end was no longer in doubt. Italian warships broke the Republican blockade of the Nationalist South, while Franco's troops steadily moved to seize territory in the Republican North. Despite the arrival of thousands of foreign volunteers, known as the International Brigades, on the Republican side, by 1938 Franco was in control of much of the country. A desperate Republican offensive to try to stem the Nationalist tide, called the Battle of the Ebro, ended in failure—in part, some claim, because this took place at the same time as the Munich Conference, where British prime minister Neville Chamberlain surrendered the Czech Sudetenland to Adolf Hitler without a shot being fired.

The Munich treaty signaled to the Republicans that they could expect no help from the European powers in their fight against fascism, which gravely affected morale in the Republican ranks. Finally, the last major Republican stronghold, Barcelona, fell on January 26, 1939, and Catalonia was occupied by the Nationalists. When Madrid was taken two months later, the Spanish Civil War came to an end. Franco sealed his victory with large-scale reprisals against anyone suspected of Republican sympathies. Though Spain has yet to make an official reckoning of the toll, estimates range from thirty thousand to one hundred thousand killed and thousands more sent to forced labor camps.

Fig. 58. Salvador Dalí, *Soft Construction with Boiled Apricots,*
also known as *Premonition of Civil War,* 1936

What was Dalí's response to this terrible drama unfolding in
his native Spain? Although he had always associated himself with
the laboring class in the 1920s, the painter remained strangely
detached from the Civil War, other than to claim that he had
anticipated the conflict in a painting completed just a few months
before the war's outbreak in 1936.

Originally, the work was called *Soft Construction with Boiled
Apricots,* which, as Dalí wrote, "shows a huge human body, all
arms and legs deliriously squeezing each other." This unusual

description, which once again underscores Dalí's penchant for equating ideas and emotions with food, does not at first glance suggest any of the terribilita that led Dalí to eventually rename it *Premonition of Civil War*. Later, though, he described the painting as "a vast human body breaking out into monstrous excrescences of arms and legs tearing at one another in a delirium of auto-strangulation." That is certainly an apt metaphor for the idea of a nation tearing itself apart, though not necessarily as eloquent or influential as Picasso's *Guernica*, or Goya's *Los Desastres de la Guerra*.

In fact, on reflection, Dalí believed that the Civil War was an abhorrent but inevitable force of nature, rather than the product of clashing political ideologies. "The Spanish Civil War changed none of my ideas," he wrote. "On the contrary, it endowed their evolution with a decisive rigor. Horror and aversion for every kind of revolution assumed in me an almost pathological form." He steadfastly refused to declare himself for either side, even though many insisted that he become, as he wrote, either a "Stalinist or Hitlerite." On the contrary, he said, he was "going to be as always and until I died, Dalínian and only Dalínian!" What did that mean? A man, he added, who "believed only in the supreme reality of tradition."[92]

Some authors have argued that Dalí's refusal to side with the elected Republican government was motivated by its strong anticlerical attitude. This was certainly true for many Spaniards; even staunch democrats could not abide the Republican vendetta against the Church. In fact, Dalí prophesized, the war would eventually produce a rediscovery of the "authentic Catholic tradition peculiar to Spain." In that sense he was certainly correct, for the overthrow of the Republican government would lead to the ultraconservative, fascist regime of Generalissimo Franco, ruling

Spain for thirty-seven years in close concert with the Spanish Catholic Church.

**As the threat** of the Civil War grew, Dalí and Gala decided to leave Spain and embark on a series of travels. In 1936, and again in 1939, they sailed to the United States. They were finally able to do so because Dalí had seen an opportunity in merchandising his growing "brand" to the fashion and theater circles in Paris. He met with Coco Chanel and other designers and wound up creating a perfume bottle in the shape of a mussel, as well as other objets d'art. Breton, who took a dim view of such philistine behavior, composed an anagram of "Salvador Dalí," transposing the name to "Avida Dollars."

But there was no denying that Dalí was becoming a household name, not only in Europe but also in the land that would give Dalí financial security, the United States. During his second trip to New York in December 1936, he even appeared on the cover of *Time* magazine, a singular honor. Not surprisingly, perhaps, all twenty-five paintings that were exhibited at the Levy gallery that month were sold.

In 1938, when the fighting in Spain reached a fevered pitch, Dalí and Gala fulfilled a long-cherished wish to travel to Italy and see the art of Renaissance masters in the museums of Florence and Rome. That Italy at this time was under the sway of the fascist Duce, Mussolini, did not deter them, though many Surrealists saw this as the final straw. In Dalí's defense, many Europeans and Americans continued to visit Italy during these prewar years, given that Italian Fascism, while odious, had yet to devolve into the excesses witnessed in Nazi Germany.

Thus, Dalí was finally able to visit the Uffizi Museum in

Florence and the Borghese Gallery in Rome. This marked his first significant encounter with both Greco-Roman sculpture and the art of the Renaissance, beyond the few works he had seen previously in the Prado and the Louvre. It was a watershed moment. We should always remember that unlike modern ones, the art reproductions of the era were usually in black and white, or in faded, off-color prints. Seeing the work of the Renaissance masters up close, in full color, must have made a deep impression on Dalí, though the full impact from this and subsequent visits to Italy would not be felt in full until well after the war. Indeed, the encounter with Italian art strengthened his conviction that after the war, he should devote himself to studying the great masters of the Italian Renaissance in-depth. "While my country was interrogating death and destruction," he wrote, "I was interrogating that other sphinx, of the imminent European 'becoming,' that of the Renaissance." This shift did not escape the notice of his fellow Surrealists, including Breton, who immediately criticized Dalí's embrace of "the lesson of Cosimo and da Vinci."[93]

Figs. 59–60. Salvador Dalí, *The Image Disappears* (left), 1938, and Johannes Vermeer, *Woman Reading a Letter* (right), 1663

But the Dutch Golden Age, and particularly the art of Vermeer, continued to exert a powerful influence as well. *The Image Disappears* of 1938 is a meditation on a favorite Vermeer motif, that of a young woman reading a letter by the light of an open window.

Fig. 61. Salvador Dalí, *The Enigma of Hitler*, 1939

In Vermeer's *Woman Reading a Letter,* the map in the background suggests that the sender is a seafaring husband or lover, writing from one of the exotic places unlocked by the Dutch maritime fleet. The map in Dalí's painting depicts Spain, the battlefield of the Civil War. But the image of the woman reading the letter is also a striking double image, an optical illusion device that Dalí would use with increasing frequency. In this case, it shows a profile portrait of his great Spanish hero, Diego Velázquez. Dalí's interest in Vermeer is further attested by at least two drawings for a design of *Metamorphosis of a Man's Bust into a Scene Inspired by Vermeer* (1939).

Meanwhile, as the clouds of war gathered over Europe, Dalí continued to experience prophetic visions that he expressed in some of his paintings. A prominent example is *The Enigma of Hitler*, which shows a photo of the Führer on a dish under a large, weeping telephone handset, as well as an umbrella—the signature attribute of Chamberlain. The work was reportedly painted after the Munich Agreement of 1938, in which the British prime minister gave away Czechoslovakia's Sudetenland territory in exchange for a promise of peace. Dalí explained the work as "announcing the medieval period which was going to spread its shadow over Europe," which was certainly a correct prediction: less than six months after the Munich Agreement, Hitler invaded the rest of Czechoslovakia. Next, Germany invaded Poland in September of 1939, prompting declarations of war from both France and Britain. For the next six years, much of Europe would suffer under a terror not seen since the Middle Ages.

At the same time, the experience of visiting Rome continued to reverberate in Dalí's fertile mind. Two works from this period, *Inventions of the Monsters* (1937) and *Spain* (1938), are inspired by classical sculpture. In *Inventions of the Monsters*, Gala and Dalí appear in the foreground, seated at a table with a Leonardesque figure holding an hourglass and a butterfly.

This, he later explained, is another variation on the theme of "premonitions of war." In 1943, when the painting was acquired by the Art Institute of Chicago, Dalí expanded on this theme, arguing that "the canvas was painted in the Semmering mountains near Vienna a few months before the Anschluss"—the 1938 political union of Austria and Germany engineered by Hitler. "According to Nostradamus, the outbreak of war is presaged by the apparition of monsters," he added and explained that "horse women equal maternal river monsters. Flaming giraffe

equals masculine apocalyptic monster. Cat angel equals divine heterosexual monster. Hourglass equals metaphysical monster. Gala and Dalí equal sentimental monster." In fact, the only figure in the painting that does not represent a monster is "the little blue dog."[94]

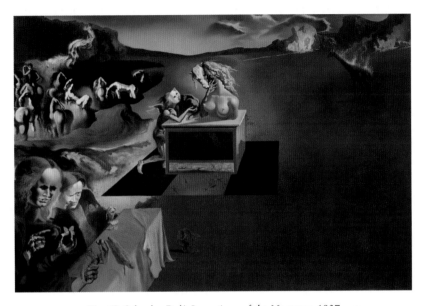

Fig. 62. Salvador Dalí, *Inventions of the Monsters*, 1937

Certainly, the figure with the hourglass and butterfly, inspired by Leonardo's Madonna paintings, is a symbol of both death and the fragility of life. While Dalí and Gala seem happily involved in conversation with one another, they appear oblivious to the monster apparitions behind them, including the nude bust of a mythological figure, a young woman with the head of a horse, which harks back to *Invisible Sleeping Woman Horse, Lion* of 1930. In the distance, a giraffe is on fire, while ominous clouds gather around mountains in the distance.

Given the growing threat of war, it must have been a relief to

once again travel to the United States. Here, Dalí was invited to design a pavilion for the 1939 World's Fair in New York. Held in the last months of the fragile peace in Europe, the World's Fair was devoted to the future. Among the technological inventions show-cased by the exhibitors were such novelties as air-conditioning, nylon, and color photography.

Amid this upbeat view of what the future might hold, Dalí was asked to design a Surrealist pavilion on the theme of "Dream of Venus." He did not disappoint. To enter, visitors had to walk between a pair of women's legs surmounted by a huge cutout of Botticelli's *Birth of Venus*, which Dalí had admired in the Uffizi Museum in Florence not too long before. The ticket booth was shaped in the form of a fish head, while the space inside had been conceived as an undersea grotto, where topless women swam in lavishly decorated pools.

Elsewhere, a nude woman slept, Cinderella-like, in a huge bed in front of a rock-crystal cave. Other figures were prostrate in front of enlargements of Dalí's canvases, including a tableau loosely inspired by *The Persistence of Memory*, which by now had acquired cult status. But the artist was not satisfied. He had originally wanted to replace the head of Botticelli's Venus on the façade with the head of a fish, but the organizers demurred. Deeply aggrieved, Dalí fired back with a pamphlet entitled "Declaration of the Independence of the Imagination and the Rights of Man to His Own Madness," featuring the painting of the fish-head Venus as he had envisioned it.[95]

Unfortunately, this altercation came on the heels of an inci-dent in which he smashed a store window at the department store Bonwit-Teller, because the arrangement of the window he had been asked to design did not follow his instructions. Both experiences taught Dalí an important lesson: that Americans

Fig. 63. Salvador Dalí, exterior of the Dream of
Venus Pavilion, 1939 World's Fair

were not always as pliable as their French counterparts, and that there was a limit to what audiences in the US would tolerate from the paranoiac-critical method. But it did make for great publicity, which could have been the purpose of these tantrums. Indeed, the exhibit at the Julien Levy Gallery that opened on March 1939

was once again a remarkable success. Almost all of his paintings sold for over $25,000, making him instantly one of the "richest young painters in the world."[96]

In many ways, Dalí and 1930s America were made for each other. He understood that the American media was fascinated with the European archetype of the *nonconformista*, the uncompromising, dangerously provocative but always exciting genius. He rushed to meet that expectation—not only with predictably eccentric behavior but also with paintings that sacrificed allegorical depth for purely visual titillation. Such a frisson could be sparked by his familiar blend of nudity and erotically tinted themes, executed in meticulous realism, but it could also involve the use of cleverly designed double images, where optical illusion could produce two very different interpretations. A key example is *Endless Enigma* of 1938. Breton dismissed it as little more than a visual crossword puzzle, but it proved to be a hit at the 1939 Levy exhibit. To facilitate the "unraveling" of this visual mystery, the gallery produced a catalog that featured no fewer than six superimposed cellophane sheets, each depicting (or "decoding") one layer in the painting. Audiences were enthralled, as Dalí knew they would be.

The invasion of the Low Countries, Belgium, and France by Nazi forces in May 1940 meant that Dalí and Gala no longer had a Paris home to return to. For the next eight years, they joined a throng of other artistic emigrés seeking refuge in the United States, including Max Ernst, Marc Chagall, Piet Mondrian, André Breton, Fernand Léger, and Yves Tanguy. This invasion of European talent into American creative circles was warmly welcomed by some, but observed with some apprehension by others, including "action painting" artists such as Jackson Pollock, Willem de Kooning, and Mark Rothko. They feared that

the influx of foreign talent would strain the still-fragile network of modern art patronage in New York, with more artists now vying for the same sources of private funding and gallery space. They also remained staunchly devoted to Abstract Expressionism and therefore looked upon Dalí with deep suspicion. While they could find much to admire in the abstract Surrealism of Miró, they thought of Dalí as little more than an illustrator, a purveyor of cloyingly pleasing commercial pictures that had no place in the ongoing development of twentieth-century art.

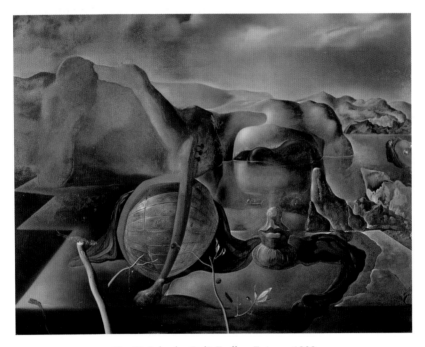

Fig. 64. Salvador Dalí, *Endless Enigma*, 1938

This only pushed Dalí to produce ever more provocative works that would establish him as the leading light of Surrealism, even if much of the Surrealist movement had by now disowned him. It also compelled him to write furiously, defending himself

153

and his art. This led in 1942 to his first autobiography, *The Secret Life of Salvador Dalí*.

His standing in the New York art world received a major boost when in November of 1941, the Museum of Modern Art hosted a major retrospective exhibition of Dalí, with some additional works by Miró. The exhibit subsequently traveled throughout the United States and did much to cement Dalí's reputation in this country. In the introduction to the accompanying catalog, MoMA publicist Monroe Wheeler wrote that "we believe that Dalí is an artist of the greatest interest at the moment, and meaningful in this historic sense," because "his imagination is not abnormal, at least no more so than that of a number of geniuses of painting in the past; no more so than the tormented psyche of today which is its basic theme." And while Dalí's conduct "may have been undignified," Wheeler continues, "the greater part of his art is a matter of dead earnest, for us no less than for him."

The subsequent essay by MoMA curator James Thrall Soby readily acknowledged the influence of Old Masters such as Johannes Vermeer, Diego Velázquez, Hieronymus Bosch, and the Spanish and Italian Baroque. In fact, Soby called Dalí's interest in Vermeer's art no less than "obsessive," noting that "at various times in his career, [Dalí] declared that his ultimate ambition is to be able to paint like Vermeer."

Notwithstanding the prestige of this retrospective, as well as the attention that the American press continued to lavish on Dalí, the sales of his paintings gradually declined after the United States entered World War II following the Japanese attack on Pearl Harbor. As the wealthy patrons of New York turned to funding the war effort, the idea of investing in Surrealist art by a Spanish painter receded in importance. In response, Dalí plunged himself into writing, producing a novel, *Hidden Faces,* in

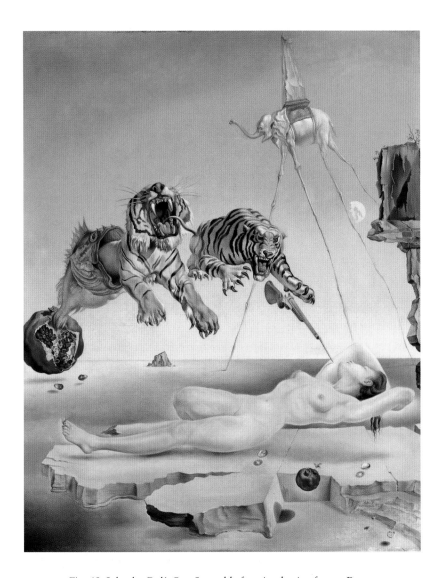

Fig. 65. Salvador Dalí, *One Second before Awakening from a Dream
Caused by the Flight of a Bee around a Pomegranate*, c. 1944

1944, while being forced to accept commissions to paint portraits of New York socialites. Needless to say, this further dimmed his standing in Modernist circles. Indeed, even the most passionate devotees of Dalí's art would admit that the war years in exile were not the artist's most fertile period, with only a few works of genuine merit. By contrast, Dalí produced some of his best designs for the stage during this time, including the sets for the 1941 ballet *Labyrinth* at the Metropolitan Opera, and the 1944 ballet *The Mad Tristan*, choreographed by Leonide Massine based on Richard Wagner's opera *Tristan und Isold*.

After a lengthy stay at Hampton Manor, the home of Caresse Crosby in Virginia, the Dalís divided their time between the St. Regis Hotel in New York and Pebble Beach, Monterey, on the California coast. They rented a bungalow near the Del Monte Lodge Hotel. The proximity to Hollywood led to a conversation between Dalí and Walt Disney, who had achieved tremendous success with his 1938 animated feature *Snow White*. Subsequent Disney films had not fared as well at the box office, largely due to the loss of overseas markets following the outbreak of World War II. Disney and Dalí decided to together embark on an animated short, entitled *Destino*. It was not the first time that Disney had reached out to a prominent member of the arts to raise the creative ambitions of his animated features; the 1940 motion picture *Fantasia* had been a critical success, not in the least because it featured the prominent conductor Leopold Stokowski conducting the Philadelphia Orchestra.

*Destino* was based on a story in Greek mythology of the god Chronos falling in love with a mortal woman named Dahlia. To visualize this fable, Disney envisioned Dahlia dancing through a series of fantastic and surreal settings, each based on Dalí's paintings. The soundtrack was to consist entirely of music, without any

Fig. 66. Salvador Dalí, *Design for the set of "The Mad Tristan,"* 1944

dialog, based on compositions of Mexican songwriter Armando Domínguez. Dalí set to work with one of Disney's top artists, John Hench, and for eight months worked on a series of storyboards that mapped out the film. In 1946, however, the project was halted. Some believe a clash of artistic ideas between Dalí and Disney was to blame, which certainly sounds plausible. Others point out that the studio was in deep financial trouble following the war years, when it was compelled to produce a great number of training films for the American armed forces at a small profit margin. In other words, the studio was in no position to embark on highly speculative art projects when it should have been focusing on regaining its traditional family audience with animated fairy tales.

In a last-ditch effort to save *Destino*, Hench produced a seventeen-second animation test proving the viability of the concept, but it failed to change Disney's mind.[97] Dalí had more luck working with Alfred Hitchcock, who asked him to

design Gregory Peck's dreamlike experience in the 1945 film *Spellbound*.

In 1945, US president Harry Truman decided to drop nuclear bombs over the Japanese cities of Hiroshima and Nagasaki, in an effort to suppress any further Japanese resistance. The horrific carnage that followed shook the Japanese nation, and indeed the world—including Dalí, as we will see shortly. The Japanese emperor sued for peace, and World War II came to an end. In 1948, Dalí and Gala moved back to their house in Port Lligat, despite howls of protests from some artists, who saw Dalí's decision to return to Spain as an implicit endorsement of the Franco regime.

But Dalí's thoughts were elsewhere. The eight-year exile in the United States had given him the opportunity to reflect on his career and to formulate a new purpose for the next phase of his life as an artist. Already, in a foreword to the 1941 MoMA exhibition, he had announced his decision "to become classic." Some authors believe that Gala may have played a role in convincing Dalí to reject Surrealism and to pursue a more overt classicism, given that this new orientation strongly resonated with the American buying public. To do so, he needed to end his ambivalent relationship with French Surrealism and define a new style firmly based on historical models.

**Looking back at** the first twenty years of the artist's activity, then, we can draw some initial conclusions about the secret of Dalí's success as an artist. Certainly, from the very first, his allegiance to the realism of the Old Masters was evident, particularly Spanish Baroque artists such as Francisco de Zurbarán and Diego Velázquez. The key elements that Dalí absorbed from these artists were their virtuoso command of texture and a Caravaggesque

Fig. 67. A frame from the 2003 reconstruction of *Destino*, based on
original designs by Salvador Dalí and John Hench © 2000 Disney.

chiaroscuro—the dramatic contrast of light and dark passages.
This is particularly evident in Dalí's growing mastery of elaborate
folds and drapery, which lends a figure both mass and gravitas.
First developed during the Gothic period in Northern Europe, the
use of drapery would become a hallmark of the High Renaissance
and subsequently transmitted to the Baroque through artists
such as Correggio. But while elaborate drapery functioned as a
spatial motif in Renaissance art, it gained an entirely new func-
tion during the Baroque, by endowing the saintly figure with an
ethereal quality, fully released from earthly bonds.

Beyond such specific motifs, techniques, and compositions,
another key influence of the Spanish Baroque on Dalí was its
fluid integration of the terrestrial and the spiritual, the material

and the immaterial. As Dalí would argue in 1964, "Transcendent reality had to be integrated into some fortuitous part of pure reality, in the same way that Velázquez's absolute visual imperialism had achieved it."[98] A third aspect of the period's influence was the Baroque artist's interest in documenting human joy and suffering as no period had ever done before—its "willing descent into the wounds of human experience." In Dalí's hands, that influence translates into a deep interest in death, decay, and putrefaction. As he put it in his interview with Alain Bosquet,

> I'm passionately fond of anything I can learn from painting, and I'm not the least bit interested in the feeling of weakness I might show when viewing a work. One of the least questionable paintings I know, Velázquez's *Las Meninas*, provided me with a cascade of astounding information. As for the spirit of this work, it accurately reproduces an epoch, and that's why I take off my hat to it. The people depicted offer me information of an incredible precision and I feel I know the painting down to the smell inhabiting the Infanta's house. Velázquez also teaches me something about light, reflections, and mirrors—and he teaches me a lot more than whole scientific volumes. His work is an inexhaustible treasure hoard of computation and exact data.[99]

But other Old Masters exerted a strong influence as well. One of these was Leonardo da Vinci, whose *Virgin of the Rocks, Mona Lisa, St. Anne,* and *St. John* Dalí would have admired at the Louvre in Paris in the 1920s. During his subsequent visits to Italy in the mid-1930s, he would also have seen Leonardo's *Annunciation, The Baptism of Christ* (painted with Verrocchio), and the *The Adoration of the Magi* in the Uffizi. Leonardo's influence on Dalí

was more subtle, particularly in the latter's discovery of atmospheric perspective, and what Dalí believed was his early embrace of the paranoiac-critical method. "Leonardo proved an authentic innovator of paranoiac painting," Dalí wrote, "by recommending to his pupils that, for inspiration, in a certain frame of mind they regard the indefinite shapes of the spots of dampness and the cracks on the wall, that they might see immediately rise into view, out of the confused and the amorphous, the precise contours of the visceral tumult of an imaginary equestrian battle."[100] He also cited some of Leonardo's works in his art, notably an image of the *Mona Lisa* in *Imperial Monument to the Child-Woman* of 1929. But Leonardo's influence, particularly in the area of optical illusion, would only come to full fruition in the second part of Dalí's career, after his reorientation to religious and historical subject matter.

A more direct model in the 1920s and 1930s was Johannes Vermeer. Dalí assiduously studied and even copied works by this Dutch master, as he would continue to do in subsequent decades, and at times even adopted Vermeer's unique palette of blue, yellow, and pink. Several times, Dalí declared his ambition to "be able to paint like Vermeer." When he learned that a woman artist in Vienna had fully mastered Vermeer's demanding technique, he wanted to go and visit her, only to learn that she had fled Austria in advance of Hitler's Anschluss in 1938.

However, as we will see in the second half of this book, as Dalí's art matured so did his embrace of the Pompiers, the French paragons of nineteenth-century academic painting. This is particularly striking because after the cataclysm of World War I, these academic painters had lost every shred of credibility in the art circles of the early twentieth century. Not surprisingly, Dalí's connection to these Salon artists is rather restrained, other than

the odd reference to Ernest Meissonier. But there is no question that Dalí was fascinated by the technique of these artists and the astonishing way in which they could evoke a nearly photographic facsimile of life in paint, whether cast in the bright sunlight of the outdoors or the muted tones of a moonlit bedroom at night. Despite their focus on historical and mythological themes that had lost their meaning in a Europe devastated by the Great War, there was no denying that these artists used their palettes to create illusions of an unprecedented power and persuasion.

Fig. 68. Ernest Meissonier, *1807, Friedland*, 1875

Thus, the influence of the Pompiers on Dalí's art would become even stronger in the late 1950s and early 1960s. Photographs taken in 1965 reveal that Dalí had quietly amassed an impressive collection of some of these French artists, including *La Baigneuse* (1870) by William-Adolphe Bouguereau and a version of *1807, Friedland*, a massive canvas depicting Napoleon's 1807 victory at Friedland, by Meissonier (1875). These and other artists of nineteenth-century realism would become paramount in the next phase of Dalí's remarkable life.

Fig. 69. William-Adolphe Bouguereau, *La Baigneuse*, 1870

# 6.

# THE ATOMIC ERA: 1945-1955

*Mistakes are almost always of a sacred nature.*
*Never try to correct them.*

Salvador Dalí

**W**riting in *50 Secrets of Magic Craftsmanship* (1948), upon his return to Spain after his exile in the United States, Dalí declared his intention that, "now at forty-five, I want to paint a masterpiece and to save Modern Art from chaos and laziness." The foundation for this new *alterstil* was the *Manifeste mystique* of 1951, in which he declared his decision to recommit his art to spirituality and the reconciliation of science and mysticism. "The paroxysmal crisis of Dalínian mysticism," Dalí wrote with his familiar penchant for syncretism, "mainly relies on the progress of the particular sciences of our times, especially on the metaphysical spirituality of the substantiality of quantum physics, and, at a level of less substantial simulacra, on the most ignominiously

supergelatinous results."[101] This new interest in mysticism is on full display in the principal works from this period, including *The Madonna of Port Lligat* (1949), *Christ of Saint John of the Cross* (1951), *Eucharistic Still Life* (1952), and *The Crucifixion (Corpus Hypercubus)* (1954).

Dalí's desire to blend these mystical images with "science" as he understood it had other origins, however. Like many intellectuals in Europe and the United States, Dalí was deeply affected by the unfathomable destruction wrought by the atom bomb on the city of Hiroshima on August 6, 1945. The idea that a single bomb could cause nearly a quarter of a million casualties while leveling major parts of a modern city seemed to raise the folly of humankind's tendency toward self-immolation to an entirely new level. But it is easy to overlook the sense of genuine relief that the nuclear attacks on Hiroshima and Nagasaki brought to the Allies, and particularly the American population. Early estimates suggested that an invasion of the Japanese mainland would have cost anywhere between half a million and a million American casualties, far more than those suffered on the battlefields of Europe. Though this is perhaps difficult to imagine, given our deep aversion toward nuclear weapons today, in 1945 the atom bomb was also the subject of awe and pride, and not incidentally a symbol of complete American military hegemony. It is in this context that we should judge Dalí's fascination with atomic weapons. Dalí was enamored, not with weapons of mass destruction, but with the idea that atomic power could suspend the principles of physics and allow matter to arrange itself according to an entirely new set of laws. This idea was captured in his 1947 painting *Three Sphinxes of Bikini,* in which the horrific image of a nuclear mushroom cloud is incorporated into various objects in a deceptively pastoral park-like setting. The Bikini Atoll was

the site of several American nuclear tests in the 1940s. Atomic explosions, he wrote, evoke "idyllic, mossy, and mushroomy trees of terrestrial paradise, after all the hells of the heaven of the war just ended."[102]

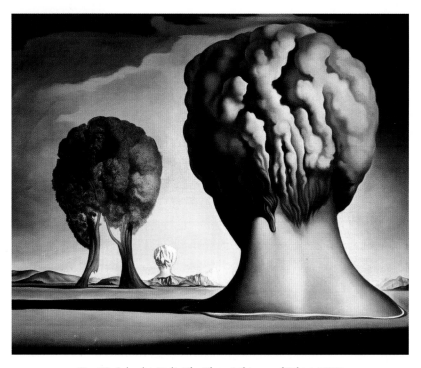

Fig. 70. Salvador Dalí, *The Three Sphinxes of Bikini*, 1947

The theme of atomic dissolution and rearrangement also produced one of Dalí's greatest and most memorable works of the late 1940s, *Leda Atomica*. The original story is taken from Ovid's *Metamorphoses*. The Roman author tells us how the Greek god Zeus fell in love with the beautiful Leda, wife of King Tyndareus of Sparta. Zeus proceeded to seduce her in the guise of a swan. As a result of this encounter as well as marital congress with her spouse, Leda conceived and bore two sets of twins, each

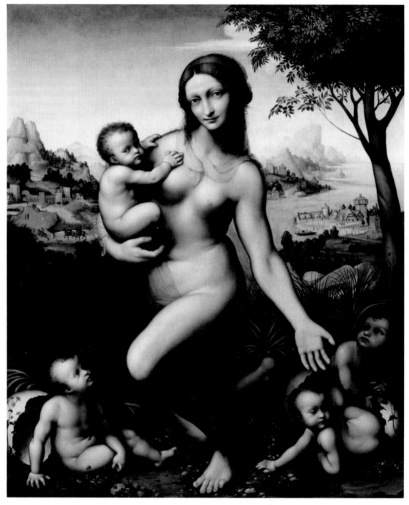

Fig. 71. Giampietrino, *Leda and the Swan*, c. 1506–1510

delivered in an eggshell: Helen and Polydeuces, children of Zeus, and Castor and Clytemnestra, children of Tyndareus.

It was obviously a very risqué subject that was difficult to reconcile with Dalí's new commitment to Catholic mysticism, but it did produce a quintessentially Dalínian work of great power

Fig. 72. Raphael, *Study for Leda and the Swan after Leonardo*, c. 1504

and virtuosity. Indeed, Dalí could point to a long tradition in Renaissance art that had likewise probed the motif, including such venerable artists as Leonardo da Vinci, Correggio, and Michelangelo. Perhaps the reason for the appeal of this motif is that it allowed artists to depict the passion of human intercourse

with the swan as a proxy—an idea that naturally appealed to Dalí's own continuous exploration of the human sexual response.

Of all these artists' interpretations, Leonardo's would have the greatest influence on Dalí's development of the theme. In the original iteration, dating from the early 1500s, Leonardo depicted Leda as a nude woman kneeling beside her infant children.

This "kneeling Leda" concept was further developed in several drawings, including one from the Devonshire Collection in Chatsworth, which also introduced Leda's suitor, Zeus, in the form of a swan. In one version, the long-necked swan kisses Leda tenderly on her neck. The "kneeling Leda" type was then developed into a painting by one of Leonardo's closest collaborators, the artist known as Giampietrino, possibly painted between 1506 and 1507.

The problem with this treatment was that it did not capture the erotic tension between Leda and her would-be suitor, Zeus, in the guise of a swan. This was corrected in Leonardo's final—and most satisfactory—solution. Leda does not kneel but stands upright, in classic contrapposto pose, with the libidinous swan rubbing against her thigh. While her torso is turned toward her suitor, her voluptuous thighs are facing the beholder, and her gaze is facing the other way, toward the four infants scrambling out of their broken eggshells. This "standing version" probably dates from 1504, when Raphael briefly joined Leonardo's studio, for we have a drawing by the young artist that closely follows this composition.

For many years now, there has been a lively debate whether Leonardo actually executed a painting based on this composition or whether it was left to his studio associates to translate the drawing (or perhaps a more finished cartoon) into a panel. The fact that many copies by Leonardo's pupils have survived would

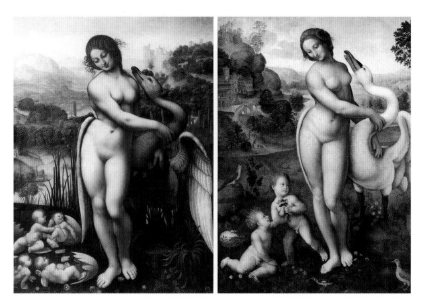

Figs. 73–74. Two versions of *Leda and the Swan* after Leonardo:
Cesare da Sesto (left), 1508–1510, and Il Sodoma (right), 1510–1515

argue that there was indeed a painted Leonardo original, but this also answers the question of how Dalí could have seen Leonardo's treatment. In fact, no fewer than five Leonardeschi painted copies of the *Leda*, all produced after 1510, would ultimately be distributed throughout Europe. This includes versions by Il Sodoma (1510–1515, now in the Galleria Borghese); Francesco Melzi (1515, Uffizi Museum, Florence); Cesare da Sesto (1515–1520, Wilton House, England), Giampietrino (C. Gibbs Collection, London); and at least one other version, now in the Philadelphia Museum of Art, attributed by some to Fernando Yanez de la Almedina. In addition, five other versions of this work have been documented, though their authorship is in question.

In Dalí's version, the model for Leda is, of course, Gala. She is seated, Madonna-like, on a pedestal, though fully nude

as Leonardo's precedent dictates. The swan hovers just behind her and seems to bend forward to kiss Leda on the neck, as in Leonardo's first treatment of the subject. Unlike in the Renaissance formula, however, the scene is set not in a pastoral landscape but in Dalí's favorite location, a beach framed by the rocky formations of Cap Norfeu, at the southeast end of the Cap de Creus peninsula. The other distinguishing feature is that not only the two principal characters but also a square, a book, and two stepping-stones seem to hover as if suspended in gravity. This mysterious levitation reflects Dalí's view that the atomic age had upended the earth's natural harmony. The painting, he wrote, reveals a "libidinous emotion, suspended and as though hanging in midair, in accordance with the modern 'nothing touches' theory of intra-atomic physics."[103]

Paradoxically, the suggestion of weightlessness gives the painting a unique sense of gravitas, the sense that something important is happening. This is also imparted by the scrupulous attention that Dalí devoted to the triangular composition, which reveals the artist's growing interest in geometry as the framework for his creative conceptions. It was an interest shared by Leonardo, who was firmly convinced, like Luca Pacioli and ancient authors such as Plato before him, that nature corresponds to a fundamental set of laws. Indeed, they believed that these laws appear in their most perfect, their most *ideal* form in a human being.

This idea is what inspired Leonardo to draw his famous *Vitruvian Man*. It also prompted Leonardo to collaborate with Luca Pacioli, a noted mathematician, on the latter's book *De Divina Proportione* (Divine Proportions), a work about sacred geometry, for which Leonardo provided the illustrations. Dalí was likewise convinced that nature is governed by perfect proportions, and drew his inspiration from the work of a Romanian

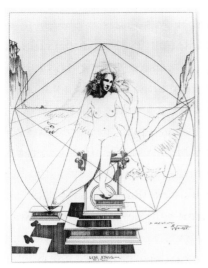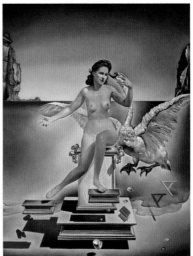

Figs. 75–76. Salvador Dalí, *Study for Leda Atomica* (left), and
the finished painting, *Leda Atomica* (right), 1947–1949

mathematician named Matila Ghyka, who was likewise influenced
by Pacioli. As several preparatory drawings show, for example,
*Leda Atomica* is based on a perfectly balanced pentagon. For
Dalí, these geometric laws "proved" the importance of a new
discipline called quantum physics, though it is debatable whether
Dalí fully grasped the ramifications of this theory. "I decided to
turn my attention to the pictorial solution of quantum theory,"
he told André Parinaud, "and invented quantum realism in order
to master gravity." That is how he painted *Leda Atomica*: as a
"celebration of Gala, the goddess of my metaphysics."[104]

The same idea of upstaging the laws of gravity inspired Dalí to
develop his famous photograph with Philippe Halsman in 1948,
based on a composite of many different exposures. In the mean-
time, however, Dalí's reputation in European art circles continued
to deteriorate, particularly after his lecture at the María Guerrero

Theater in Madrid on November 11, 1951. Entitled "Picasso and I," the presentation was intended as an homage to the genius of the Spanish artistic tradition but rapidly devolved into a political manifesto. Though Dalí declared Picasso's "genius" as his own equal, he also denounced the other artist as a Communist—a detractor of the Franco regime. By contrast, Dalí extolled the "spirituality of Spain today" and argued that "here we believe in the total and Catholic liberty of the human soul." The fact Franco had been responsible for the murder of between two hundred thousand and four hundred thousand Republican opponents only a decade earlier, during the so-called White Terror, seemed to have escaped him.

Nor did Dalí's claim of the "Spanish liberty of the human soul" include any mention of the quarter of a million men and women who at that moment were still languishing in Spanish prisons because of their political views, particularly after Franco's promulgation of the "Decree-Law on the Repression of Crimes of Terrorism and Banditry" in 1947. Many of these were refugees who had returned to Spain after World War II, in the false belief that their past involvement with the Republican cause had either been forgiven or forgotten. Scores were still in prison at the fall of the Franco regime in 1975, and it took a special law, known as the 1977 Amnesty Law, to set all remaining political prisoners free.

What inspired Dalí to so overtly endorse the quasi-fascist Franco regime? Was he simply naïve, as some have claimed, or was he trying to ingratiate himself with el Caudillo personally— and by extension, with the regime's strong supporter, the Spanish Catholic Church? As we saw earlier, Dalí's political views were always difficult to pin down, as they seemed to move with the ebb and flow of his own Dalínian-centrist ideology. The problem was, Dalí *needed* Spain. He needed Port Lligat and the view of the Cap

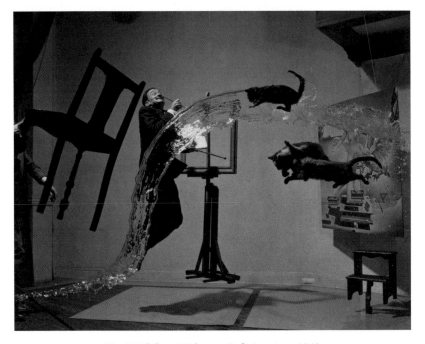

Fig. 77. Philippe Halsman, *Dalí Atomicus*, 1948

de Creus, just as Cézanne needed the Montagne Sainte-Victoire. He could not function as an artist without being surrounded by the Catalan world that had nurtured and inspired him. Unlike Picasso, who was perfectly content to toil away in his Paris studio, even under German occupation, Dalí was the quintessential Spaniard who thrived on Spanish culture, language, and cuisine. The only place where that could be obtained was Spain itself. Ergo, back to Spain he went.

In return, Franco was glad to have Dalí, or more specifically, Dalí's Madrid speech, because Spain was coming under attack in the early 1950s for its repugnant human rights record. He therefore ordered the pliant Spanish press to give extensive coverage to Dalí's lecture and to exploit it to maximum effect for propaganda

purposes. Sadly, this only served to deepen Dalí's alienation from Europe's cultural mainstream.

Dalí himself was well aware of these changing winds of favor. "I needed ten years to win the Surrealist battle," he declared in a curious document known as "The Current Situation of Dalínian Painting." "Now I need a year to win my classical, realist, and mystical battle. Against me are ranged all the extreme left-wing intellectuals, of course." But, he added, "With me are the intuitive public, the new current of the epoch, the leading intelligences."

This was a very clever turn of phrase, because what Dalí claimed was not wrong. The public at large was increasingly alienated from the resurgence of abstract art, both in Europe and the United States. Art was in danger of becoming the exclusive preserve of an elite once more—of people who had the ability to decode an artist's intentions—just as it had been in the eighteenth century. This explains that, notwithstanding Dalí's bad press in academia and artist circles, the artist remained popular among the public on both sides of the Atlantic. Dalí was increasingly seen as the maverick of the contemporary art world, the wild, slightly mad genius who goes against the grain of modern art—a reputation that Dalí eagerly cultivated and abetted.

In declaring his intent to wage a "classical, realist, and mystical battle," Dalí had effectively summarized a stylistic approach that would govern much of his postwar oeuvre. As it happened, the infatuation with "atomic principles" or "nuclear mysticism" was relatively brief, and the language returns only sporadically in the artist's writings after 1955. But that is certainly not true of his newfound fascination with religious mysticism, which would begin to dominate his work with ever greater force. At the same time, the search for religious themes moved him into closer contact than ever before with the Old Masters of the Renaissance and Baroque.

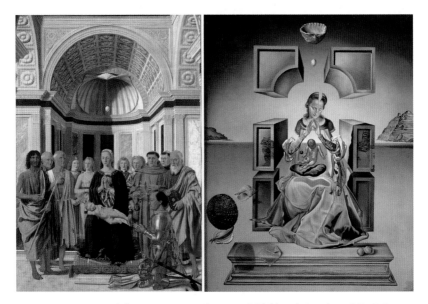

Figs. 78–79. Piero della Francesca, *Madonna and Child with Angels and Six Saints* (left), 1474, and Salvador Dalí, *The Madonna of Port Lligat* (right), 1949

The first major work of the mystical period is *The Madonna of Port Lligat*. Its pedigree is the motif of the Madonna Enthroned that had been a fixture in Italian art since the Byzantine period and was further developed by Duccio, Giotto, Piero della Francesca, and the Bellini brothers. Gala served as the model for Mary, now shown as a demure woman with folded hands and downcast eyes, and depicted with delicacy reminiscent of Raphael. The composition is derived from a work by Piero della Francesca, known as the *Madonna and Child with Angels and Six Saints*. This type of group portrait is known as a sacra conversazione in the art history literature, suggesting that the Madonna is engaged in prayerful conversation and reflection with certain saints that were of particular relevance to the donor or church who commissioned the work. In accordance with the usual treatment of this

motif, Mary and her Child are seated in the apse of a Renaissance church, which framed the scene with a contemporary setting, at least for its audience. In Dalí's treatment, however, the apse is compressed into an alcove, which is broken up in free-floating pieces according to Dalí's sense of "nuclear mysticism"—the idea that matter is made of atoms that do not touch each other. All other elements in the painting are suspended as well, undisturbed by the laws of gravity, as we saw previously with *Leda Atomica*. Mary's body is pierced, like a Magritte figure, to allow us a view of her womb with the infant Christ holding a crucifix. In addition, she is surrounded by such familiar Dalínian motifs as seashells, an egg, lemons, and fish. The location is once again the Bay of Cadaqués.

Dalí was very pleased with this work and even submitted a smaller version to Pope Pius XII for his review. Etherington-Smith claims that the real reason for Dalí's requesting an audience with the pope was that he wanted to marry Gala in a Catholic ceremony. The death, three years previously, of Gala's former husband Paul Éluard had removed the last obstacle to a Catholic wedding, though of course it was well known that Dalí and Gala had already lived as husband and wife for many years. In any case, Dalí was successful on both counts. He obtained a papal license to marry Gala in a church ceremony and received the pope's approbation of *The Madonna of Port Lligat*.[105] The wedding took place in 1958 in Girona, with only a few guests present.

*The Madonna of Port Lligat* introduced a new approach to space in Dalí's art, just as the illusion of space in early Renaissance art had been transformed by the discovery of linear perspective. During the subsequent High Renaissance, the concept of spatial realism had undergone another transformation: the idea of suggesting form and depth through the manipulation of light,

shadow, and atmosphere. Now, Dalí believed he had found another way to suggest optical depth: by dissolving the bonds of gravity that tethered objects to their earthly domain. The purpose of nuclear mysticism was exactly that: to create the illusion of metaphysical beauty and grace in the service of a spiritual idea, a sacred motif. In this he once again found inspiration in the work of the Baroque, which was the first to explore the dissolution of boundaries between actual and simulated reality, or between the painting and the architectural frame that surrounds it. Known as trompe l'oeil ("deceive the eye"), it was often used in church frescoes on the ceiling or dome to afford the faithful a precious glimpse of heaven.

Fig. 80. John of the Cross, *Christ Crucified Seen from Above*, c. 1550

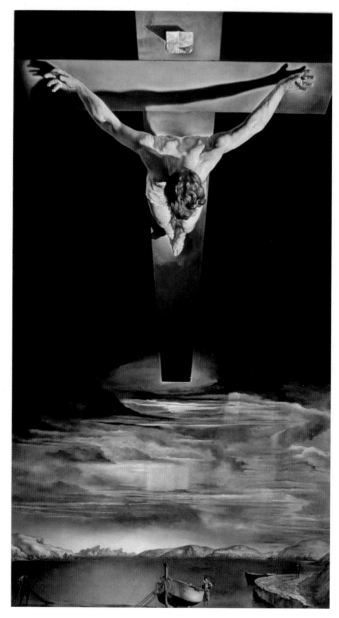

Fig. 81. Salvador Dalí, *The Christ*, 1951

Perhaps the most important work to emerge from this period is *The Christ*, also known as *Christ of Saint John of the Cross*, painted in 1951. The title refers to a drawing of the crucified Christ by a Spanish mystic, John of the Cross, which one day had been shown to Dalí by a French Carmelite monk named Bruno de Jésus-Marie. Dalí was already familiar with the mystic's work, and his writings may have exerted considerable influence in Dalí's pivot from the paranoiac-critical process to nuclear mysticism—as he termed it, his change from a "profane" self to a rebirth as a Christ-like "sacred self."

Particularly since John of the Cross was an accomplished draftsman and painter himself, Dalí may have strongly identified with him.[106] While the subject of the crucified Christ is eminently familiar from countless depictions throughout Christian history, the vantage point is not: Dalí places us far above the cross, looking down, thus obscuring the face of Christ. What's more, this unusual perspective appears to clash with the now ubiquitous view of the Bay of Port Lligat, with a fisherman standing idly by a boat. That part of the painting is seen at eye level, in frontal view. The fisherman is inspired by the standing figure in *Peasants in Front of Their House* (1642) by the French Baroque painter Louis Le Nain.

Dalí defended this unorthodox take on Christianity's most hallowed motif by arguing that he had received this image in a dream. "I had a 'cosmic dream,'" he wrote, "in which I saw this image in color and which in my dream represented the 'nucleus of the atom.' This nucleus later took on a metaphysical sense; I considered it 'the very unity of the universe,' the Christ!" The composition is, like that of *Leda Atomica*, determined by the "sacred geometry" of the triangle and the circle, which Matila Ghyka had identified as among the most canonical forms in nature.[107] According to Gill Davies, Dalí engaged a Hollywood

stuntman, Russell Saunders, and hung him from the ceiling so he could observe exactly how the body of a man would appear from this unusual angle.[108]

Nonetheless, to Dalí's surprise the painting was initially not well received. Christian authors questioned how this painting could elicit any devotion when the face of Christ, or any of the usual attributes of his Passion, such as the nails, were not visible. When the director of Glasgow Museums, Tom Honeyman, purchased the painting, a petition was filed by the students of the Glasgow School of Art to protest the acquisition. Nine years after it went on view at the Kelvingrove Art Gallery in 1952, a visitor attacked the work and caused considerable damage. Forty-five years later, however, public attitudes toward the painting had changed. A 2006 poll asking the public to name Scotland's favorite painting resulted in a win for *The Christ*.

The reason is not difficult to understand. It is one of Dalí's most memorable works, with the arresting image of the floating Christ set against a dramatic sunset at Cap de Creus. The unusual perspective, and the sharp detail so reminiscent of Velázquez's own version of the crucifixion, was bound to have a favorable response in an age besotted with cinematic illusion and optical effects. At the same time, *The Christ* marks Dalí's decisive return to the vernacular of the art of Velázquez, Murillo, and Zurbarán.

In the Renaissance, depictions of the crucifixion invariably involved a large group of characters, including Mary, Mary Magdalene, and John. Velázquez stripped the motif down to the very essentials of the moment: a man in his prime, stripped naked and nailed to the cross, on the threshold of the death that will redeem mankind. The painting establishes a deep intimacy between Christ and the beholder, further enhanced by the dark background that focuses all attention on the dying heartbeat of

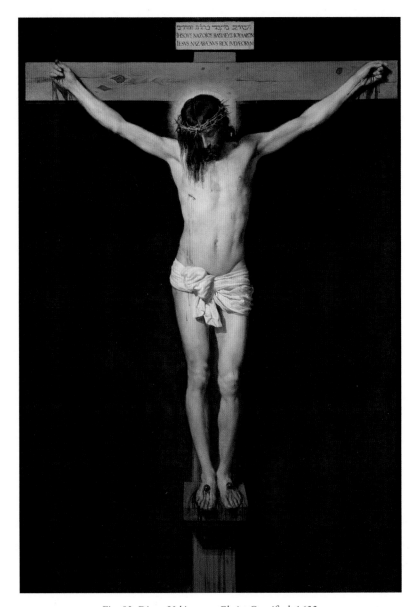

Fig. 82. Diego Velázquez, *Christ Crucified*, 1632

the man on the cross—thus fulfilling one of the principal icono-graphical objectives of the Counter-Reformation.

Spanish artists had always sought this intimate connection, particularly in the uniquely Spanish tradition of polychrome sculpture, but Velázquez translated that idea into painting as no Baroque artist had yet done. According to Dalí, his parents had a reproduction of Velázquez's painting in their bedroom, so he was familiar with this work from an early age. As the artist wrote in *Unspeakable Confessions:* "In my parents' bed-room . . . there was a majestic picture of Salvador, my dead brother, next to a reproduction of Christ crucified as painted by Velázquez; and this image of the cadaver of the Savior whom Salvador had without question gone to in his angelic ascension conditioned me."[109]

*The Christ* led to a series of similar variations on the cru-cifixion theme, with or without nuclear dissolution, such as the *Arithmosophic Cross* and the *Nuclear Cross,* both of 1952, and the *Assumpta Corpuscularia Lapislazulina,* painted that same year, which includes a citation of *The Christ* in the diaphanous view of the Virgin. This depiction of Mary as a tall, elongated figure appears to be influenced by Murillo's 1665 depiction of the *Immaculate Conception of Mary,* which Dalí had probably seen in the Prado in Madrid.

Another famous painting in this series is the *Corpus Hypercubus* of 1954, in which Gala, wrapped in elaborate drap-ery of white and gold, contemplates the crucified Christ floating in front of a cubic cross. This particular depiction of the cross as a tesseract, a hypercube with eight cubical cells, was report-edly inspired by a work entitled *Discurso sobre la figura cúbica* (Discussion of the Cubic form) by the sixteenth-century Spanish mathematician and architect Juan de Herrera. The drawing

below shows Dalí's thinking process as he experimented with the juxtaposition of Christ and the hypercube.

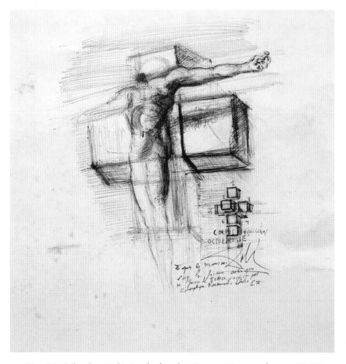

Fig. 83. Salvador Dalí, *Study for the Corpus Hypercubus*, c. 1954

Some authors have seen this work as Dalí's attempt to create an analogy between the unfathomable nature of Christ as the Son of God and a cubic construct of four dimensions that is likewise well beyond human comprehension. This particular idea—that a cube can have a fourth dimension in the metaphysical domain, as Ghyka had argued in his book *Esthétiques des proportions dans la nature et dans les arts*—seemed the perfect synthesis between science and mysticism, the very essence of sacred geometry. The human element in painting is portrayed by Gala in the guise of Mary Magdalene, who according to the Gospel of Mark was the

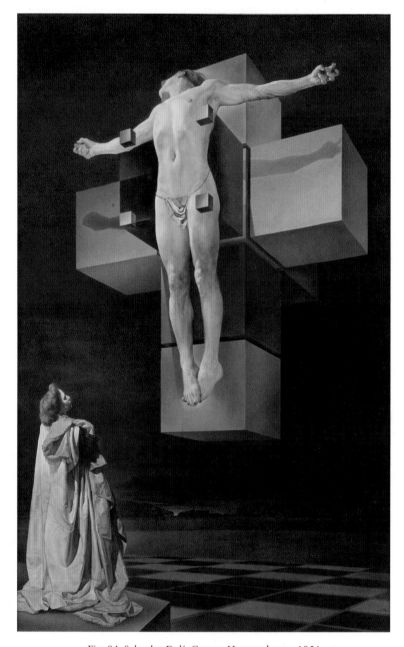

Fig. 84. Salvador Dalí, *Corpus Hypercubus*, c. 1954

first to discover the empty tomb after the Resurrection. As such, Dalí wrote, she is the "perfect union of the development of the hypercubic octahedron on the human level of the cube."

*Corpus Hypercubus* enjoyed a more favorable reception than *The Christ* three years earlier. After it was acquired by the Metropolitan Museum of Art in New York and put on exhibit, the noted American novelist Ayn Rand saw it and wound up spending many hours in front of the painting. According to a biographer, Jeff Britting, Rand saw a link between Dalí's portrayal of Christ and the defiance of her character John Galt in her novel *Atlas Shrugged*.[110] In a BBC television special, art historian Fiona Macdonald called it "arguably the greatest expression of [Dalí's] scientific curiosity."[111]

**In 1950, Dalí** made the acquaintance of a young French filmmaker, author, and photographer named Robert Descharnes. Descharnes had had some articles printed in art periodicals such as *Art News* and *Réalités*, and the two men hit it off. Descharnes spent some time in Port Lligat in 1952 and two years later collaborated with Dalí on an experimental film entitled *L'Aventure prodigieuse de la dentellière et du rhinocéros* (*The prodigious adventure of the lacemaker and the rhinoceros*). As the title reveals, the film revolved around Dalí's continuing preoccupation with Vermeer's *The Lacemaker*, as well as his curious obsession with rhinoceros horns, not only for their "logarithmic curves" but also for their obvious phallic connotation.

In a 1955 lecture at the Sorbonne in Paris, Dalí proceeded to expound on this strange connection, while referring to other symbolic totems such as sunflowers—a favorite theme of Van Gogh's—and cauliflowers. At the end of the lecture, Dalí said that

Fig. 85. Dalí and Gala bathing with a photograph of Vermeer's The *Lacemaker*, 1959

"After my remarks this evening, I think that in order to be able to proceed from the *Lacemaker* to the sunflower, from the sunflower to the rhinoceros, and from the rhinoceros to the cauliflower, one must really have something inside one's skull."[112]

As it happened, *L'Aventure prodigieuse* was never released, but by then Descharnes had become a firm fixture in Dalí's inner circle. In 1981 he became Dalí's personal secretary, and eventually he became the foremost authority on Dalí's oeuvre. After the artist's death, Descharnes served as the ultimate arbiter in authenticating works by Dalí and rejecting an ever-growing number of fakes and forgeries. When Descharnes died in 2014 at

Fig. 86. Robert Descharnes and Dalí in an undated photograph

age eighty-eight, his son Nicolas followed in his footsteps and is considered today a leading authority on Dalí's work.

The interest in *The Lacemaker* and rhinoceros horns remained. In 1955, Dalí executed a painstaking copy of Vermeer's work, which, as he declared in his Sorbonne speech, "attains the highest degree of biological dynamism thanks to the rhinoceros horns of which the painting consists."[113] One would be hard-pressed to distinguish anything resembling a horn in Vermeer's work, though it seems that Dalí was particularly intrigued by the curves of the lacemaker's fingers as they deftly weave the needle in and out of the fabric of the lace. It even inspired him, in the midst of his nuclear-mystical preoccupation with the sacred, to produce a highly charged erotic work that harked back to the overt autoeroticism of his early paranoiac-critical period: *Young Virgin Auto-Sodomized by Her Own Chastity*. In the painting, a young nude woman leans suggestively over the railing of a balcony overlooking a sea view. Her buttocks are actually

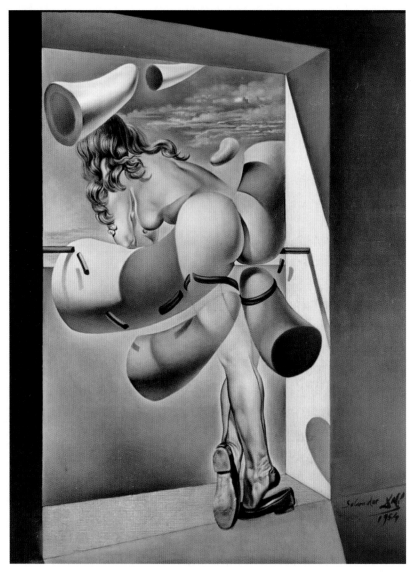

Fig. 87. Salvador Dalí, *Young Virgin Auto-Sodomized by Her Own Chastity*, 1954

composed of two horns, while their junction is probed by two smaller horns that appear ready to penetrate the girl's anus. The "atomic" treatment, however, guarantees that the elements never touch, never actually arrive at any form of physical congress. This is why Dalí felt that "Paradoxically, this painting, which has an erotic appearance, is the most chaste of all." The nuclearity, he argued, guarantees the girl's chastity.

Interestingly, this is one of the few paintings of this period for which Gala did not serve as the nude model. According to Descharnes, Dalí used an image from a 1930s soft-porn magazine instead.[114] Some authors have compared the painting to Dalí's 1925 work *Figure at a Window*, which was a portrait of his sister, Ana María. As it happened, when Dalí painted *Young Virgin*, his sister had just published an unflattering portrait of Dalí, entitled *Dalí: Scenes from Infancy to Adolescence*; therefore, these authors argue, the painting could be interpreted as a riposte.[115] The painting hung in the Playboy Mansion in Los Angeles for many years until it was auctioned at Sotheby's in 2003 for 1.3 million pounds sterling.

The idea that the "nuclear" treatment of objects could create the diaphanous transparency necessary to elicit a devotional response, which previously produced the *Assumpta Corpuscularia Lapislazulina*, found its way into other expressions as well, such as the *Madonna in Particles* of 1952, the *Galatea of the Spheres* in 1952, and *Portrait of Gala with Rhinocerotic Symptoms* of 1954. It also led to a newly imagined nuclear projection of Dalí's early masterpiece, now entitled *The Disintegration of the Persistence of Memory* (1954). In this version, the dark beach-like foreground has been flooded with water and disintegrating brick-like elements that express Dalí's idea of quantum physics. The trademark melting clocks are still present, though they too

have become subject to the "de-nuclearization" process, with the hands floating above the timepieces. Another memorable work from 1954 is a portrait of the nude Dalí himself as he kneels to contemplate an atomic constellation of spheres containing many different elements. As we mentioned before, the atomic deconstruction process was also applied to Dalí's favorite work by Vermeer, *The Lacemaker* of 1670. He first executed a painstakingly accurate copy of Vermeer's original, before painting a second version using the paranoiac-critical process to disaggregate the work into key components, including rhinoceros horns.

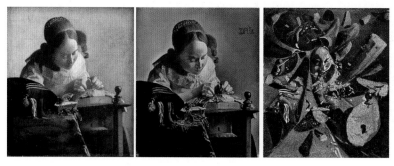

Figs. 88–90. Vermeer's *The Lacemaker* (left), 1670, Dalí's copy (center), 1954–1955, and Dalí's *The Paranoiac-Critical Study of Vermeer's Lacemaker* (right), 1955

In the foregoing we have largely focused on the influence of the Spanish Baroque in the "nuclear-mystic" phase of Dalí's art. But the memory of Leonardo da Vinci lingered as well, though perhaps in more subtle ways. As David Lomas has argued in a monograph, Leonardo's work "afforded an inexhaustible resource from which Dalí drew in distinct ways at various moments throughout his career, but most intensively when he embarked on a neotraditional return to painting."[116] Among others, Lomas cited the example of Dalí sketching a subject, such as a human face, from multiple perspectives, as Leonardo did with his studies

for *The Lady with an Ermine.*[117] We previously saw the influence of Leonardo's sketches for *Leda and the Swan* on Dalí's painting of *Leda Atomica.* But the greatest example of the Leonardesque in Dalí's work is unquestionably his ambitious effort to reimagine the theme of the Last Supper, inspired by Leonardo's legendary 1499 fresco in the refectory of the convent of Santa Maria delle Grazie in Milan.

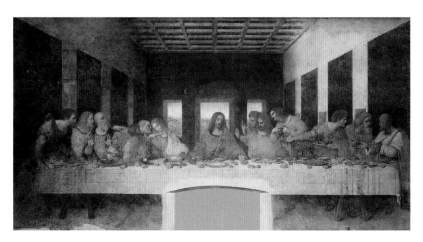

Fig. 91. Leonardo da Vinci, *The Last Supper,* 1495–1499

As we described in our book *The da Vinci Legacy,* Leonardo broke with the traditional Italian iconography of this sacred event in several ways. Traditionally, depictions of the Last Supper show the moment when Christ breaks bread, thus instituting the sacrament of the Eucharist (Mark 14:23–24). This marks the moment when, according to Catholic doctrine, the substance of bread and wine is transformed into the body and blood of Christ. Over the centuries, a strict iconography had developed around this sacred event that was consistently maintained through many centuries of Byzantine, medieval, and early Renaissance art. Leonardo, however, recognized a key problem with this convention: it

gives the Apostles very little to do. This is why in the versions by Ghirlandaio, Castagno, and other Quattrocento artists, the Apostles are essentially passive actors, inevitably cast in various poses of contemplation. This militated against Leonardo's desire to capture the "motions of the mind" of his characters.

In response, Leonardo developed a very different approach to the Last Supper theme, by showing the moment when Jesus declares that one of the Apostles will betray him (John 13:21–27). This gave him the opportunity to capture the disciples in a great variety of poses as they each respond to this shocking announcement. The radically different treatment of the subject, and its highly realistic execution with monumental, larger-than-life figures, ensured that Leonardo's *Last Supper* would become an iconic work with lasting influence on the development of Western art.

According to an article in *The New Yorker* of 1958, the idea for Dalí to create a modern version of the Last Supper scene came about after the arts patron Chester Dale acquired Dalí's *Crucifixion* for the Metropolitan Museum of Art. Dale then asked Dalí if he would execute one more monumental religious painting: one that would match the best work of the Renaissance masters. "After the *Crucifixion* I told him he had to do one more religious picture—'The Sacrament of the Last Supper,'" Dale remembered. "He didn't do anything else for a whole year."

That Dalí was aware of Leonardo's *Last Supper* is attested by an early study, dated between 1954 and 1955 and now in a private collection. Christ is depicted at the center of a long table, with his Apostles arranged on either side of him, as in Leonardo's original composition. The scene is set in a highly compressed space, as in the Leonardo precedent, while a large window framing the Christ figure gives access to a vista beyond. Jesus meanwhile seems to reach to what appears to be a loaf of

bread, which may signal either the beginning of the Eucharist or the announcement of his betrayal.

When in the Gospel of John, the "beloved disciple" asks Jesus to identify the traitor, Jesus responds: "It is the one to whom I give this piece of bread when I have dipped it in the dish." The sketches at the bottom of this study reveal Dalí's mind at work as he looked for variations on the scene, including a "nuclear" treatment of exploding elements. At the same time, the drawing shows Dalí's preoccupation with geometric ideas, particularly the concept of the "golden section," or "golden rule" documented by Luca Pacioli in his book *De Divina Proportione*.

First coined by the Greek mathematician Pythagoras (570– 495 BCE), the "golden rule" refers to the most perfect geometric figure in nature as a rectangle defined by $\varphi$ or *phi*, with a length-to-width ratio of 1:1.618 that can be replicated ad infinitum in a series of the exact same proportion. The thirteenth-century mathematician Leonardo Fibonacci developed this theorem into the so-called Fibonacci series, whereby each number is the sum of the previous two (for example: 1, 1, 2, 3, 5, 8, 13, 21, 34, etc.).[118] Pacioli, a Franciscan friar, called *phi* a "divine proportion," since it appeared to be a fundamental rule used by God in the Creation. It also inspired Leonardo to create the famous drawing of *Man's Proportions*, better known as *Vitruvian Man*.

That Dalí was familiar with Pacioli's book is shown by his tongue-in-cheek advice to young American artists that they should keep Pacioli's book at their bedside (even though there was no English translation of *De Divina Proportione* available at the time). That gem of wisdom appears in Dalí's 1948 book, *50 Secrets of Magic Craftsmanship*, which also contains a number of citations from Pacioli's work. So it's unsurprising that the idea of using the divine proportion of the golden rule fascinated him. It

Fig. 92. Salvador Dalí, *Study for The Sacrament of the Last Supper*, 1954–1955

provided the perfect blend of faith and geometry, of God and science, which lay at the core of Dalí's concept of nuclear mysticism.

That idea is evident in the frontal, grid-like composition, which at first glance is a stark departure from the flowing transcendence of works such as *Assumpta Corpuscularia Lapislazulina*. In placing the group of thirteen figures around a large table with Christ as the central anchor, Dalí was certainly channeling Leonardo's solution, while the two figures in the foreground endow the composition with scale and depth. As David Lomas has argued, the composition of the Apostles, dressed in heavy cassocks with their heads bowed in prayer, is a series of pentagons, while the painting itself follows the dimensions of the golden rule. Where the two versions differ is that Dalí returned to the traditional idea of the Last Supper as the institution of the Eucharist, as conveyed by the

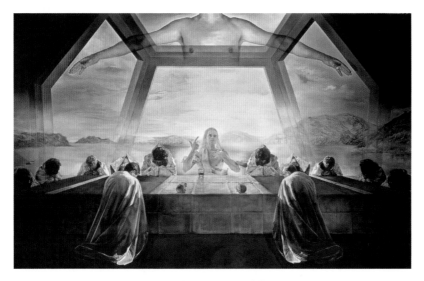

Fig. 93. Salvador Dalí, *The Sacrament of the Last Supper,* 1955

title, *The Sacrament of the Last Supper.* Consequently, the disciples have reverted to their traditional poses of prayer and reflection, so that everything is focused on Jesus. But like Leonardo's Christ, Dalí's Jesus is engaged in an elaborate pantomime of gestures that, we assume, carry an important theological meaning.

With his left hand, he points to himself, while with his right he points upward. The left hand underscores the idea that during the Eucharist, the substance of bread and wine is transubstantiated into Christ's body and blood. This explains the prominent placement of the glass of wine and the two pieces of bread. With his right hand, Jesus points to a heavenly torso floating above, signifying his coming resurrection and ascension into heaven. The nude torso, with its faint echo of Leonardo's *Vitruvian Man,* may also signify the *ekklesia,* the Church representing the body of Christ on earth. To further emphasize the transcendental nature of Christ and his coming resurrection as a divine being,

his figure is transparent against the ubiquitous backdrop of the Bay of Cadaqués as seen from Port Lligat.

Dalí himself described the work as follows: "The first holy Communion on earth is conceived as a sacred rite of the greatest happiness for humanity. This rite is expressed with plastic means and not with literary ones. My ambition was to incorporate to Zurbarán's mystical realism the experimental creativeness of modern painting in my desire to make it classic."[119]

To add to the geometric complexity of the work, the scene is set in a vast dodecahedron, a twelve-sided geometric model that, according to Plato, symbolized the universe. Leonardo once drew such a dodecahedron for Luca Pacioli's *De Divina Proportione*. One also appears in Jacopo de Barberi's 1495 portrait of Luca Pacioli as a model made of glass, suspended on a string. It has been suggested that Leonardo painted the dodecahedron in this painting, given the sheer complexity of its shape. In sum, *The Sacrament of the Last Supper* is perhaps the clearest example of Leonardo's influence on Dalí, even though strangely Dalí did not credit Leonardo in the citation, nor in any of his other comments on the picture.

Today, the work is among the most popular items in the National Gallery in Washington, DC, even though the large canvas now hangs in the hall near the stairwell on the lower level, rather than in one of the main galleries. A 2010 exhibit in Atlanta underscored the painting's popularity as one of Dalí's most famous works. Its catalog extolled the painting as the perfect synthesis of Dalí's interest in the "intersection of science and mathematics with the subconscious mind." Curator Elliott King added that Dalí's late work "reflects his conviction that science, and in particular nuclear physics, offered proof for the existence of God."[120]

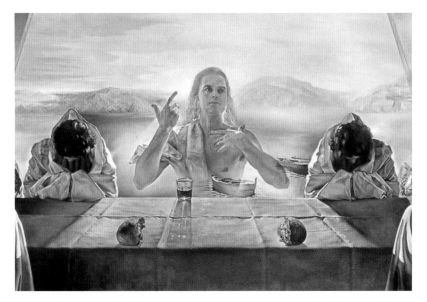

Fig. 94. Salvador Dalí, *The Sacrament of the Last Supper,* detail of Christ, 1955

# 7.

# THE MYSTIC UNIVERSE:
# 1955–1960

*My mysticism is not only religious, but also nuclear*
*and hallucinogenic.*

Salvador Dalí

**In June of** 1956, Dalí was granted an audience with Francisco Franco at the Palace of El Pardo in Madrid. As documented by William Jeffett, Dalí and Gala later reported their impressions of Franco to one of their American patrons, Albert Reynolds Morse. Both Dalí and Gala, said Morse, were impressed with Franco and with the Caudillo's keen interest in art. Dalí and Gala "said that Franco turned out to be very nice, very intelligent," he added, and "[t]hey presented him with a copy of the large hand-made color catalog of our collection, and said that Franco had promised to write and thank us for it."[121]

The meeting between Dalí and Franco sealed the long process by which the artist hoped to be fully accepted by the

Franco regime and its patron, the Spanish Catholic Church. Such a reconciliation was by no means assured, certainly not given Dalí's well-published prewar activity inside the Surrealist movement, whose pro-Communist sympathies and anti-Franco stance were well documented. During his American exile, however, Dalí must have come to the conclusion that his future lay in Spain, not only in terms of resuming his residency in Port Lligat but also in securing fertile ground for the new phase in his art, away from American and European art circles whose hostility toward figurative painting was growing. This may explain why in 1943, while still in American exile, Dalí agreed to paint a portrait of Franco's ambassador to the United States, Don Juan Cárdenas. Dalí chose to depict the envoy in front of the Escorial, the palace built by King Philip II and often compared to Louis XIV's Versailles Palace. The juxtaposition served to cement Franco's regime and his corps of diplomats as the legitimate successors of Spain's hallowed Golden Age.

Dalí's desire for rehabilitation was further buttressed by his 1951 speech in Madrid, which was widely reported by the Spanish press. Dalí's 1956 audience with Franco was therefore the culmination of a deliberate and sustained campaign. His goal was not so much to endorse the Franco regime as to secure for himself a home where he could pursue his interest in classicist mysticism without fear of being castigated by an unrestrained press corps of art critics, as would have been the case if he had returned to Paris after the war. In that sense, the repressive Franco regime with its extensive press censorship and close ties to the Spanish Catholic establishment suited Dalí perfectly. His patron Morse understood this. Writing in the journal *Art in America*, Morse said that Dalí "most certainly would have been persona non grata in Spain if he had continued as a prophet of rebellion,

emanating the discord that was apparent in his early works up to 1939." There was therefore, in Morse's acute analysis, a "definite parallel . . . between his own announced intention to 'become classical' and the actual facts of his subsequent development." Morse admitted that in doing so, "he has perhaps compromised some [of] his more forceful expressions as a younger man, but no one should deny him his home or his maturity."[122]

The visit with Franco serves as a convenient benchmark for the next phase in Dalí's career, for with the regime's full support the artist could now wholeheartedly dedicate himself to his ambition to reconcile the rapid advances in modern science with his reverence for Spanish Catholicism. Thus his fervor for religious motifs, kindled by *The Sacrament of the Last Supper*, produced another huge work framed by geometric motifs: *Saint James the Great*. The title is slightly misleading, for the Apostle in question is actually called St. James the Greater, son of Zebedee and Salome, to distinguish him from another James in Jesus' orbit, James the Lesser, the son of Alphaeus. The first James (or Santiago as he is called in Spanish) is a major religious figure in Spain and Portugal. He is often considered Spain's patron saint, based on a legend suggesting that he was buried in Santiago de Compostela, in the province of Galicia, after his execution on orders from King Herod Agrippa of Judea. According to one version of this legend, his decapitated body was lifted by angels into a boat, which then unerringly sailed to the Spanish coast without any sailor to guide it. After James's tomb was rediscovered by a hermit named Pelagius in the ninth century, Santiago de Compostela became one of the main pilgrimage destinations in Europe.

In Dalí's paean to this quintessential Spanish icon, the mounted saint is seen from a rather bizarre angle, beneath the rearing horse whose genitalia have been tactfully covered up

by an atomic explosion that carries the steed aloft. St. James brandishes a crucifix that shows the crucified Christ from the same steep foreshortening. An elaborate rib-vaulted dome hovers over the scene, based on a photo of the Church of the Jacobins in Toulouse, France, where one tradition also places the tomb of James.

Dalí historian Paul Chimera has argued that the unusual perspective was inspired by the fact that the painting was originally intended for display high on a church altar. To experience the same vantage point, he encouraged visitors to the Beaverbrook Art Gallery in New Brunswick, Canada, to lie flat on the floor—advice that is apparently often followed.

As usual, the location of this strange composition is the beach of the Bay of Cadaqués, with the ever-faithful Gala, dressed in a monk's robes, serving as silent witness in the foreground. Some thirteen feet high, the painting is one of the largest Dalí made, and a harbinger of similar huge vertical scenes to come.

Indeed, *Saint James the Great* was followed by an equally impressive work, *Christopher Columbus*. This painting had been commissioned by Huntington Hartford, a wealthy patron and heir to the A&P supermarket fortune, who was planning an art museum at Columbus Circle in New York. Its subject blends various American, Christian, and Catalan motifs, because a persistent claim at the time suggested that Columbus was really a Catalonian rather than an Italian. The result is a montage of various scenes, executed on the mammoth scale of fourteen feet by nine feet. In the center is a frontal view of a galleon that brings Columbus to the American shore, while directly at left a seminude youth—arguably an allegorical figure representing Columbus himself—plants a banner showing Gala as the Virgin Mary, thus claiming the land for Christendom.

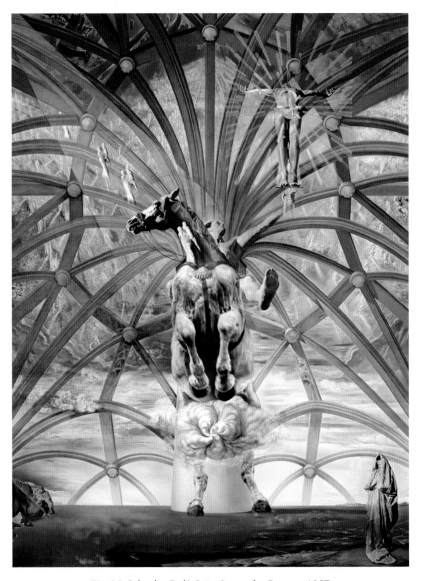

Fig. 95. Salvador Dalí, *Saint James the Great*, c. 1957

Bishops at the extreme left of the canvas bless this moment, while to the right, several nude and seminude youths carry a phalanx of banners, halberds, and crucifixes that echo the lances in Velázquez's major work, *The Surrender of Breda,* which marked an important triumph by Spain over the Dutch Provinces during the Eighty Years' War. Among the banners at right is a ghostly image of *The Christ.* Dalí has depicted himself in the foreground as the balding monk holding a crucifix to his forehead. While the influence of Velázquez is obvious, the execution of the work, with its photographic, backlit realism, reflects the continuing memory of Meissonier and other Pompiers.

A curious story sprang from Dalí's decision to place a rather unattractive sea urchin right in the foreground of this painting. Why should that ugly object be there? Dalí's patron and collector Morse asked the artist. Dalí, who could never tolerate anyone questioning his artistic instincts, was upset by the comment but then went out of his way to explain during the actual exhibition of the work that "the pear shape of the ringed urchin alluded to the earth as seen from the American spaceship Explorer, and symbolized nuclear science."

This was an allusion to *Explorer 1,* which was not a spacecraft but the first American satellite, launched in 1958.[123] Eleanor Morse, wife of the collector, would later argue that the sea urchin actually prophesied the moon landing of *Apollo 11,* which took place ten years later in 1969.

Particularly in the figure of young Christopher Columbus, Dalí deployed an almost photographic realism by casting the figure in backlight. That he was now increasingly relying on photography in the composition of his paintings was something the artist was never afraid to admit. "I have made use of photography throughout my life," he told the art critic André Parinaud during

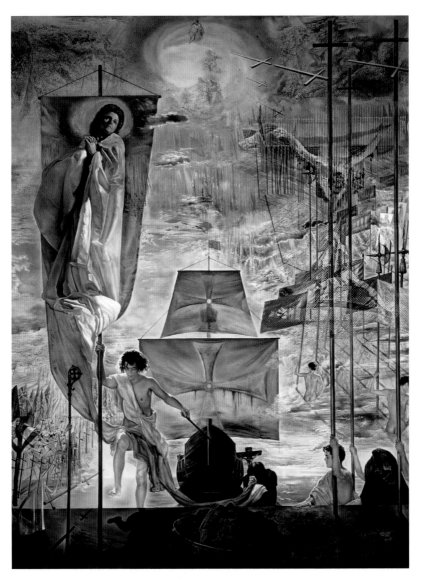

Fig. 96. Salvador Dalí, *Christopher Columbus*, 1958

a radio interview for ORTF's *Forum des Arts*. "I stated years ago that painting is merely photography done by hand, consisting of superfine images the sole significance of which resides in the fact that they were seen by a human eye and recorded by a human hand." Moreover, Dalí was "convinced that Vermeer used a mirror to view his subjects and make tracings of them."

In his interview with Alain Bosquet, Dalí went further and argued that "With photographs and new spatial techniques, I'll achieve a synthesis that we might actually call classic, and even absolutely classic. Images will remain photographic as always and from these images the moving points and lines come. The element of genius is obtaining a surface full of tiny points as in the era of pointillism, except that for the eye there will appear to be different variable distances and spatial locations between them."[124]

The choice of Christopher Columbus's arrival in America as the subject matter for an oversized painting was not unusual. Dalí had every reason to be grateful to America and for the bounty that wealthy American collectors had bestowed on him. He and Gala continued to shuttle between the artist's main studio in Port Lligat and romps in Paris and New York, where they were cosseted in their favorite suites at the Meurice and the St. Regis hotels. Here, Dalí would receive an unending string of fawning reporters, photographers, writers, and clients, while Gala made herself scarce in order to satisfy her sexual appetites with handsome young men. That Dalí was not outwardly upset by this behavior, which was widely hinted at in the tabloid press, underscores the curious and by now largely platonic love that he harbored for his principal muse and model.

*Christopher Columbus*, perhaps the most important painting of this period, is significant for another reason as well: it marks the end of the artist's fascination with "atomic" suspension and

disaggregation, in favor of what perhaps could best be called "magical realism." The term is usually applied to literature by Latin authors such as Jorge Luis Borges and Gabriel García Márquez, but it seems particularly apt in reference to Dalí's late work. *Realismo mágico* refers to a style of heightened realism with fully realized characters and settings, leavened with allegorical or supernatural motifs that give the work a mysterious or fantastic dimension.

Thus, while Columbus's ship and the characters that emerge from it are drawn in sharp, almost painfully photographic realism, the floating crucifixes and other otherworldly elements give the painting a mysterious and seemingly mythic quality that saves the work from being a mere historical depiction. Among them are a number of citations from Old Master art, such as the small pietà at the very top of the work, inspired by Michelangelo's marble *Pietà* of 1502. Another ambiguous feature is the figure of Gala on the banner at left, posing as the saint or muse who inspired Dalí's own "discovery" of America, in a composition that is once again reminiscent of Murillo's *Immaculate Conception* (1678). The association with this work is entirely appropriate because Columbus's principal ship was called *La Santa María de la Inmaculada Concepción*. But in Dalí's version, the top of Gala's figure appears to be a painted image on the banner, whereas the rich drapery that surrounds her breaks free from the fabric to become a three-dimensional object in itself.

The same mysterious and somewhat disconcerting atmosphere attends the enigmatic *St. Helena of Port Lligat* (1956), and *Virgin of Guadalupe* painted in 1958. The latter work refers to one of the most iconic paintings in Latin Catholicism and today is displayed in the Basilica of Our Lady of Guadalupe in Mexico City. Presenting the Virgin in a mandorla or aureole, it

commemorates the reported appearance by Mary to a local man named Juan Diego, who would become the first indigenous saint of the Americas. The mandorla represents the "white radiant cloud" in which the Virgin manifested itself to the young Mexican, who had only recently been converted to Catholicism.

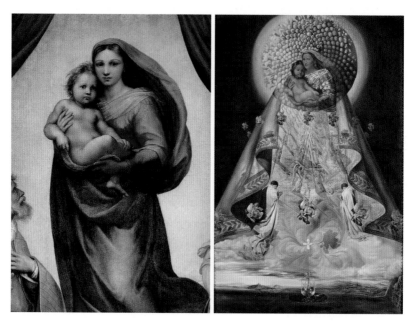

Figs. 97–98. Raphael, *The Sistine Madonna* (left), 1514, and Salvador Dalí, *Virgin of Guadalupe, Patron Saint of Mexico* (right), 1958

In Dalí's treatment, the Virgin is once again portrayed as Gala, but in a composition inspired by Raphael's *Sistine Madonna* of 1512. In this work, Mary's robe drapes itself around a group of angels and praying disciples apparently borrowed from *The Sacrament of the Last Supper*, who are in turn encircled by a series of roses. Their significance is explained by the fact that the Virgin, during one of her apparitions, told Juan Diego to collect roses to show to the bishop. When the boy did so, the roses

had turned into a beautiful image of the Virgin on Juan Diego's shirt—which inspired the icon now in Mexico City. Behind Mary and the Christ Child, by way of a halo, is the core of a favorite Dalínian motif: a huge sunflower, Fibonaccian symbol of the perfection of God's creation.

*The Sistine Madonna* by Raphael would serve as the inspiration for another Dalí painting, which also heralds another interest in Dalí's art: optical illusion. As we have seen, the magic of trompe l'oeil had fascinated the artist from an early age and exerted an even stronger appeal in the 1950s, beginning with *The Christ*. The desire to depict the crucified or the ascendant Christ from an unusual vantage point also inspired works such as the *Ascension* of 1958, also known as *Pieta*. But in the meantime, Dalí had become fascinated with new reproduction techniques that were then emerging from the publishing industry. One of these is the so-called benday dot printing process, named after the late-nineteenth-century printer Benjamin Day Jr. The technique essentially reduces a color image into an array of closely spaced and sometimes overlapping colored dots in four elementary colors—yellow, black, magenta, and cyan. When viewing these dots from a distance of a foot or more, the human eye and brain blend them in convincing shades and tones of flesh and texture.

The use of benday dots to create large canvases would become the signature style of Roy Lichtenstein in the 1960s, but Dalí beat him to it with *The Sistine Madonna* of 1958. Up close, the painting shows a highly rasterized version of Raphael's *Sistine Madonna* but when seen from a distance, the work actually reveals a giant ear, which Dalí called "the pope's ear."[125] With this painting, Dalí presaged the explosion of Pop Art in the decade to come—a fact that has forced many modern critics to take his work of the late 1950s more seriously.

Fig. 99. Salvador Dalí, *The Sistine Madonna*, 1958

Dalí also embraced another medium that defined the late 1950s, American network television. He appeared on a CBS morning show in 1956 and in 1958 sat for a long interview with CBS's *60 Minutes* anchor Mike Wallace, who at the time was hosting a series for ABC called *The Mike Wallace Interview*.

During this TV special, Dalí freely admitted that his eccentricity, his embrace of himself as an unparalleled genius, was part of a calculated act.

"Time and again you have called yourself a genius and you're very serious about this," Mike Wallace said. "Now you want to be evidently, you want to be a genius in two fields. First of all, you have called yourself a genius?"

"In many different fields, you know," Dalí replied.

"What else besides an artist?" Wallace asked.

"Most important in my life," Dalí responded in his tortured English, "modern clown, modern painting, modern draftsmanship, is my personality. . . . My personality is more important than any of those little facets of my activities." And he added, "The painting, the clowning, the showmanship, the technique—everything is only one manner for express the personality of Dalí."

The artist then went on to extol the art of Raphael. Just as Raphael epitomized the Renaissance, Dalí claimed, so too "does Dalí paint the atomic age and the Freudian age nuclear things and psychological things."

Were there *any* contemporary artists whom he admired? Wallace wondered.

"First Dalí," Dalí replied. "After Dalí, Picasso. After this, no others."[126]

The interview is particularly interesting because it shows—if any such proof were still necessary—that Dalí saw himself in line with, and indeed the culmination of, the Old Masters; and that, as one who remained true to the Renaissance tradition of figurative realism in the twentieth century, he had no parallel.

Dalí also cited Picasso, but of course Picasso was almost the diametrical opposite of Dalí: an artist who almost singlehandedly had

forged the path of twentieth-century modern art. And it is doubtful whether Picasso, who detested Dalí for his support of the Franco regime, would have been pleased with this particular assessment.

Mike Wallace was a skilled interviewer who in his long career had grilled a number of celebrities and statesmen, including the Persian Shah and his nemesis, Ruhollah Khomeini; the Palestinian Fatah leader Yasser Arafat and his counterpart, Israeli premier Menachem Begin; and a number of authors and artists, including Ayn Rand, Maria Callas, and Frank Lloyd Wright. As a result, Wallace was not as intimidated by outsize egos as many modern TV interviewers are. He didn't hesitate to ask Dalí some tough questions, including whether his newfound interest in religious motifs reflected a genuine conversion or simply another phase in his art.

Fig. 100. Mike Wallace and Salvador Dalí during the 1958 interview for ABC.
© American Broadcast Companies, Inc. All rights reserved.

"I spoke with you about a year ago and we talked about religion, and you said that as the years go by, you embrace Roman Catholicism more and more with your mind but not yet completely with your heart," Wallace alleged.

"This is true," Dalí replied.

"Why not?"

"Because," Dalí said, haltingly, "perhaps it is my early intellectual training and information. But now every day is more approach of this real feeling of religion. Just one month ago—is one tremendous operation of appendix—a broken appendix. After this operation becoming three times more religious than before."

"Are you formally involved with your religion?" Wallace persisted. "Do you go to church a good deal—do you pray?"

"Every day more," Dalí said, "but is not sufficient. . . ."

In 1953, British biophysicist Francis Crick coauthored a paper with the American biologist James Watson for the journal *Nature*. It postulated the structure of human DNA. Their "discovery" actually drew heavily from the research of other researchers, including a British chemist named Rosalind Franklin. As was typical of this "Mad Men" age, her contribution was not recognized when both men were awarded the 1962 Nobel Prize in physiology and medicine, respectively.

The discovery was widely published in the press, including the *New York Times*, as a breakthrough revelation in the building blocks of life. As such, it was almost inevitable that the news would reach Dalí, who was always on the lookout for evidence of his syncretic theory regarding science and the divine. Various indirect references to DNA are attested in several of his works from this period, but he would make the most overt statement in 1963, with the painting that informally became known as *Homage to Crick and Watson*.

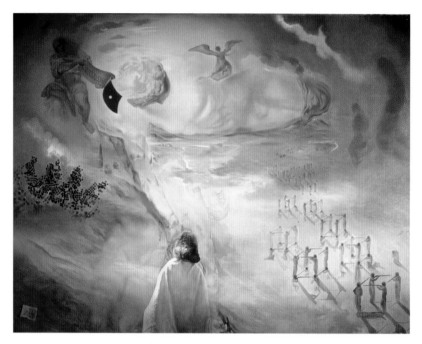

Fig. 101. Salvador Dalí, *Galacidalacidesoxyribonucleicacid*
(*Homage to Crick and Watson*), 1963

The result is a rather mannered work that tries to accomplish many things and as a result lacks some of the arresting majesty and visual power of the paintings we've reviewed. The central motif is the act of creation: God reaches down to hold the lifeless figure of his only Son, Jesus Christ, whose face, barely visible through the clouds, is once again reminiscent of Michelangelo's *Pietà*. Inside the head of God are depictions of Christ and the Madonna. Directly beneath this vision is Gala, with her back turned toward us, in her traditional role as the human observer of this supernatural vision.

To the left is a cluster of dots that represents, in Dalí's imagination, the molecular structure of DNA, while to the right a series

of cube-like clusters, each composed of what appear to be robed Berber riflemen, illustrate Dalí's idea of molecular structures. Each of the Berbers holds a rifle aiming at the man opposite him. These cubes, Dalí averred, suggest the fragility of life; if one man shoots, the others would respond, thus destroying the complexity of the human molecular structure.

To complete this highly literate montage, the prophet Isaiah appears at top left. This figure is a close citation of Raphael's fresco of *Isaiah*, painted for the Basilica di Sant'Agostino in Rome in 1512. In addition, the painting includes miniature pictures of Crick and Watson, and the legends "Watson: a model builder" and "Crick: Life is a three-letter word."

As Dalí explained in the catalog that accompanied the painting's first exhibition at New York's Knoedler Gallery in 1963, "As announced by the prophet Isaiah—the Savior contained in God's head from which one sees for the first time in the iconographic history his arms repeating the molecular structures of Crick and Watson and lifting Christ's dead body so as to resuscitate him in heaven." The overall thrust of the painting, Dalí argued, was to show that the double helix of DNA is "the only structure linking man to God."[127] Elsewhere, Dalí also claimed that the human cubes represent the structure of sodium chloride or table salt, one of the most important compounds for sustaining life, but some chemists have pointed out that this is a misrepresentation.

One striking aspect of the work is that the scene is not set on the familiar shore of Port Lligat, in northern Spain, but rather in the country's south, the area once known as Moorish Al-Andalus (today's Andalusia), or perhaps Spanish Morocco. The scene emerges not from a rich Dalínian aquamarine but from the swirling browns and yellows of the desert, lit by the bright light of the African sun. This is reflected in the unpronounceable

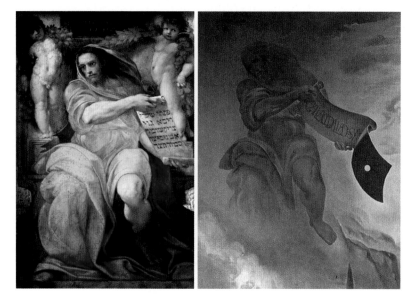

Figs. 102–103. Raphael, *The Prophet Isaiah* (left), 1512,
and detail of Salvador Dalí, *Galacidalacidesoxyribonucleicacid* (right), 1963

title of the work—*Galacidalacidesoxyribonucleicacid*—which is
a contraction of "Gala Dalí"; the name of the legendary Spanish
commander El Cid; "Allah," the name of God in Arabic; and
"deoxyribonucleic acid," the molecule that carries the double helix
of DNA. In a 1965 dedication, Dalí explained the title as follows:

> The arm of the eternal God carries the man-Christ back up to
> heaven as the Jesuit Father Teilhard de Chardin would have
> had it, thus verifying the Dalínian idea of the "persistence
> of memory"; in my own life, the persistence of memory of
> the history of Spain, my country, and of the Arab people,
> consubstantially mingled to the point that only the cybernetic
> machines of the future will be able to disentangle them with
> clarity, thanks to the microphysical structures of moire,
> mescaline of the retina.[128]

According to Albert Reynolds Morse, the cubic groups of the Berbers with their rifles relate to "the religious war just building in the Near East, where one trigger pull initiates another until no one is left." It isn't quite clear what religious conflict Dalí had in mind, though according to the writer Carlton Lake, Dalí was thinking of the war between the Algerian National Liberation Front and the French colonial powers in Algeria. This would explain why the riflemen appear as Berbers, because that war was primarily a guerilla war between Algerian Berbers and the French armed forces.[129] The painting was acquired by the New England National Merchants Bank of Boston for $150,000, an impressive sum for that time.

Dalí's drive to create ever-larger canvases culminated in *The Ecumenical Council* of 1960, which commemorates the election of Pope John XXIII in 1958—the same pope whose ear was the inspiration for *The Sistine Madonna*. As in the case of *Homage*, *The Ecumenical Council* does not represent a unified image but a collage of many disparate themes and ideas that float about the sky without any concern for spatial realism or perspective.

The top half depicts the Holy Trinity, though God is portrayed as a young man in the nude, floating against what appears to be a section of the interior of St. Peter's in Rome. He is flanked by two figures: Jesus on the left, and another on the right representing the Holy Spirit, whose face is obscured by the nimbus of a dove. The faces are deliberately left vague to emphasize their mystical nature.

All around these figures are various groupings of prelates, including what appears to be the coronation ceremony of the new pope. The foreground is once again occupied by Gala in the role of St. Helena, holding a crucifix and hovering over the bay of Cadaqués with the craggy, metal-gray rocks of Cap de Creus behind her.

A surprising detail is shown at bottom left, where Dalí has painted a self-portrait at his easel that reminds the viewer of Velázquez's self-portrait in *Las Meninas* of 1656. Both he and Gala are painted in the sharp realism of the Pompiers, while much of the remainder of the canvas is rendered in fleeting brushstrokes.

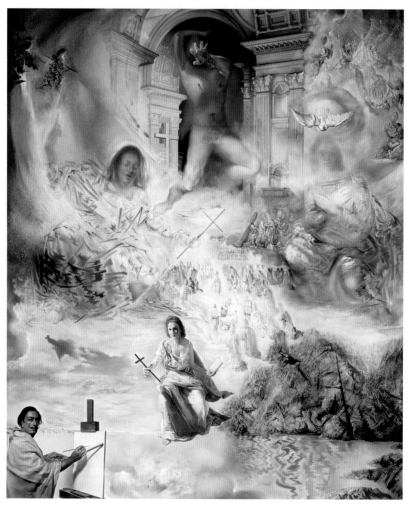

Fig. 104. Salvador Dalí, *The Ecumenical Council*, c. 1960

Dalí reportedly used the distinction to differentiate between heaven and earth according to the prevailing Catholic cosmology, which also governs Michelangelo's signal masterpiece, the fresco of *The Last Judgment* in the Sistine Chapel.

The most striking aspect of the painting, however, is the idea of showing God as a young nude man. While in the final version a cloud covers God's genital area, a study in oil and canvas for this passage shows the figure fully nude. The treatment has clear echoes of Michelangelo's frescoes in the Sistine Chapel ceiling: for example, the figure from the group of "the Saved" in the *Last Judgment*, but also the figure of Haman in the southeastern pendentive of the ceiling.

What was Dalí trying to convey with this massive canvas? When the work was first exhibited, Dalí stated that it commemorated "the greatest historical event of our time and which, prudently, I have painted before it has met."[130] We saw previously how Dalí had an uncanny ability to sense the dawn of momentous events, and the pontificate of John XXIII was certainly such a moment in the history of Catholicism. Formerly known as Angelo Roncalli, cardinal of Venice, the pope was generally assumed to be a reliable traditionalist until he declared his intent in 1960 to schedule a Second Vatican Council, thus continuing the work begun by the First Vatican Council of 1869–1870, during the pontificate of Pope Pius IX. The council's charter was to radically rethink the Church's role in modern times, and in that sense the gathering of cardinals, bishops, and clergy did not disappoint. Its decisions would eventually touch nearly every aspect of the Catholic Church, from the form of its liturgy to a greater activism for social justice, and even the traditional habit of nuns. The title of the painting, *The Ecumenical Council,* actually refers to the official title of the pope's convocation, even though it was strictly

speaking a Catholic assembly with few, if any, other Christian denominations involved. But it did convene clergy from all ranks, from cardinals to abbots, which is perhaps reflected in the distribution of different clerical figures throughout the painting.

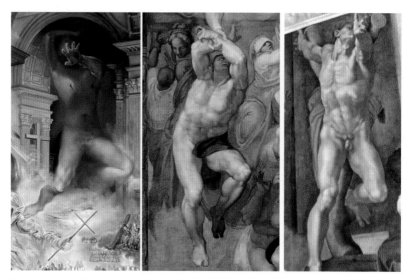

Figs. 105–107. Salvador Dalí, *The Ecumenical Council* (detail, left), 1960, and details from Michelangelo's *Last Judgment* (center), 1541, and *Hamam is Denounced* (right), 1512

Gala's crucifix, meanwhile, reminds the viewer of the fact that Helena, the mother of Emperor Constantine, is traditionally credited with discovering the True Cross underneath the rubble of Golgotha in Jerusalem in the fourth century. The location would later be marked with the construction of the Church of the Holy Sepulcher. St. Helena had a special significance for Dalí, for she was considered the patron saint of Port Lligat, the location of his principal studio.

At the same time, the swirling mass of the *Ecumenical Council* and its blend of the real and the supernatural, of matter and spirit, conveys Dalí's continuing fascination with the idea of blending

modern science with religious ideas, of reconciling two funda-
mentally opposing views of how the modern world was supposed
to function. In 1958, he was introduced to quantum physics and
particularly to Werner Heisenberg's Uncertainty Principle, which
argues that it is impossible to determine the exact position and
momentum of a particle simultaneously. It posits that the very
act of measuring one invariably affects the value of the other.[131]
Dalí interpreted this as proving his theory that human and divine
elements are inexorably interlinked, and that the mysteries of the
world can never be defined by scientific theorems alone. It also
underscored the validity of his thesis that the subconscious mind
was a rich and credible source of interpreting the physical world
around us. In his 1958 manifesto, Dalí wrote: "In the Surrealist
period I wanted to create the iconography of the interior world
and the world of the marvelous, of my father Freud. Today the
exterior world and that of physics, has transcended the one of
psychology. My father today is Dr. Heisenberg."

*The Ecumenical Council* was the last of Dalí's *grandes
machines* of his nuclear-mystical period: the last of the huge
canvases to communicate his fascination with the intersection of
science and the rich panoply of Catholic tradition. While they
did not find much favor with art critics, they certainly found a
willing market among wealthy Americans, eager to have such
large, impressive paintings from a celebrated modern artist, exe-
cuted in a narrative style they could understand. In that sense, the
works of this period strike an interesting parallel with academic
art of the nineteenth century and its analogous obsession with
historical, religious, or mythological subject matter.

The art of the Pompiers likewise found an eager buying public
among the nouveaux riches of the late nineteenth century, as France
came late to discovering the potential of capital concentration

and mass production made possible by the Industrial Revolution. This may be another reason why Dalí never hid his admiration for artists such as Meissonier, Bouguereau, or the Spanish academic artist Marià Fortuny y Marsal. Indeed, he even painted a rare semiabstract work entitled *Homage to Meissonier* in 1965. Perhaps we may conclude that if the work of this period, from 1950 to 1960, was full of references to Velázquez, Raphael, and da Vinci, the principal source of inspiration for motif, technique, and composition was always the Salon art of the French belle epoque.

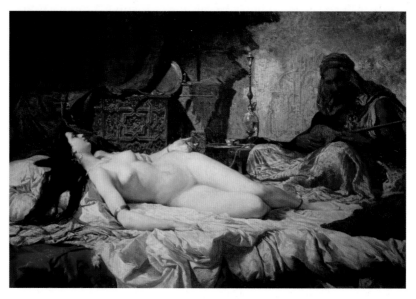

Fig. 108. Marià Fortuny y Marsal, *Odalísque*, 1861

# 8.

# A RETURN TO THE PAST: 1960–1968

*Drawing is the honesty of the art. There is no possibility*
*of cheating. It is either good or bad.*

Salvador Dalí

**I**f the latter part of the 1950s was remarkable for its stylistic treatment and focus on nuclear-mystical motifs, that cohesion slowly disintegrated in the last major period of Dalí's long and highly productive career. Now fifty-six years old and in the twilight of his life as an artist, Dalí seemed to return to earlier themes of his artistic oeuvre, including the eroticism and Surrealism of his paranoiac-critical method, as if in search of old and familiar anchors. He had by now also become a wealthy man, even though this may not have been immediately apparent to him. Gala was in full control of his finances and would not hesitate to keep him locked up in a hotel room until he finished a commissioned work for a wealthy patron. The celebrated ballet choreographer

Maurice Béjart, for example, arrived at Dalí's hotel room in Venice in 1961 to discuss the opening of their collaborative venture, the *Ballet de Gala* at the Teatro La Fenice, only to find that Gala had barred his way and would not let him in until Dalí had finished two bespoke paintings.[132] But Gala's rather chaotic approach to money also meant that the income of their enterprise could sometimes wind up in suitcases, deposited in bank accounts that were soon forgotten, or carried around as uncashed checks, often for years.

The couple's fortunes were buoyed by publishing ventures such as Robert Descharnes's 1962 book *The World of Salvador Dalí*—one of the few positive assessments of Dalí's career by an art critic that was published in his lifetime. "The fact that both his work and his personality are in dispute changes nothing," Descharnes wrote in the introduction, in response to what he undoubtedly expected to hear from modern art circles. Indeed, Descharnes continued, each of Dalí's paintings tends to "[stir] up a polemic." And yet, he wrote, "controversy proves how fully alive his work is, and we are compelled to recognize that a prodigiously gifted artist lies behind the eccentricity."[133]

As Descharnes wrote these words, it was less than two years after Marcel Duchamp's decision to include Dalí's *The Sistine Madonna* in the 1960 International Surrealist Exhibition had provoked an angry response from André Breton and fellow artists. Dalí was attacked as a "religious bigot," an "avowed racist," "Hitler's onetime apologist," and the "fascist artist-friend" of Franco's hated regime.[134] It may be difficult to imagine today, when Dalí is once again enjoying a surge in public interest with commensurate prices at auction, but art circles of the 1960s and 1970s, particularly in Europe, were vociferously opposed to Dalí and his art. One of the authors of this book, Dr. Isbouts,

remembers that when he attended a graduate art history class at Leiden University in the mid-1970s, one professor refused to even utter the artist's name, let alone include Dalí's work in his course on postwar modern art.

At around this time, the new mayor of Figueres, Ramon Guardiola Rovira, realized that it was rather odd that the city's art collection, the Empordà Museum, did not have a work by its most famous son. He reached out to Dalí in May of 1962 and wondered if the artist would be willing to donate some works for the museum, in return for which a special room would be dedicated to the art of Salvador Dalí. Dalí, however, had other ideas. He would not accept a room in the museum. He wanted to have a whole museum dedicated to Dalí, and no one else. In fact, he told Guardiola, he had already chosen the site for such a museum: the Teatro Principal, which had been destroyed in a fire during the Civil War. Here, he remembered, he had exhibited his very first works as a young man. The deal was therefore straightforward: if the mayor agreed to restore the building, then Dalí would make a sizable bequest of his works.

The problem was that the Teatro Principal was no ordinary building. Completed in 1850, it was designed in the same opulent Beaux-Arts style with which its bigger sister, the Liceu in Barcelona, had been conceived. Rebuilding such a lavish structure from its dilapidated condition would have been a major undertaking.

But Dalí was up to the task. A bullfight was organized, at the beginning of which Dalí appeared in the bullring, riding a Cadillac convertible, accepting the ecstatic applause from the crowd. During a reception later that day, the formation of the Salvador Dalí Museum was officially announced. But it was not until 1968 that the funding was secured, based on designs by

architect Joaquim de Ros i de Ramis, who was also responsible for the Picasso Museum.

Of course, Dalí's imprint can be found all over the design, including Dalínian motifs such as giant eggs, and the large geodesic dome that covers the building. "I want my museum to be like a single block, a maze, a great surreal object," Dalí explained. "It'll be a completely theatrical museum. Visitors will leave feeling as if they've had a theatrical dream."

Figs. 109–110. The Teatro Principal of Figueres before its restoration (left), and the Teatre-Museu Dalí today (right)

Still, many obstacles remained, not least because the official authority in charge of the project was not the Spanish Ministry of Fine Arts but, remarkably, the Ministry of Housing. Dalí found himself repeatedly traveling to Madrid in order to plead with Franco and then-Prince Juan Carlos to revive the project. Thus it was not until 1970 that the first spade actually entered the soil. Four years later, on September 28, 1974, the Teatre-Museu Dalí (Dalí Theatre-Museum) was finally unveiled. [135]

As the opening day approached, Dalí characteristically launched into a frenzy. He "directed, instructed, painted, gave interviews, posed for the cameras, talked to the mayor, and got everything ready," so that on the eve of the official opening, he sat down, exhausted.[136] The opening ceremony was carried on Spanish television and was attended by a host of local politicians and celebrities. Also spotted in the crowd was Jeff Fenholt, the star of the musical *Jesus Christ Superstar*, who since 1973 had been the favored lover of the now eighty-year-old Gala. According to Gibson, Mayor Guardiola was offended. He had wanted the opening to be attended by Europe's creative elite, including artists, writers, and intellectuals, rather than this mixture of Franco officials and politicians. After a slow start (largely because there were few major works by Dalí on display), the museum steadily grew in popularity, particularly after Dalí made the bulk of his donations in 1983. Soon after that, it became Spain's second most visited museum after the Prado in Madrid—a fact that would have undoubtedly made Dalí proud. In 2016, the museum received over 1.3 million visitors.

**In the meantime,** however, Dalí had returned to his principal pursuit, that of painting. In 1960, he produced what the present authors consider one of his finest works: *Gala Nude from Behind* (right). The most striking aspect of this painting is its sheer simplicity: a nude woman shown from the back, against a neutral background. References to atomic disaggregation, nuclear mysticism, or any other form of surreal illusionism are nowhere in evidence, so that the eye can linger on the superb detail of Gala's torso, the intricate curls of her hair, and the gentle drapery of her white gown. The obvious model for this work is one of

Dalí's most favorite artists, Jean-Auguste-Dominique Ingres's portrait of *La Grande Baigneuse*. Here is the same focus on the soft texture and gentle curves of a woman's body, set against the crisp white linen of her bed, in sharp contrast to the cool gray of the background. With this painting Dalí came close to matching, if not surpassing, the art of nineteenth-century France.

Figs. 111–112. Jean-Auguste-Dominique Ingres, *La Grande Baigneuse* (left), 1808, and Salvador Dalí, *Gala Nude from Behind* (right), c. 1960

The lure of nineteenth-century artists continued when in 1961 Dalí set himself to reinterpret perhaps the most famous canvas by the Spanish artist Marià Fortuny y Marsal. The work, which was left unfinished when Fortuny died, is a vast cinemascope-like canvas, ten yards wide, which depicts the Battle of Tetouán during the Spanish-Moroccan War of 1859–1860. This conflict, which marks one of the more unsavory chapters in the history of European colonialism, was launched as an attempt

by Spain to expand its territory in Morocco, after the latter had suffered a major defeat to France. Spain, eager to exploit Morocco's weakened state, launched an attack from the Spanish city of Ceuta, using an expeditionary force of thirty-six thousand men and no fewer than sixty-five cannon under the command of the Conde de Reus. Under pressure from this army, Moroccan troops were gradually pushed back until they sought refuge in the city of Tetouán. After two days of relentless bombardment, the city fell and the pillaging of the Mellah, the city's Jewish quarter, began. All sense of order broke down as citizens and Spanish soldiers alike roamed through the town, plundering and stealing as they went.

The surrender forced the Sultan of Morocco to sue for peace, and the war came to an end. Somewhere along the way, however, the uneven battle between a modern, mid-nineteenth-century army and a mounted Berber force with little more than spears and rifles was elevated to epic status, not least since this was the first major conflict to be covered, in near-real time, by the growing popular press. This, as we will remember from the introduction, took place in an era when Spain had very few victories to crow about. Upon its return, therefore, the Conde de Reus's expeditionary force was granted a triumphal entry into Madrid, and Fortuny was commissioned to capture the battle for all posterity.

The artist duly traveled to the battlefield in 1860, and again in 1862, and then returned to his residence in Rome to try to make sense of the scores of drawings and sketches he had made. The principal concept of the work is the (utterly fictional) breakthrough of Spanish mounted forces in the Moroccan camp at the *pointe de frappe*, scattering tribesmen in all directions.

But the task of creating such a vast panoramic vision clashed with Fortuny's interest in detail and the emotional intimacy of

his characters, and the work was eventually abandoned. As a mid-century work, the painting is nevertheless a tour de force, combining the rich color palette of Hans Makart with the vivid orientalism of Delacroix.

Why Dalí chose to create a reinterpretation of the painting is not entirely clear. In 1927, during his development as an avant-garde Surrealist painter, he had denounced Fortuny's "greasy painting" and "succulent brushstrokes."[137] But later, writing his *Secret Life of Dalí*, Dalí revised his judgment, calling him "one of the most skillful beings in the world."

In 1958, following a brief but sharp conflict known as the Ifni War, Franco was compelled to surrender the last strip of Spanish territory in West Africa to Morocco with the Treaty of Angra de Cintra; only the cities of Ceuta and Melilla remained in Spanish hands, which is—remarkably—still the case today. Perhaps the surrender of so much overseas territory prompted nostalgia for the days when Spain ruled supreme in much of northern Morocco, inspiring Dalí to return to the theme. The fact that Fortuny's painting is technically unfinished may have also encouraged him to produce a "finished" Dalínian version. Lastly, 1962 coincided with the centenary of the original's execution, and we should always remember that Dalí considered himself Moorish, at least in part.

In Dalí's vision, the center portion of Fortuny's painting is enlarged to fill much of the canvas, although it is the Moroccan army, rather than the Spanish cavalry, that is the focus of his interest. According to Robert Descharnes, Dalí arrived at the setting when he found a crumpled copy of *Time* magazine in the snow on a wintry evening in New York. Inside was a photograph of an Arabian scene. "I have found my battle of Tetuán!" he declared. But in the actual painting, Fortuny's careful observation

Fig. 113. Marià Fortuny y Marsal, *The Battle of Tetouán*, 1862–1864

of the topography of the actual battlefield has been replaced by the familiar horizon of Cadaqués. In the center of the painting is a whitewashed shack that may refer to Dalí's earliest home in Port Lligat.

But in every other sense, it is difficult to discern a cohesive idea. The approaching phalanx of mounted Moroccan tribesmen in the foreground is superbly executed in almost photographic detail, but its dramatic effect is mitigated by the appearance of Dalí's and Gala's faces on two of these fierce warriors, in a way that makes it appear as if their faces were pasted on. Similarly, a flying horse looms large at the top left without any obvious connection to the foreground scene, while a squadron of mounted Berbers flies through the sky at right. Behind the horse is a creature that reminds us vaguely of *Premonition of Civil War*.

In the background, meanwhile, massed formations with halberds are emerging, in an echo from *Christopher Columbus,* while a flashing saber appears in the top right, wielded by the arm of a Spanish officer. High above this mayhem is a vision of a heavenly Gala who smiles, Madonna-like, as if pleased by the massacre unfolding before her eyes.

In sum, *The Battle of Tetuán* is a very strange composition, even by Dalínian standards. A study from 1962 is more satisfying

233

Fig. 114. Salvador Dalí, *The Battle of Tetuán (Homage to Marià Fortuny)*, 1962

and reveals an indebtedness to the Fortuny original that is not entirely visible in the final painting.

*The Battle of Tetuán* may have largely escaped scholarly attention because of its remote location. We often think of Dalí as an artist beloved by North American patrons, but he is also admired in Asia. This painting, for example, is exhibited in the Morohashi Museum of Modern Art in the prefecture of Fukushima, Japan, which doesn't usually figure prominently on the itinerary of art aficionados. The work is a bequest from Teizo Morohashi (1934–2003), a founder of Japan's XEBIO Corporation and a latter-day arts patron, who during his lifetime built up a collection of 330 paintings, sculptures, prints, and other works by Dalí. Morohashi acquired *Battle of Tetuán* at auction from Christie's in 1990, for the then-princely sum of $2 million. As a result, the Morohashi Museum has actually the

Figs. 115–116. Marià Fortuny y Marsal, detail of *The Battle of Tetouán* (left), 1862, and Salvador Dalí, *Study for the Battle of Tetuán* (right), 1962

third largest collection of Dalí art in the world, after the Dalí Theatre-Museum in Figueres and the Salvador Dalí Museum in St. Petersburg, Florida.

One of Dalí's next works is *Hercules Lifts the Skin of the Sea and Stops Venus for an Instant from Waking Love* of 1963, which signals an abrupt return to his prewar Surrealism. As the title implies, it depicts the Greco-Roman demigod Hercules as he "lifts" the surface of the sea while Venus, the goddess of love, reaches for her son Amor, or Love. The work is a throwback to the 1920s, including his youthful work *Venus and Amorini* of 1925, even though Venus and Amor are here executed with the confidence of a mature artist. At the same time, he executed several drawings of young women in full frontal nudity, such as *The Judgment of Paris,* while also painting a muscular Jesus in the fashion of a nineteenth-century devotional print in *The Sacred Heart of Jesus* (1962). Then followed a return to the benday dot technique in *Portrait of My Dead Brother,* where the dots of the young man's hair slowly resolve themselves as cherries and

eventually small figures. To the right are a group of warriors of a vaguely Greek origin. To the left is a rural scene with echoes of Millet's *L'Angelus*.

Fig. 117. Salvador Dalí, *Portrait of my Dead Brother*, 1962

According to Pierre Roumeguère, Dalí had subconsciously cast himself as the role of Pollux to his dead brother's Castor from an early age. As we saw earlier, in Greek mythology Castor and Pollux were the twin sons of Leda, queen of Sparta, who were born from an egg, but with a key difference. Castor was the issue of Leda's cohabitation with her husband Tyndareus, the mortal king of Sparta, while Pollux was the result of his mother's tryst with Zeus, the supreme god. Unfortunately, Castor was killed, whereupon Pollux beseeched Zeus to reunite them once more. Zeus agreed and transformed them as demigods

in the constellation known as Gemini (the Latin translation of their Greek name Dioscuri). Dalí's identification with Pollux, the brother who tries to reunite himself with his long-lost brother, is obvious, Roumeguère claimed. This analogy also explained the role of Gala, who served as Helen of Troy, the sister of the twins, whose beauty would spark the Trojan War.

When *Portrait of My Dead Brother* was first exhibited, Dalí wrote, "The Vulture, according to the Egyptians and Freud, represents my mother's portrait. The cherries represent the molecules, the dark cherries create the visage of my dead brother, the sun-lighted cherries create the image of Salvador living thus repeating the great myth of the Dioscures Castor and Pollux." The portrait itself is, of course, imaginary, since as we know, Dalí's brother died as an infant. Some believe Dalí used a newspaper photograph that appealed to him, in a sense that it conveyed to him what his brother might have looked like if he had lived to adulthood. This idea would return in much of Dalí's late work. One of his sketches for *The Battle of Tetuán*, for example, is dedicated to "Helen, from her Dioscuri."

For most travelers who have crossed the border between Spain and France, Perpignan is a frontier post just inside France. Long identified as a part of Spain when it was known as Perpenyà, ruled by the Count of Barcelona, and then by the king of Majorca, it was only captured by the French in 1642 during the Thirty Years' War, the most violent war in Europe's history until the world wars of the twentieth century. But it never lost its soul as part of Catalonia, and that is how Dalí experienced it as he approached its railway station on September 19, 1963. While sitting in its waiting room to make the connection from the Spanish to the French railroad—the two operate with different gauges—Dalí experienced a "cosmogonic ecstasy." It revealed to

him that the railway station is actually the center of the universe. Later, he would add that Perpignan is the pivot around which the Iberian Peninsula rotated some 132 million years ago. All this would explain why, in this humble railway station, Dalí would have "my most unique ideas." And he explained:

> Even miles before this, at Boulou, my brain starts moving; but it is the arrival at Perpignan station that marks an absolute mental ejaculation which then reaches its greatest and most sublime speculative height. I remain for a long time at this altitude, and you will note that during this ejaculation my eyes are always blank. Towards Lyon, however, the tension begins to slacken, and I arrive in Paris appeased by the gastronomic phantasies of the journey.[138]

The idea that the crossing point at Perpignan would elicit a deep emotional response in Dalí is not surprising. The town, which has few noteworthy sights other than its fourteenth-century stronghold, Le Castillet, and its modest Beaux-Arts railway station in red brick and limestone trim, was really the crossing point between the two principal territories of Dalí's artistic universe: Spain, the land of his birth and his studio; and France, the land of his artistic awakening as a Surrealist and the scene of his early prewar triumphs. It was also the dividing line between liberal, democratic France and the last wartime fascist regime in Europe, between his native hearth and the center of his commerce, the selling of art. Indeed, that is why he traveled from Barcelona to Paris by train to begin with, because his paintings were usually transported from his studio in Port Lligat to the galleries of the fifth arrondissement by railroad.

*The Railway Station at Perpignan,*[139] painted in 1965, is an attempt to capture his many conflicting feelings upon crossing the border from Spain into France. There is the train, of course, barreling toward us in the center, with a worm's-eye view of Dalí, seemingly jumping out of the sky, based on a photograph from the cover of his book *Diary of a Genius.* France is represented by the now-familiar figures of the peasant and his wife in Millet's *L'Angelus* and by two groups of ghostly figures that show the peasant couple hauling a large sack of potatoes (or is it a corpse?) on the left, symbolizing labor, and preparing for what may be a sexual act on the right, symbolizing lust. In the center of the scene is the ephemeral and rather incongruous figure of the crucified Christ with his crown of thorns, painted with such thin illusionism that he is barely visible. The diminutive figure of Gala, seen from the back, is depicted in the center bottom in her customary role as observer. In sum, the painting combines a number of motifs that seek to epitomize some of the key themes of the preceding years: the abiding influence of François Millet and the erotic connotation of *The Angelus*; the continuing inspiration of faith and religion; and the role of Christ (and, by implication, Dalí himself) as the Salvadore, the savior of the world and modern art in particular.

A similar desire to produce an anthology of all of the ideas that had preoccupied him in years past is evident in Dalí's most ambitious and perhaps most confounding work of his late period: *Tuna Fishing.* The title evokes the image of a placid fishermen's troll on the high seas, but in Dalí's hands it becomes a violent naumachia, of the type staged in Roman amphitheaters that were flooded so as to treat their audiences to the bloody realism of naval combat. In the foreground, a group of nude young men are engaged in a bloody hunt to capture several shark-sized tunas.

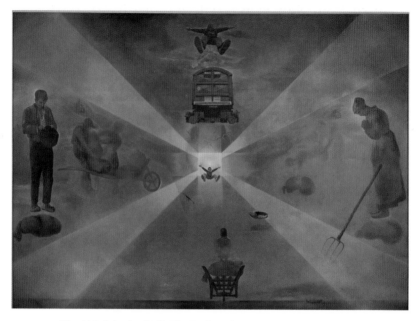

Fig. 118. Salvador Dalí, *The Railway Station at Perpignan*, c. 1965

Their desperate slashing and stabbing at these monsters recall Peter Paul Rubens's *The Lion Hunt*. Their golden spears flash in the sun as the blue of the sea slowly turns red with blood. The men themselves are painted in every style imaginable. Indeed, with these figures Dalí tried to revisit all of the styles that he had worked on throughout his artistic career: Surrealism, action painting, pointillism, academic art, and pop art.

For example, the figure at far left, copied from the figure of Alkyoneus on the Hellenistic Pergamon frieze, strikes a stark contrast with the op art–like stencil of a young male in the foreground, or the fantastically colored Surrealist nude male to the right. In the background, another battle is in progress, this time involving a group of fishermen on their vessel, grappling with tuna of whale-like proportions. This scene carries echoes of

Théodore Géricault's *The Raft of the Medusa,* one of the most famous works of French nineteenth-century Romanticism, which depicts the survivors of a real-life shipwreck clinging to a hastily built raft amid the swells of a storm. In the midst of all this mayhem rises a nude nymph, calmly raising her right leg as if to dry herself after a leisurely bath.

According to Gibson, the scene is set in a cove outside the town of Roses called L'Almadrava, from an Arabic word denoting the spot where tuna fish are caught. Dalí was once told of this place by his father, who "with a narrative gift worthy of Homer," as Dalí put it, described a terrifying hunt filled with the frenzy of killing tuna.

Dalí spent the summers of 1966 and 1967 working on this immense, ten- by thirteen-foot painting and even documented its progress in a series of photographs, complete with his nude male model. "It is the most ambitious picture I have ever painted," Dalí commented, "because its subtitle is *Hommage à Meissonier*"—the leader of the Pompiers so admired by Dalí. And the reason why the scene is so violent, Dalí explained, is that "the universe and cosmos are finite—which the latest discoveries have confirmed." As a result, he continued,

> . . . it was that finite quality, the contractions and frontiers of the cosmos and the universe, that made energy possible in the first place. The protons, antiprotons, photons, pi-mesons, neutrons, all the elementary particles have their miraculous, hyper-aesthetic energy solely because of the frontiers and contraction of the universe. In a way, this liberates us from the terrible Pascalian fear that living beings are of no importance compared with the cosmos; and it leads us to the idea that the entire cosmos and universe meet at a certain point—which, in this case, is the tuna catch. Hence, the alarming energy in the painting![140]

In other words, in Dalí's vision the bloody tuna hunt becomes a metaphor for the clash of species, of man against animal and man against man, as the modern world hurtles toward its inevitable nuclear Armageddon.

*Tuna Fishing* was purchased by the French pastis magnate Paul Ricard, after he decided to dock his yacht at Port Lligat with the intention of visiting Dalí's studio and perhaps buying a print or two. Instead he found himself agreeing to pay $280,000 for the painting, which was duly delivered to the Paul Ricard Foundation on the island of Bendor, off the coast of France. Paul Chimera has vividly described how in 1973, the huge canvas was taken by thieves, removed from its stretching bars and rolled up

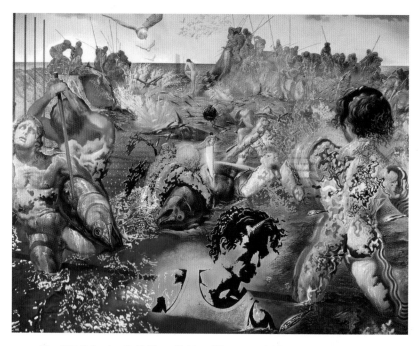

Fig. 119. Salvador Dalí, *Tuna Fishing (Hommage à Meissonier)*, 1966–1967

like a carpet. It then went missing for years, only to be recovered in an airport hangar at Orly near Paris.

Traumatized by the theft, the board of the Paul Ricard Foundation vowed never to lend the work for exhibition. Eventually, however, the foundation came to its senses, not in the least because so few visitors are able to visit Bendor, a private island only accessible by an infrequent ferry service from Bandol on the Côte d'Azur. Since then, *Tuna Fishing* has been exhibited in various public venues including the Centre Pompidou in Paris.[141]

A similar desire to create a composite of predominant Dalínian themes, including optical illusionism, produced another major work from this period, *The Hallucinogenic Toreador,* completed in 1970. Once again realized on a massive scale, using a canvas measuring thirteen by ten feet, the work harks back to his early Surrealist period, and particularly the influence of the Italian Surrealist de Chirico. The painting sets its scene in the enclosure of a classical bullfighting ring, with the face of Gala— who hated bullfights—ghosting in the top right corner. Several classical statues, most notably the *Venus de Milo* (shown no fewer than twenty-eight times throughout the painting) parade across the foreground. The painting actually has a double image, another instance of Dalí using negative space to create a hidden meaning. The torso of the second Venus resolves itself into the face of the toreador: her left breast is his nose, and his left eye is her right cheek. Swarms of gadflies complete the picture by denoting the bullfighter's cap, while the colorful green of Venus's chiton dress doubles as the toreador's tie. In the far right corner, a young boy—a portrait of the youthful Dalí—observes the scene in wonder. Other motifs include a teardrop welling in the bull- fighter's inferred eye (indicating that he knows he is to die, as Dalí claimed); the praying peasant woman from Millet's *L'Angelus;*

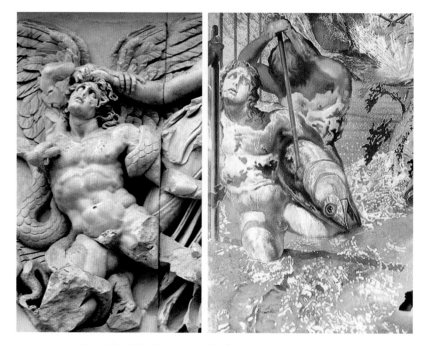

Figs. 120–121. Alkyoneus (left), from the third century BCE
Pergamon frieze, and a detail of *Tuna Fishing* (right)

and the atomic particles that burst forth from the bull's head as the toreador's sword delivers the coup de grace. Dalí later told one of his biographers, Luis Romero, that the face of the doomed toreador was inspired by the recent deaths of several friends, including Lorca, René Crevel, and *Un Chien Andalou* actor Pierre Batcheff—assimilated, of course, with Dalí's imaginary portrait of his dead brother.[142]

Dalí reportedly came up with the idea of producing the portrait of the toreador in negative space when he visited an art supplies store in New York in 1968 and his eye fell on a box of Venus Pencils, decorated with a reproduction of the *Venus de Milo*. Suddenly, he saw the face of a bullfighter in the exquisite

244

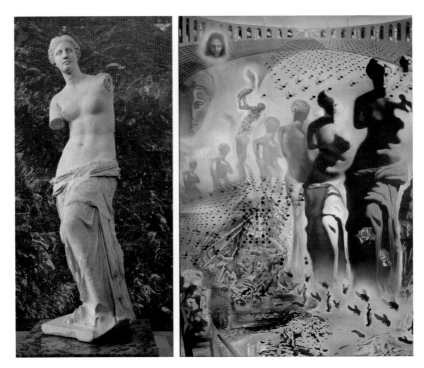

Figs. 122–123. Praxiteles (?), *The Aphrodite of Milos* (left), c. 130 BCE,
and Salvador Dalí, *The Hallucinogenic Toreador* (right), 1970

marble texture of the Greek statue (which, as a Greek work of art, should be properly named *The Aphrodite of Milos*). In this he may have followed Leonardo da Vinci's advice to "look at walls splashed with stains, or stones of various mixed colors . . . in which you may find fantastic inventions that awaken the genius of the painter."[143]

As an attempt at creating an optical illusion using negative space—such as the image of the toreador in the contours of the *Venus de Milo*—this work was less successful. When it was first exhibited in New York City, visitors were given a helpful guide to decoding the painting, with certain areas matted out so as to

245

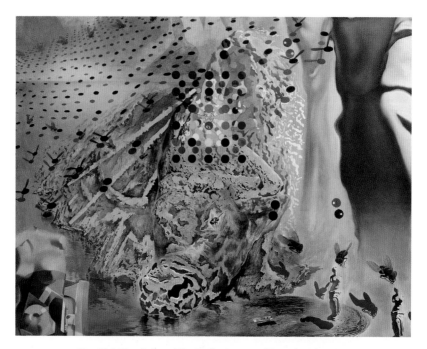

Fig. 124. Detail from *The Hallucinogenic Toreador,* showing
a burst of atomic particles from the bull's head

make the identification of the toreador more obvious. In 1972,
Dalí returned to the theme, this time clearly establishing the face
of the teary-eyed toreador as the dominant theme of the painting.
It is often shown side by side with the 1967 original, by way of a
visual key with which the first version can be better understood.

Many critics consider *The Hallucinogenic Toreador* the
last major work by Salvador Dalí, and the finale to the monu-
mentalism of his late phase. It was acquired by Dalí's longtime
patron, Albert Reynolds Morse, one of the last major works he
would purchase from the artist. Seen in retrospect, then, *The
Hallucinogenic Toreador* may mark the end of Dalí's long and
fruitful career as a leading twentieth-century artist.

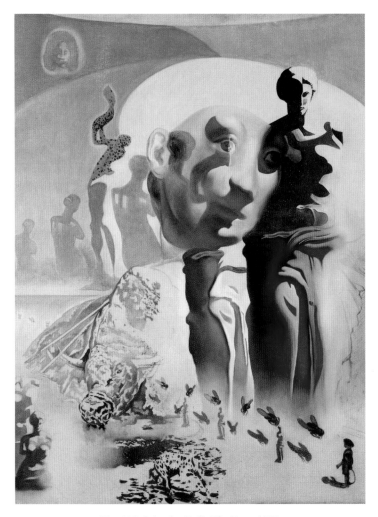

Fig. 125. Salvador Dalí, *The Face*, 1972

Morse was born in Denver, Colorado, in 1914 and earned an MBA from Harvard Business School. His father owned a machine tool company, the Morse Brothers Machinery Company, but Albert decided to strike out on his own and in 1949 started a business using the new technology of injection molding,

developed and perfected during World War II. Seven years earlier, he and his fiancée, Eleanor Reese, had traveled to Cleveland to see the traveling MoMA exhibit on Salvador Dalí, which opened on March 6, 1942. The couple was enchanted by Dalí's surrealist visions. "We were just engaged to be married," Eleanor recalled many years later, "and discovered that we had one more thing in common: a consuming admiration for the painting by Dalí." What struck them above all was his "superb draftsmanship," the "nostalgia of his deep perspectives," and his "unusual surrealist subject matter." The MoMA catalog, edited by James Thrall Soby, subsequently became their "Dalí Bible."[144]

One year later, they acquired their first Dalí painting, *Araignée du Soir, Espoir,* completed in 1940 on Caresse Crosby's estate. Dalí renamed it *Violincello, Spider, Great Masturbator,* but the Morses were more comfortable with the original French title, and so they dubbed it *Daddy Longlegs of the Evening—Hope!* The price charged by the George Keller Gallery was $600, with an option to have it framed. When Morse agreed to have the painting delivered in a wooden carved frame, he discovered that the cost of the frame was twice that of the work itself: $1,250.[145]

Thus began a thirty-year patronage that would place the Morses among the leading collectors of Dalí art. For a long time, their collection was on display in their home in Cleveland, Ohio, until a loan of some two hundred works to a Dalí retrospective in 1965 persuaded them that their treasure trove of Dalí art needed a permanent home. Their first museum was opened in Beachwood, Ohio, in a property that sat next to the Injection Molding Supply Company's headquarters. But as the throng of visitors continued to grow, the couple realized that a far greater facility was needed. Eventually they settled on a warehouse in St. Petersburg, Florida, which opened its doors on March 7, 1982.

This building also soon proved to be inadequate for handling the growing number of visitors. In 2008, an entirely new, thirty-million-dollar structure was built on Tampa Bay by the philanthropist and builder Henry C. Beck III, based on designs by the architect Yann Weymouth. This museum opened on January 11, 2011. Today it is the largest collection of Dalí art in the Western hemisphere and the second largest Dalí museum in the world after the Dalí Theatre-Museum in Figueres, Spain. The museum has since continued to acquire Dalí prints, drawings, writings, photos, objects, and paintings and today owns over twenty-one hundred works representing every phase of the artist's oeuvre, including ninety-six oil paintings. The museum's collection is particularly strong in the oversized canvases of the late 1950s and 1960s, which the museum terms "masterwork" paintings.

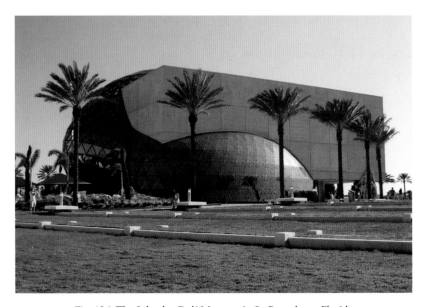

Fig. 126. The Salvador Dalí Museum in St. Petersburg, Florida

# 9.

# THE LATER YEARS: 1968–1989

*When you are a genius, you do not have the right to die, because we are necessary for the progress of humanity.*

Salvador Dalí

**In search of** new ideas, Dalí turned to an old and reliable source, the art of the golden era of Dutch seventeenth-century painting. As it happened, in the spring of 1969 the Petit Palais in Paris had opened an exhibition on the work of the Dutch artist Gerrit Dou. A product of the Leiden school of *fijnschilders,* who excelled in small-scale paintings executed with minute and exquisite detail, Dou studied art in the Leiden studio of the twenty-one-year-old Rembrandt van Rijn, who was his senior by only seven years.

After some three years, Dou left the studio to strike out on his own, developing a highly individual vernacular that betrayed his obsession with optical effects. Though this did not endear him to his sitters and his work as a portraitist rapidly declined, the

meticulous realism of Dou's art soon ensured a loyal following of a different character: patrons who were astonished by the virtuosity with which Dou could cram so many realistic objects on so small a surface. Many of these were executed with a concave lens, sometimes in combination with a convex mirror, but somewhere along the line, Dou may have hit upon the idea of creating a pair of views of the same scene from slightly different viewpoints so as to create the illusion of genuine depth when seen together. Officially, the stereoscope was only invented in the 1830s by Charles Wheatstone, but it is certainly possible that Dou, given his experience with optical effects and the ubiquitous use of concave eyeglasses in the seventeenth century, may have developed an early sample himself. Dalí, for one, was convinced that Dou was "the first stereoscopic painter," as he told Luis Romero, pointing out that the first microscope had been developed in 1636 in Dou's native city of Leiden.

Fig. 127. Gerrit Dou, *The Sleeping Dog*, 1650

Fig. 128. Salvador Dalí, *Dalí Seen from the Back painting Gala from the Back Eternalized by Six Virtual Corneas Provisionally Reflected by Six Real Mirrors*, c. 1972–1973

A fascination with optical effects, anamorphic forms, and negative space is a constant that runs throughout Dalí's extensive oeuvre. Now, in the final phase of his art, this repertoire was to be expanded with holography and stereoscopy. A special exhibition on the subject, held at the Dalí Theatre-Museum in Figueres in 2015, featured *Dalí Seen from the Back painting Gala from the Back Eternalized by Six Virtual Corneas Provisionally Reflected by Six Real Mirrors*, c. 1972–1973; *Gala's Foot*, c. 1975–1976; *According to 'Las Meninas' by Velázquez*, c. 1975–1976; *The Structure of DNA*, c. 1975–1976; *Dalí's hand drawing back the Golden Fleece in the form of a cloud to show Gala, completely nude, the dawn, very, very far away behind the sun*, 1977–1978; and a second variation of *Hercules Lifts the Skin of the Sea*, entitled *Dalí lifting the skin of the Mediterranean Sea to show Gala the birth of Venus*, 1978. Taken together, these works are the most memorable of Dalí's late period.

Of these, *Dalí Seen from the Back painting Gala from the*

*Back Eternalized by Six Virtual Corneas Provisionally Reflected by Six Real Mirrors* is perhaps the most successful. We see the artist and his sitter from the front and back, left and right, thus simulating, in two-dimensional form, an effect akin to a three-dimensional experience. In addition, Dalí executed two versions of the painting, each from a slightly different viewpoint, which

Fig. 129. Johannes Vermeer, *The Art of Painting*, 1668

when seen through a stereoscope resolve themselves as a true stereoscopic image.

The painting reveals the influence of Vermeer's *The Art of Painting* (1668), in which the artist is seen in an almost identical pose behind his easel. When, in his interview, Alan Bosquet asked Dalí which painting he would rescue, if all humankind "was to disappear in an hour," Dalí replied: "*The Artist's Studio* by Vermeer, in Vienna," referring to *The Art of Painting*.[146]

Fig. 130. Salvador Dalí, *Dalí's hand drawing back the Golden Fleece in the form of a cloud to show Gala, completely nude, the dawn, very, very far away behind the sun*, c. 1977

A second major work, *Dalí's hand drawing back the Golden Fleece in the form of a cloud to show Gala*, was undertaken in 1977 as a flashback to the Surrealism of Magritte and de Chirico, complete with classicist staging and nostalgic, late-afternoon lighting. An idealistic view of the nude Gala, seen from behind,

is placed over the horizon of a coastal scene inspired by the French seventeenth-century painter Claude Lorrain, specifically his *Seaport at Sunset* of 1639. These binocular experiments, Dalí declared, provide "a royal road of the spirit and the metaphysical dimension par excellence, for at long last we have recovered the third dimension."

Fig. 131. Claude Lorrain, *Seaport at Sunset*, 1639

Another print series that illustrates Dalí's return to the roots of Old Master art is a group of lithographs entitled *Changes in Great Masterpieces* completed in 1974. Released as an initial edition of 350 sets by Sidney Lucas in New York, the six prints each depict one major work in the history of Western art, though with some small additions or modifications by Dalí. The featured "masterpieces" include works by Raphael, Vermeer,

and Rembrandt; two by Velázquez; and, of course, one by Dalí himself, namely *The Persistence of Memory.*

The purpose of this print collection was to illustrate Dalí's argument that while we may "look" at these masterpieces, we do not actually "see" all the details that qualify a painting as a true masterpiece. Thus, the changes are meant to intrigue and tantalize, as if in a visual puzzle. They challenge the beholder to identify the subtle changes that Dalí made in the work. In Rembrandt's *Self-Portrait*, for example, Dalí added a Vermeer-like view of a receding hallway that leads to a brightly lit room with a young woman.[147] Similarly, in his version of Velázquez's *Las Meninas (Maids of Honor)*, the man standing in the doorway in the background has been replaced by another Vermeer-like scene of a young woman in front of a large map. In Vermeer's *The Letter,* by contrast, the

Figs. 132–133. Johannes Vermeer, *The Love Letter* (left), 1666, and Salvador Dalí, *Vermeer's La Lettre* (right), 1974, from *Changes in Great Masterpieces*, 1974

figure of the maid who delivers a letter to her mistress is replaced by that of a toreador, whose face is blotted out.

Most importantly, the *Changes in Great Masterpieces* series reminds us of Dalí's deep devotion to Old Master art and specifically the influence of three artists whom we have encountered throughout this book: Raphael, Vermeer, and Velázquez.

In addition, Dalí was fascinated by the development of holography from its inception in the 1970s. This technology of creating a laser-based three-dimensional image, which is still a staple of science fiction movies but has never found consistent use in modern life, prompted him to experiment with several multilayered montages. Two of these works are *Alice Cooper's Brain* and *Dalí painting Gala*, which were most recently exhibited in the Gala Dalí Castle in Púbol in 2012. The technical challenges of creating a holographic image in color proved to be too steep, however, and eventually Dalí abandoned the technology as a viable art form.

In between these optical tours de force, Dalí often returned to a theme that had both intrigued and terrorized him from the beginning, the female nude. Specifically, his consuming interest in sodomy as illustrated by *Young Virgin Auto-Sodomized by Her Own Chastity* asserted itself once more. Female visitors to his Port Lligat studio would sometimes be asked to undress and sit on a bed of wet clay. They would then be asked to part their buttocks, to enable a more realistic and unimpeded impression of their anuses. These impressions would be framed as if they were ready-made artworks, complete with the names of the "sitters."

"I persuade the most beautiful of women to undress," he explained to André Parinaud in 1972. "I always say the greatest mysteries can be penetrated via the behind, and I have even discovered a profound correspondence between the buttocks of one of the women who visited me at Port Lligat and undressed for me

Fig. 134. Salvador Dalí, *Figure Climbing a Stair*, 1967

and the space-time continuum, which I have named the continuum of the four buttocks (incidentally, this continuum is simply the representation of an atom)."[148] During a taped interview with French television, Dalí declared that "the most important thing

in the world is the arsehole." Needless to say, this passage was omitted from the broadcast.[149]

Figs. 135–136. Salvador Dalí, *Untitled*, also known as *Dawn* (left), 1977, and Michelangelo's *Dawn* (right), 1523

Dalí also created a collection of drawings of nudes, executed between 1940 and 1968, and published them in a 1969 book called *The Erotic Metamorphoses*. The difference between eroticism and pornography, Dalí wrote in this work, is that eroticism was "divine by nature" and a source of happiness, whereas pornography debased the human body and could only produce unhappiness. Some of his late nude studies, such as *Figure Climbing a Stair*, 1967, and the *Nude*, 1974, are exceptional works of art that show Dalí's unique talent as a draftsman, even this late in his career.

As Dalí grew older, his reliance on Renaissance, Baroque, and nineteenth-century models became even more pronounced.

His 1977 book *The Wines of Gala and the Divine,* a sequel to his book *The Dinners of Gala,* which is now largely forgotten, features two absurdist collages, one of which combines a flood of Bouguereau nudes with a photo of a cat. The painting *Athens is Burning!* (1980) revisits Raphael's monumental *School of Athens* (1509–1511). *Copy of a Rubens Copy of a Leonardo* (1979) is a close rendition of Peter Paul Rubens's 1603 copy of Leonardo da Vinci's *Battle of Anghiari.* Actually, Ruben's drawing was taken from another intermediary version, since the original (unfinished) fresco by Leonardo was destroyed in the 1550s.

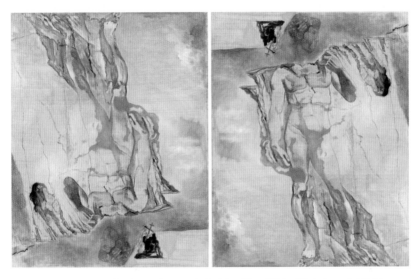

Figs. 137–138. Salvador Dalí, *Untitled (After "David" by Michelangelo)* (left), c. 1983, and the same painting turned upside down (right)

*Dawn* (1977) and *Giuliano's Head* (1982) are just two of a series of meditations on the work of another celebrated Old Master: Michelangelo's figures from his Medici tombs (1524–1534) in the Medici Chapels in Florence. Similarly, *The Pearl* (1981) is a study of the figure of the Infanta Margarita Teresa

from Velázquez's *Las Meninas* (1656) and forms one of a series of paintings in the early 1980s inspired by this Baroque masterpiece. A particularly interesting interpretation is Dalí's *Pietà* of 1982, inspired by Michelangelo's sculpture group from 1502. Another intriguing painting, a 1983 landscape with a hidden image of Michelangelo's *David*, appears to be a study of a rock formation. When the painting is turned upside down, it becomes a depiction of *David*.

Dalí's longtime muse, Gala, died in the early morning of June 10, 1982. For sixteen years, she had lived separately from Dalí in a castle in Púbol that he bought and renovated for her at great expense. Gala reciprocated his generosity by stipulating that he was allowed to visit her in Púbol only if explicitly invited to do so—in writing. Dalí could do little but obey, sheepishly remarking that "sentimental rigor and distance—as demonstrated by the neurotic ceremony of courtly love—increase passion."

That distance, however, also allowed his wife to indulge in her passion for young lovers to her heart's content, as a "lady looking for her lost Russian youth," in the words of Jordi Artigas Cadena, one of the curators of a 2018 exhibition about Gala Dalí at the National Art Museum of Catalonia in Barcelona.[150]

Salvador Dalí's last years were therefore not happy ones, notwithstanding the honors that were increasingly bestowed upon him. In 1979, he was elected to the Académie des Beaux-Arts at the Institut de France—a signal honor for any artist, certainly a Spanish one. In 1982, he was raised to nobility by the newly restored King Juan Carlos, with the title of Marquès de Dalí de Púbol. In 1983, a major retrospective of his work was opened at the Museo Español de Arte Contemporáneo in Madrid by Prince Felipe, the King's son.

But the loss of Gala—even as the remote goddess that she had become—was a shock too much to bear. "If Gala died, it would be terribly difficult to come to terms with it," he confessed in 1966.

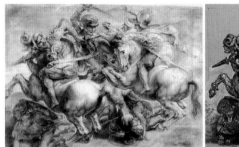

Figs. 139–140. Peter Paul Rubens, *Battle of Anghiari* (left), 1603, and Salvador Dalí, *Copy of a Rubens Copied from a Leonardo* (right), c. 1979

No one could ever take her place. "It's a total impossibility," he said. "I'd be completely alone." Now, that terrible event had come to pass.[151]

He moved to Gala's rambling castle at Púbol, never to set foot in Port Lligat again. His studio, abandoned, was never sealed or placed under guard. Rumors have swirled ever since about the treasure trove of drawings, prints, photos, and archival material that various people may have absconded with.

Dalí himself became increasingly obsessed with death, as illustrated by his many drawings and studies after Michelangelo's Medici tomb figures. He lost his voice and could only be understood by those adept at lip-reading, or patient enough to decipher the hoarse murmurs escaping from the artist's lips. On November 27, 1988, he was admitted to the hospital in Figueres with symptoms of the flu. The next day, he was transferred to a clinic in Barcelona, but since the ambulance was too big to arrive at the front door, Dalí was carried into the hospital on a stretcher, in full

view of a phalanx of reporters and cameramen.

The weeks that followed were punctuated by a steady series of medical bulletins, reminding many Spaniards of the stream of press releases that had attended the slow decline of General Franco, thirteen years earlier. On December 5, 1988, even the king came to pay the visibly weakening Dalí a visit. Then, on January 21, 1989, as Dalí lay dying, the world was treated to the unusual spectacle of the mayor of Figueres, Marià Lorca, declaring during a press conference that Dalí had expressed his wish to be buried underneath the great dome of the Dalí Theatre-Museum, rather than next to Gala's tomb in Púbol. This announcement was highly controversial, as others maintained that Dalí had always insisted on a burial next to his lifelong muse Gala.

Nonetheless, after Dalí died two days later at age eighty-four—reportedly to the strains of his favorite record, Wagner's *Tristan und Isold*—he was duly interred in the Theater and Museum in Figueres. The funeral service took place in the Església de Sant Pere where young Dalí had been baptized and taken his first communion.

# EPILOGUE

*Have no fear of perfection—you'll never reach it.*

Salvador Dalí

**W**hat **is the** secret of Salvador Dalí's enduring success? The artist himself would have argued, as he did in his radio interview with Parinaud, that he was the only one in the twentieth century who maintained the standards of draftsmanship and beauty that had defined Western art for over five hundred years. While modern art lost itself in a spiral of nonfigurative, abstract art that would ultimately come to negate the painted surface itself, Dalí believed that he had remained true to "ultra-academic painting." He had cleaved to a form of art, in sum, that was accessible and enjoyable for the general public, regardless of age or social condition—in sharp contrast to abstract art movements that were of interest only to a small elite of critics, collectors, and investors. "It is only through

virtuosity of such an order that the possibility of something else becomes available," he declared.

Increasingly, Dalí saw himself as a messianic figure who could resolve the growing tensions between science and art, between sterile modernism and pure beauty, between reason and faith. True to form, he prophesied that his style of "quantum realism" would eventually become the dominant art form of the new age. "It will take into account what the physicists call quantum energy," he said, "what mathematicians call chance, and what the artists call the imponderable: beauty." The picture of tomorrow, he argued, "will be a faithful image of reality, but one that will sense that it is a reality pervaded with extraordinary life." In that sense, he added, Velázquez and Vermeer had shown him the way. "They already intuited the fears of modern man. . . . The great artist must be capable of assimilating nothingness into his painting. And that nothingness will breathe life into the art of tomorrow."

But as we have seen throughout the arc of Dalí's oeuvre, the artist used the work of the Old Masters selectively. He could borrow their motifs; he could cite certain passages, such as Raphael's *Sistine Madonna* or Vermeer's *The Lacemaker;* but the *Gestaltung,* the overall realization, was always undeniably Dalínian. Rarely did he copy a Renaissance or Baroque composition outright, unless he merely sought to study the master's way of thinking, as with da Vinci's *Battle of Anghiari* or Vermeer's *The Lacemaker.* Instead, throughout his career his art remained rooted in the academic vernacular of the nineteenth century, of the Pompiers and their Spanish followers, even if the conceptualization remained imbued with surrealist imagination and wit. For Dalí, painters such as Meissonier and Fortuny were "a thousand times more interesting than the representatives of all those fast-fading 'isms' of modern art."[152]

# Epilogue

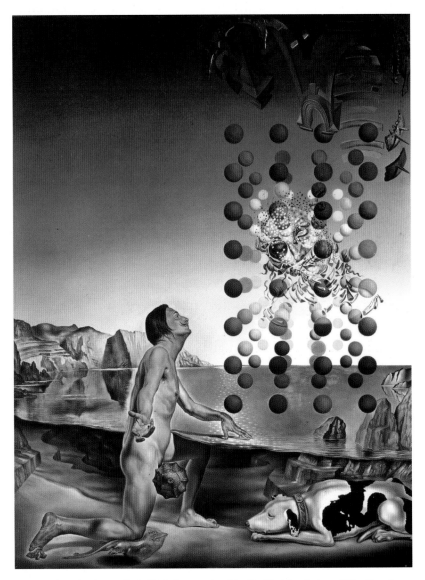

Fig. 141. Salvador Dalí, *Dalí Nude, entranced in the Contemplation of Five Regular Bodies Metamorphosed in Corpuscles, in which suddenly Appears Leonardo's "Leda," Chromosomatised by the face of Gala,* c. 1954. Dalí saw himself as a messianic figure who would resolve the growing tensions between science and art, between modernism and beauty, between reason and faith in the postwar world.

In leading the revolt against the figurative abstractions of his era, Dalí in a sense mounted his own counterreformation, just as the artists he so admired—Velázquez, Murillo, Zurbarán—were leading exponents of the Counter-Reformation to northern Protestantism. It was Dalí's misfortune that his ideas, and particularly his later work, were not well received by the art critics of his time, and not just because they were repelled by his eccentric behavior, his rambling theories, or his devotion to media celebrity. No, in their eyes Dalí's ultimate sin was that he abandoned the guiding principle of modern art, the ongoing deconstruction of form. He instead chose to return to the discredited ideas of nineteenth-century academic formalism.

Fortunately, the critics' hostility stood in sharp contrast to the popularity that Dalí's art enjoyed among the public. While modern art increasingly became the province of the elite, Dalí's art rekindled the yearning among audiences—and particularly American audiences—for a form of artistic expression that was beautiful to look at, and sufficiently mysterious to provoke thought. As Jean-Louis Ferrier wrote in his 1980 book *Leda atomica—Anatomie d'un chef-d'oeuvre,* "Salvador Dalí differs from most modern painters in his extraordinary virtuosity, which consists in a direct continuation of classical austerity. The artist's painstaking craftsmanship goes hand in hand with a polymorphous grasp of culture, which includes traditional disciplines of knowledge as well as contemporary science. . . . These things are vital to the meaning of his art."

Many of his critics blasted his postwar oeuvre as a break with Surrealism, but Dalí himself would not agree. He rejected the idea that a return to the technique and style of traditional realism also implied a break with Surrealist principles. Only by blending reality and imagination, the physical and the metaphysical, he

argued, could Surrealism continue to plumb the human subconscious and the wellspring of spontaneous ideas. In that sense, the Spanish Baroque of the Counter-Reformation served him well not only because of its plethora of religious motifs but also because the Spanish Baroque had explored new ways of negotiating the boundaries between the earthly and the ethereal.

At the same time, Dalí was perhaps the only modern artist in which a devotion to religious themes could move in parallel with highly explicit erotic ideas. Even during his nuclear-mystical phase, as we saw, he remained passionately devoted to exploring the mysteries of the human sexual response, but now in a more abstract, almost clinical manner—or what William Jeffett has coined a "cold" eroticism versus the "hot" eroticism of the late 1920s and early 1930s. Two years after painting *Young Virgin Auto-Sodomized by Her Own Chastity*, Dalí declared that "I am in a state of permanent intellectual erection, and all my desires are granted." Much of his work, he explained, including his "long masturbatory discipline," has produced "the creation of a veritable cult of my own cock, which I never ceased celebrating in all my work and actions, essentially notable for their aggressively phallic value."[153] For Dalí, eroticism was the secret energy that powers human life, including the human impulse to create art. Therefore, the two were closely intertwined.

And yet, while Dalí was certainly an artist of the twentieth century, his temperament was always infused with the tradition of Western art. He channeled Vermeer in the psychological heft of his figures, just as he took inspiration from Velázquez and Murillo in the treatment of texture, surface, and light. His still-life studies breathe the art of Zurbarán, just as his attempts to apply "sacred geometry" follow in the footsteps of Leonardo da Vinci. His draftsmanship, without parallel in the twentieth century, was

schooled in the art of Ingres. But his mise-en-scène, his conceptualization of a scene as a narrative of myth and imagination, was always indebted to the virtuoso technique of the Pompiers, the paragons of nineteenth-century academic art. "Those who do not want to imitate anything, produce nothing," he famously stated, which is why every painter "must have ultra-academic training." Without that essential command of the palette and the optical effects it could conjure, there could be no art—at least not in the conventional sense.

"In the future, when Dalí's paintings have fallen into the proper perspective with the work of artists of all periods, much that seems significant to us today may lose its interest," Theodore Rousseau, then-curator of paintings at the Metropolitan Museum of Art, wrote in a prescient 1962 essay. "However, he will always stand out as one of the very few twentieth-century painters who combines a profound respect for the traditions of the past with intensely modern feelings." Therefore, Rousseau concluded, "People will always look at his work because of his extremely personal and always surprising imagination, for that is where his genius lies."

Dalí would have wholeheartedly agreed with that assessment. After all, he always claimed that "my art is neither intellectual nor sentimental"—thus taking a deliberate swipe at the "conceptual" movements that swept the art world in his later years. Instead, he added, "[It] is that essential part of my existence that is located in the hole of my being, between what has been sensorially and physically lived and inquisitorial intelligence. I paint in order to be, and to unite all the forces of the self."[154]

# ESSAYS

**by Christopher Heath Brown**

## A New Interpretation of *The Persistence of Memory*

**O**f all of Salvador Dalí's works, *The Persistence of Memory* is perhaps the most famous and the most evocative of the master's Surrealist approach to modern reality. Originally known as *Soft Watches* but soon baptized as *The Persistence of Memory,* the painting was anonymously donated in 1934 to the New York Museum of Modern Art, which itself had only been established in 1929. Thus, the art of Dalí was introduced to a nation that would serve as his refuge and the source of his wealth in the decades to come.

As we saw in a previous chapter, the title of the work was suggested by Gala. In his 1931 book, *The Secret Life*, Dalí wrote that when he showed Gala the finished painting, he asked, "Do you think that in three years you will have forgotten this image?"

271

Gala replied, "No one can forget it once he has seen it." This would lead to the painting's eventual title, *The Persistence of Memory*.

One of Dalí's notable quotes is that "the secret of my influence has always been that it remained secret." It is certainly no secret that Gala served as Dalí's muse, and that she may have pushed him toward classicism, rather than Surrealism, in the belief that he would always be in conflict with the other Surrealists—not only for purely aesthetic but also political reasons. One of the arguments of this book, however, is that the "secret" that Dalí was referring to is the impact that the Old Masters had on his oeuvre, starting with his encounter with Leonardo da Vinci as a young man in 1919. In my view, this is particularly apparent with two da Vinci works, *The Baptism of Christ* and *The Adoration of the Magi*, and the role they play in *The Persistence of Memory*.

As we saw previously, at the center of *The Persistence of Memory* is a soft, whale-like shape that is reminiscent of Dalí's profile self-portrait in *Face of the Great Masturbator*. Some have associated this shape with a passage in Hieronymus Bosch's triptych *The Garden of Earthly Delights*. The long eyelashes suggest that the face is sleeping, thus reinforcing the painting as a dream.

How to interpret this mysterious work? One way, in my opinion, is to look at precedents in the art of Leonardo da Vinci, and particularly his contribution to *The Baptism of Christ* by Andrea del Verrocchio, the master of the Florence studio where Dalí had apprenticed between 1467 and 1472. It is generally assumed that in the course of this apprenticeship, Verrocchio entered into a partnership with his young prodigy, in the sense that Leonardo worked on his canvases so that Verrocchio could devote himself to his principal talent as a sculptor.

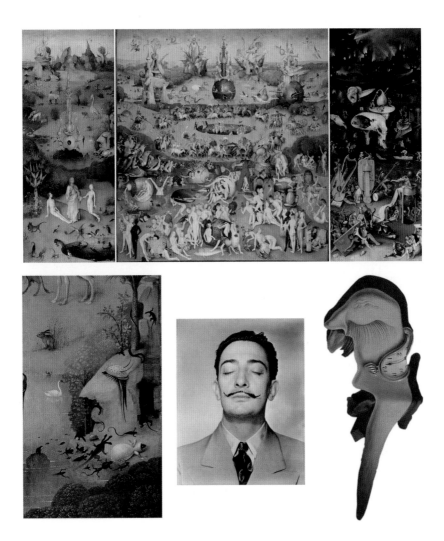

Fig. 142. Hieronymus Bosch, *The Garden of Earthly Delights* (top and bottom left), c. 1490–1510, with details of the rock, an image of Dalí sleeping (bottom center), and the shape from *The Persistence of Memory* (bottom right)

273

Fig. 143. A source for the anthropomorphic shape in *The Persistence of Memory* could be this rock near Port Lligat, a suggestion that would dovetail with Dalí's description that "This picture represented a landscape near Port Lligat, whose rocks were lighted by a transparent and melancholy twilight."

*The Baptism of Christ* was begun in 1472, Leonardo's last year in the studio, and was commissioned by the monks of the San Salvi monastery, located just outside Porta alla Croce. It is the oldest known work by Leonardo's hand, and already it reveals the extent of his talent. Vasari writes that after Verrocchio saw the angel that Leonardo had painted next to the angel by his own hand, and realized the superiority of its form and execution, "he never touched color" again. What actually happened is that Verrocchio saw that Leonardo could be entrusted to create paintings of high quality, which would enable him to focus on his sculpture commissions. Indeed, several authors have argued that the partnership between the master and the pupil continued after Leonardo left the workshop to strike out on his own.

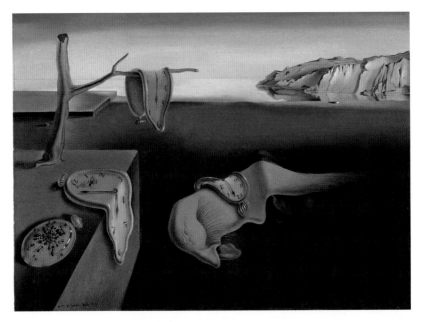

Fig. 144. Salvador Dalí, *The Persistence of Memory*, 1931

The attribution of the angel at left in *The Baptism of Christ* as a work by Leonardo was well known in the early twentieth century. Jacob Burckhardt, the foremost art historian at the turn of the century, refers to it in *The Cicerone: Or, Art Guide to Painting in Italy*.[155]

That Dalí was interested in Leonardo from an early age is attested by the fact that at age fifteen, he described Leonardo in his magazine *Studium* as "the greatest master of painting, a soul that knew how to study, to invent, to create with ardor, passion, and energy, which was how he lived his whole life." "His paintings," Dalí added, "reflect his constant love, dedication, and passion for his work."[156]

Two years before *The Persistence of Memory*, Dalí painted a miniature portrait of the *Mona Lisa* in his 1929 work *Imperial*

Fig. 145. Andrea del Verrocchio, *The Baptism of Christ*, 1475

*Monument to the Child-Woman.* This admiration for da Vinci also extended to the Surrealist pavilion he was commissioned to design for the 1939 World's Fair in New York, around the theme of "Dream of Venus," as we will see shortly. In addition to Botticelli's *Birth of Venus*, Dalí also adorned the pavilion's façade

276

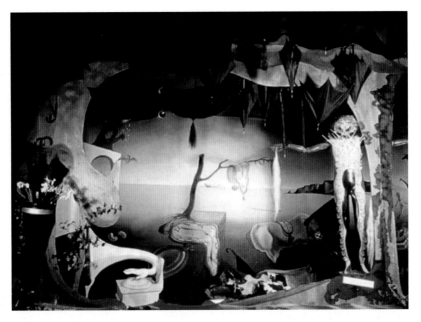

Fig. 146. The *Dream of Venus* tableau in the Dream
of Venus Pavilion, 1939 World's Fair

with Leonardo's *St. John the Baptist* (1516), though he replaced
the face of the saint with that of the *Mona Lisa* (1513).

Inside the pavilion proper, he created a tableau inspired by his
now-famous painting *The Persistence of Memory*, entitled *The
Dream of Venus*. The scene is broadly similar. The clock balanced
over the edge of the table is set at 5:58; the clock draped over the
tree branch points to 6:00; and the clock that drips over the face
in center may be set at 6:02—thus producing a circular cycle of
the past, the present, and the future. It may have been inspired by
Dalí's interest in the *vanitas* motif—the idea that the watch, as a
measure of our own mortality, is itself subject to inevitable decay.
What is particularly intriguing about this tableau is the figure at
right, with enlarged genitalia, who appears to be holding a plume.

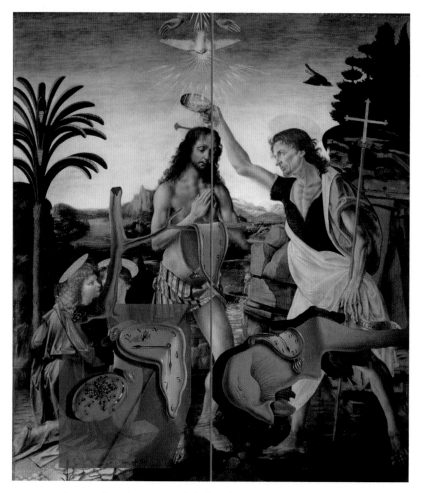

Fig. 147. Superimposition of the key elements from *The Persistence of Memory* on Verrocchio's *Baptism of Christ*

In our interpretation, he is pouring water—a suggestion that is reinforced by the presence of a scuba diver directly underneath this figure.

It is therefore conceivable that this scene is inspired by Verrocchio's *Baptism of Christ*, which also represents a circular

cycle of time. The angels symbolize the past; John the Baptist, who announces the coming of Christ to the world, is the future; and Christ himself is the never-ending present, in the sense that the redemption he brought is everlasting, as shown in the diagram.

This interpretation is further reinforced by a photograph of Dalí, seated in the center of the pavilion tableau and placed directly under the "water" being poured out by the figure standing in for John the Baptist.

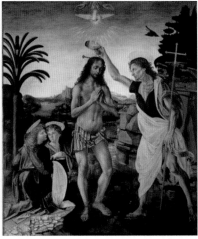

Figs. 148–149. Leonardo da Vinci, detail from *The Adoration of the Magi* (left), 1481, and Verrocchio's *Baptism of Christ* (right), 1475

There are also possible correlations between *The Persistence of Memory* and Leonardo's *The Adoration of the Magi*. In fact, when one overlays *Persistence* over *Baptism of Christ*, the relationship of the *Baptism* palm to the Dalí trunk is an exact match to the tree in the *Adoration*. Furthermore, in *The Persistence of Memory* one melting clock is hung from the tree branch, while a similar shape is present in the same position as a saddle on a horse in *The Adoration of the Magi*.

Fig. 150. Leonardo da Vinci, *Drawing with an Old Man and Concentric Circles*, c. 1490

Another Leonardo work that may have bearing on this comparison is his sketch of concentric circles, placed upon the lower left-hand area, with a hidden crucifix and an area of mountains in the middle of the page. As we argued previously, Dalí was aware of the sacred geometry theories of Luca Pacioli, which were later adopted by Matila Ghyka.

In moving each clockface (past, present, and future) to the midline when overlayed with *The Baptism of Christ*, three concentric circles are formed. It is apparent, however, that in this geometry, one concentric circle is missing. This problem was corrected when Dalí painted Changes in Great Masterpieces, and an

Fig. 151. Montage with *The Baptism of Christ*, elements from *The Persistence of Memory*, and the three concentric circles

additional time unit was placed between the present and future clocks, just as indicated by Leonardo's drawing. Not only does this comparison suggest a direct match with the geometry, but the mountain range in the drawing is also a direct match with the mountain range Dalí painted in the background to the far right.

281

The idea of *The Persistence of Memory* as a timeline is a theme that Dalí would explore in his future work as well, again using the attribute of a watch. The three Dalí drawings shown below could likewise be interpreted as a vision of the past, present, and future.

Leonardo's art would continue to exert a strong influence on Dalí in the years to come, as witnessed by his citations of da Vinci paintings in *Inventions of the Monsters* (1983), *Leda Atomica* (1949), *Dalí Nude, in Contemplation Before the Five Regular Bodies* (1954), and *The Sacrament of the Last Supper* (1955). Most importantly, Dalí saw Leonardo as one of the precursors of the paranoiac-critical method "by recommending to his pupils that, for inspiration, in a certain frame of mind, they should regard the indefinite shapes of the spots of dampness and the cracks on the wall."[157] What this suggests is that, as David Lomas wrote, Leonardo's work "afforded an inexhaustible resource from which Dalí drew in distinct ways at various moments throughout his career, but most intensively when he embarked on a neo-traditional return to painting."[158] Thus the idea that Leonardo's first painting would have played a key role in Dalí's signature masterpiece is perhaps not implausible.

Fig. 152. Salvador Dalí, *Vigor of Youth* (left), *One's Identity* (center), and *Reflections* (right), from Cycles of Life, c. 1969–1978

# Illusion and Meaning in Dalí's
## *The Skull of Zurbarán*

*T*he *Skull of* Zurbarán, currently in the collection of the Hirshhorn Museum in Washington, DC, was painted by Salvador Dalí in 1956, during the height of the artist's nuclear-mystical period. At first glance, it appears to be inspired by the search for optical illusion so typical of this era. Dalí obviously delights in the ambiguity of the cubes that make up this skull: depending on how you look at the picture, the dark surfaces of the cubes are either the bottoms (ascending) or the tops of the cubes (descending).

On closer inspection, however, there are a number of other elements at play. To begin with, the work bears no obvious resemblance to the original 1660 painting by Francisco de Zurbarán, *The Ecstasy of St. Francis*, which depicts the saint with a skull

Fig. 153. Salvador Dalí, *The Skull of Zurbarán*, 1956

as a symbol of *vanitas*, or human vanity. The Spanish artist executed several portraits of St. Francis, each showing the saint in a different pose.

Then as now, Francis was a very popular saint in Spain. The son of a rich silk merchant from Assisi, Tuscany, Francis lived the carefree lifestyle of the well-to-do before renouncing his privileged position in order to embrace poverty. He dedicated himself to ministering to the poor and the sick and gained a large following in the process. Dressed in a rough garment, he would cheerfully move

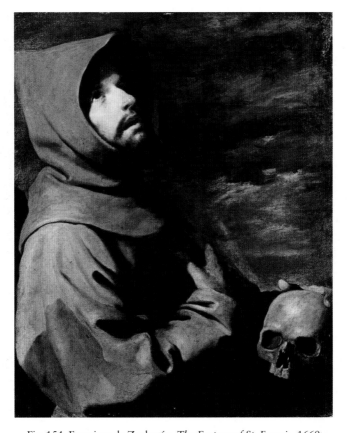

Fig. 154. Francisco de Zurbarán, *The Ecstasy of St. Francis*, 1660

from one Umbrian village to the next, singing and glorifying God while admiring the beauty and perfection of Creation. In 1209, Francis successfully petitioned to have his new movement recognized by the Pope, though he was not an ordained priest and had no clerical education whatsoever. Astonishingly, Pope Innocent III granted his request. The result was the Franciscan order, which rapidly spread through southern Europe, including Italy and Spain.

Dalí, however, seems to have focused on one particular attribute of St. Francis, namely the skull, which appears in almost

Fig. 155. Salvador Dalí, *Study for The Skull of Zurbarán*, 1955

every Zurbarán portrait of the saint. The skull is also a prominent motif throughout Dalí's oeuvre, as it exemplified Dalí's fascination with putrefaction, decay, and death.

*Study for The Skull of Zurbarán*, executed in 1955, shows the ideas that Dalí was exploring as he pondered his subject. Here, too, there is very little that reminds one of the Zurbarán original. In fact, where the skull in the Zurbarán painting lacks a jaw with teeth, the study appears to suggest that there would be some indication of the skull's teeth, though what form this would take is as yet indistinct. Instead, the study shows that Dalí's primary focus was on using the two upper dark sides of the cubes as the eyes, and to frame this skull in a semicircular archway, facing a floor with distinct black and white tiles.

In addition, Dalí was exploring the idea of creating an almost seamless transition between the tile pattern of the pavement, and

the cubes that make up the skull, so as to make the overall optical illusion even more ambiguous.

The idea for this pattern is perhaps reflected in the Zurbarán room in the Museum of Cádiz in Spain, built in the 1970s; the similarity between the tiled floor in the museum and that which appears in the drawing and subsequently in the canvas is quite obvious. In addition, the works by Zurbarán are displayed in a curving structure, like the apse in a basilica-type church, which may have been inspired by the alcove in which Dalí has placed his skull.

Fig. 156. The Zurbarán Room in the Museum of Cádiz, Spain

The drawing also includes a sketch of two robed monks at the far left, though the role that these monks would play in the final composition was yet to be determined.

That problem was resolved in Dalí's finished canvas, which is a perfect square measuring thirty-nine by thirty-nine inches and reveals a further refinement of the overall trompe l'oeil illusion. The group of monks, clad in white robes, now serves as a double

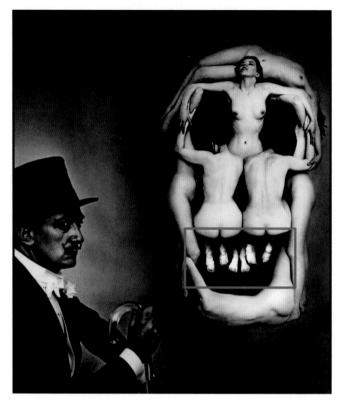

Fig. 157. Philippe Halsman, *Voluptas Mors* ("Voluptuous Death"), 1955

image, suggesting a row of teeth for the skull. This idea—to complete a skull with a row of teeth by other means—is already present in Philippe Halsman's famous photo of Dalí in *Voluptas Mors* of 1951. Seven nude women are carefully positioned to create the image of a skull, in which the feet of the center group function as a row of teeth—two central incisors, two lateral incisors, and two canines.

By comparison, if the white-robed monks in *The Skull of Zurbarán* serve to complement the image of the skull with teeth, then it is also immediately obvious that one of the monks, i.e.

288

one of the teeth, is missing. Dalí worked very deliberately in his compositions, so this omission is not by chance. Why would he have left one of the monks out of what otherwise would be a perfect row of teeth? Furthermore, the bottom cubes of the skull have been hollowed out by two circular archways. They do not seem to function as any type of anatomical landmark, so why would Dalí create them?

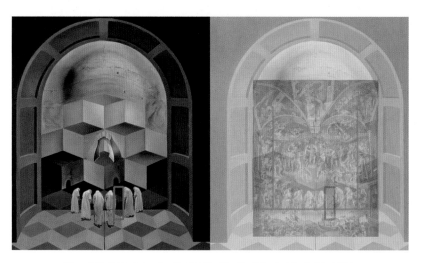

Figs. 158–159. Salvador Dalí, *The Skull of Zurbarán* (left), 1956, with missing tooth highlighted, and superimposition of *The Skull of Zurbarán* on Michelangelo's *Last Judgment* (right), 1536–1541

The answers may be found in the painting that served as a model for *The Skull of Zurbarán*, Michelangelo's *Last Judgment*. This is by no means an unusual suggestion. Throughout his career, Dalí often referred to specific figures or poses from Michelangelo's frescoes in the Sistine Chapel, including *The Ecumenical Council*. In addition, Dalí made a series of exhaustive studies of Michelangelo's figures that populate the Medici tombs in the Medici Chapels in Florence.

Like *The Skull of Zurbarán*, Michelangelo's magnificent fresco has also been proposed as an optical illusion—specifically, as a huge negative image of a skull. This is eminently plausible for a work purporting to depict the Last Judgment of Christ. Furthermore, the idea of Michelangelo's depicting a subliminal skull is supported by medieval and early Renaissance cosmology. This cosmological understanding was rooted in the Book of Genesis. A flat surface called Earth, the central element, supported human life; underneath it lay Purgatory and Hell; and above it rose the canopy of Heaven. The proportions of this cosmos were believed to be the same as those of the Tabernacle built by Moses: rectangular and twice as long as wide—dimensions that were faithfully repeated in the Temple of Solomon. These same dimensions are present in the Sistine Chapel, built by Sixtus IV between 1477 and 1480, while Leonardo was still in Florence. In other words, while the chapel's architecture deliberately echoes Solomon's Temple, the fresco of *The Last Judgment* extends those dimensions into a cosmological map of the zones of Heaven, Earth, and Hell, with Christ as the Supreme Judge at its center.[159]

When we superimpose Dalí's *The Skull of Zurbarán* on *The Last Judgment*, a few things become immediately apparent. The left archway in Dalí's canvas lines up perfectly with a figure who seems to be pointing to the figure of St. Bartholomew at right. This saint was a martyr who was flayed alive and whose attribute is therefore his own flayed skin. Remarkably, the second archway lines up with St. Bartholomew itself, so that the rather grotesque image of the skin, which is generally believed to be Michelangelo's self-portrait, fills up the lacuna of the missing tooth in Dalí's canvas.

Another remarkable observation may be made of the friar to the right of midline in Dalí's *The Skull of Zurbarán*. This is

the only friar who has a dark line at the waist level, which is consistent with the edge of the flooring over which each of the friars appears to be "floating." The choice for the verb "floating" is deliberate, since in *The Last Judgment*, individuals also appear to be suspended by clouds. If we look closely at Michelangelo's fresco, we will see that the position to the right of midline happens to contain the *only* grouping with two clouds, one above the other. In our view, the line in the friar's clothing must therefore be related to the similar division in *The Last Judgment*.

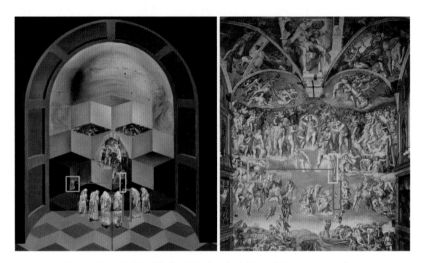

Figs. 160–161. *The Skull of Zurbarán* (left) and the corresponding position of the archways in Michelangelo's fresco (right)

What this tells us is that the influence of the Old Masters, and specifically Michelangelo, on Salvador Dalí may have unfolded on several levels. Though Dalí could quote specific passages from Renaissance, Baroque, or nineteenth-century paintings—including, for example, the figures from François Millet's *L'Angelus*—the inspiration he drew from these works also operated on a more imaginary level. Thus, Michelangelo's *Last Judgment* and

its subtle double-image allusion to a human skull may have inspired Dalí to attempt something similar with his meditation on *The Skull of Zurbarán*. There is no doubt that he considered Zurbarán one of the most influential Spanish artists. When Alain Bosquet asked him to give his opinion on Ribera and Zurbarán, Dalí replied, "Together with Velázquez, they are the greatest Spanish painters."[160]

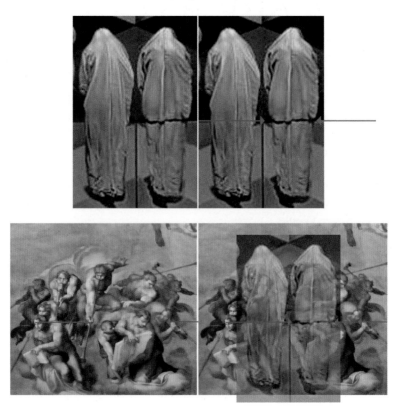

Figs. 162–163. Details from *The Skull of Zurbarán* and the group of the *Last Judgment* suspended on two clouds

# TIMELINE OF THE LIFE AND ART OF SALVADOR DALÍ

**1904**   Salvador Domingo Felipe Jacinto Dalí i Domènech is born on May 11 in Figueres, Spain. He is the son of the notary Salvador Dalí Cusí and his wife, Felipa Domènech Ferres.

**1908**   Anna Maria Dalí, Dalí's sister, is born. Dalí père enrolls Salvador at the Escuela Publica (State Primary School) under the teacher Esteve Trayter.

**1909**   Dalí is taken to his brother's grave and told by his parents that he is his brother's reincarnation. This is a concept that Dalí will come to believe.

**1910**   Dalí's father is displeased with Dalí's progress in school and transfers him to a private school (Hispano-French School of the Immaculate Conception in Figueres), where his classes are in French, the language he would use as an artist. Summer months are spent in Cadaqués. Dalí paints his first landscape piece.

**1916**   In Cadaqués, Dalí studies painting with a family friend, Ramon Pichot, and discovers Impressionism. He attends secondary school at Marist Brothers School/Figueres Grammar School and evening art classes taught by Juan Núñez at the Municipal Drawing School in Figueres.

**1917**   Dalí's father exhibits Dalí's charcoal drawings in a show at the family home.

**1919**   Dalí takes part in a group exhibit at the Societat de Concerts rooms in Figueres's Municipal Theater (which years later will become the Dalí Theatre-Museum). Dalí writes an article on Leonardo da Vinci that is published as *"Los Grandes Maestros de la Pintura."*

**1921**   Dalí's mother dies of breast cancer. His father marries her sister the next year. Henri Matisse and Raphael influence Dalí's art.

**1922**   Dalí enters the Real Academia de Bellas Artes de San Fernando (the Royal Academy of Fine Arts of San Fernando) in Madrid. Dalí experiments with several avant-garde painting styles (Cubism, Futurism, and Purism) and draws attention for being somewhat of an eccentric and a dandy.

**1923**   Dalí is expelled from the Royal Academy of Fine Arts of San Fernando for criticizing lecturers and leading a student protest. He returns to Figueres and again takes classes with Juan Núñez in the technique of etching.

**1924**   Dalí creates his first illustrated book (Catalan poem: *Les bruixes de Llers*) and returns to Royal Academy of Fine Arts of San Fernando, where he is obliged to repeat an academic year.

**1925**   Dalí's first one-man show at the Dalmau Gallery in Barcelona premieres. He does not attend school at the Royal Academy of Fine Arts of San Fernando. He paints a series of portraits of Anna Maria, including *Figure at a Window*.

**1926**   Dalí visits Paris for the first time and meets Pablo Picasso, the pioneer of Cubism. Dalí is permanently expelled from school for declaring the tribunal tasked with examining him as incompetent. He returns to Figueres and devotes himself to painting. Dalí produces *The Basket of Bread* as his first major recognition of Old Master painting.

**1927**   Dalí's second individual exhibition at Dalmau Gallery in
Barcelona, and an exhibit at the Second Autumn Salon in the
city's Sala Pares gallery. His works show the first clear signs
of Surrealism. Dalí reports to Castle of San Fernando for nine
months of military service.

**1928**   The exhibition of *The Basket of Bread* at Carnegie Institute in
Pittsburgh, Pennsylvania, gains Dalí international acclaim.

**1929**   Dalí makes his first film, *Un Chien Andalou*, with his friend Luis
Buñuel, and they officially join the Surrealist movement. Dalí
meets his future lifelong companion, Gala (Elena Ivanovna
Diakonova). He grows a mustache influenced by master
painter Diego Velázquez, which he will keep his entire life as
his trademark. Dalí falls out of favor with his father due to his
relationship with Gala and because of his comment about spitting
on his mother's portrait.

**1920s**  Dalí's art reveals the influence of various classicist artists, includ-
ing Raphael, Bronzino, Zurbarán, Vermeer, and Velázquez, often
in combination with modernist techniques. He goes to Paris and
meets artists such as Picasso, Miró, and Magritte, which leads
him to his first Surrealist phase.

**1930**   Dalí buys a home in Port Lligat, near Cadaqués. He develops
his paranoiac-critical method and fully integrates into
Surrealism. The 1930s will be known as the period in which Dalí
enters his prime years and when he becomes notorious for his
colorful personality and flamboyance. He creates the film *L'Age
d'Or* (*The Golden Age*) in collaboration with Luis Buñuel.

**1931**   Dalí paints one of his most famous works, *The Persistence of
Memory*, which features soft, melting pocket watches. He exhibits
at Pierre Colle Gallery in Paris and takes part in his first Surrealist
exhibit in the United States, held at the Wadsworth Atheneum
in Hartford. Dalí writes his book *L'Amour et la Memoire* (*Love
and Memory*).

**1932**     Dalí takes part in the exhibit Surrealism: Paintings, Drawings and Photographs, organized by the Julien Levy Gallery in New York. He writes his book *Babaouo*, in which he outlines his conception of the cinema. New York becomes a growing source of patronage for his work.

**1933**     The Julien Levy Gallery exhibits *The Persistence of Memory*. The work is compared to works of Renaissance artist Hieronymus Bosch, including *The Garden of Earthly Delights*.

**1934**     Dalí and Gala marry in a civil ceremony on January 30. André Breton, one of the Surrealist leaders, attempts to have Dalí expelled from the group after criticizing him for not following the principles of the Surrealist movement. Dalí rejects the leftist tendencies of the group.

**1936**     Dalí takes part in Exposition Surréaliste d'objets at the Galerie Charles Ratton in Paris. He gives a lecture in a deep-sea diving suit and helmet at the International Surrealist Exhibition at the New Burlington Gallery in London. He also takes part in the exhibit Fantastic Art, Dada, Surrealism at the MoMA in New York, and meets Edward James, who will become his patron and purchase many works, including the *Lobster Phone* and *Mae West Lips Sofa*. He is featured on the cover of *Time* magazine on December 14, with photography by Man Ray. The Spanish Civil War begins.

**1937**     Dalí creates fabric, clothing, and accessories for fashion designer Elsa Schiaparelli. Dalí visits Italy, where he is able to experience many art forms that prepare his shift toward a more traditional style.

**1938**   Dalí visits Sigmund Freud with the help of Stefan Zweig. He is invited by Gabrielle Coco Chanel to her home in La Pausa in Roquebrune. He paints several paintings that are later exhibited at the Julien Levy Gallery in New York. Dalí's *Rainy Taxi* is exhibited at the entrance to the Galerie Beaux-Arts in Paris for the Exposition Internationale du Surréalisme, organized by André Breton and Paul Éluard.

**1939**   Dalí creates the New York World's Fair Dream of Venus Pavilion, featuring classical motifs from da Vinci and Botticelli on its façade. He is insulted by Breton's anagram of his name Salvador Dalí: "Avida Dollars" ("Eager for Dollars"). Breton expels Dalí from the Surrealist group. Dalí designs costumes and sets for the Ballet Bacchanale at the Metropolitan Opera House of New York. He has a growing tendency to move away from Surrealism and toward the classicism of nineteenth-century academic art.

**1940s**  In the late 1940s and early 1950s, Dalí is more focused and deliberate in utilizing the classical style of the Italian Renaissance, the Spanish Baroque, and nineteenth-century classicism. At the same time, he is inspired by Catholic themes and motifs. His theory of "nuclear mysticism" seeks a synergy between faith, mysticism, and science.

**1940**   Dalí visits his father in Spain for the first time since their falling out ten years earlier. With the German invasion of France, Dalí flees to the United States. He returns to the practice of Catholicism.

**1941**   Dalí completes writing *The Secret Life of Salvador Dalí*, a partially fictionalized autobiography to be published the following year. He works on jewelry designs and meets photographer Philippe Halsman, establishing a relationship that lasts until Halsman's death in 1979. He exhibits at the Julien Levy Gallery in New York and designs costumes and sets for the Ballets Russes de Montecarlo at the Metropolitan Opera House. A MoMA gallery event is devoted to Dalí and Miró.

**1942**    *The Secret Life of Salvador Dalí* is published.

**1943**    Dalí and Gala meet Eleanor and Reynolds Morse, who become lifelong friends and devoted collectors.

**1944**    Dalí publishes his first novel, *Hidden Faces*.

**1945**    Dalí advises Alfred Hitchcock for the dream sequences of the movie *Spellbound*. The exhibit Recent Paintings by Salvador Dalí is held at Bignou Gallery in New York.

**1946**    Dalí is hired by Walt Disney to help produce the film *Destino*.

**1947**    Doubleday publishes *The Essays of Michel de Montaigne*, illustrated by Dalí.

**1947**    Dalí undergoes an exorcism by an Italian friar, Gabriele Maria Berardi, while in France.

**1948**    Dalí publishes *50 Secrets of Magic*. Dalí and Gala return to Port Lligat. For the next thirty years, this is where he will spend most of his time painting, in between trips to Paris and New York each winter.

**1949**    Dalí visits the pope and presents *The Madonna of Port Lligat*. Dalí paints *Leda Atomica*.

**1950**    Dalí's father dies. Dalí creates the "Costume for the year 2045" with Christian Dior.

**1951**    Dalí announces his development of "nuclear mysticism," inspired by the first atomic bomb on Hiroshima and subsequent atomic tests. Dalí paints *The Christ*.

**1952**    Dalí goes on a lecture circuit in the United States to espouse his nuclear mysticism. He paints *The Disintegration of the Persistence of Memory* and *Galatea of the Spheres*.

**1954**    Dalí presents the *Divine Comedy* at the Palazzo Pallavicini in Rome and paints *Corpus Hypercubus*.

**1955** Dalí paints *The Sacrament of the Last Supper* for Chester Dale.

**1956** Dalí paints *The Skull of Zurbarán*.

**1958** Dalí marries Gala on August 8 in a religious ceremony at the Els Angels shrine in Sant Vell, near Girona.

**1959** Dalí is featured in André Breton's exhibition Homage to Surrealism, marking the fortieth anniversary of Surrealism.

**1960** Dalí films the documentary *Chaos and Creation*. He begins work on the Teatro-Museo Gala Salvador Dalí and paints a portrait of Juan de Pareja, an assistant to Velázquez.

**1962** Dalí writes the book *The World of Salvador Dalí* and appears in a Manhattan bookstore in a bed wired to a machine that traces brain waves and blood pressure.

**1963** Dalí paints *Portrait of My Dead Brother* and publishes his book *Le mythe tragique de "L'Angelus" de Millet* (*The Tragic Legend of the 'Angelus' by Millet*).

**1964** Dalí is awarded the Gran Cruz de Isabel la Católica, which represents the highest Spanish honor. A Dalí retrospective exhibition is held at the Seibu Museum in Tokyo.

**1965** Huntington Hartford's Gallery of Modern Art in New York exhibits the entire Reynolds Morse Collection of Dalí art.

**1969** Dalí purchases Púbol Castle and decorates it for Gala. He becomes fascinated with optics, holography, science, and math in a quest to master three-dimensional images.

**1970** Dalí announces the creation of the Dalí Theatre-Museum in Figueres at a press conference at the Gustave Moreau Museum in Paris.

**1971** Dalí attends the opening of the Salvador Dalí Museum in Beachwood, Ohio, housing the Morse collection.

**1972**   Dalí's holograms are exhibited at New York's Knoedler Gallery.

**1973**   Dalí publishes various books including *A Study of His Art in Jewels*, *How One Becomes Dalí*, and *Les diners de Gala*.

**1974**   Dalí writes a prologue for and illustrates Sigmund Freud's book *Moses and Monotheism*. He opens the Dalí Theatre-Museum on September 28 in Figueres, Spain.

**1976**   Dalí paints *Gala Contemplating the Mediterranean Sea*.

**1977**   Dalí writes *Les Vins de Gala*.

**1978**   Dalí presents at the Guggenheim Museum in New York with a hyper-stereoscopic painting called *Dalí lifting the skin of the Mediterranean Sea to show Gala the Birth of Venus*. He is elected to the Académie des Beaux-Arts in Paris. He begins work on a series of paintings inspired by Michelangelo and Raphael.

**1980**   The London Tate Gallery organizes a Dalí retrospective with 251 works by Dalí. Dalí spends most of the year at his home in Port Lligat, recovering from illness. A tremor in his hands is diagnosed as Parkinson's disease.

**1982**   Gala dies on June 10 in Port Lligat. Dalí has her buried in a crypt at her home in Púbol Castle in Spain. The Salvador Dalí Museum moves to St. Petersburg, Florida. Dalí is ennobled as Marquès de Dalí de Púbol by Spain's king Juan Carlos I and goes to live at Púbol Castle.

**1983**   Dalí paints his last painting, *The Swallow's Tail*. A major anthological exhibition including four hundred works by Dalí from 1914 to 1983 is held in Madrid, Barcelona, and Figueres. Dalí designs *Universal Tarot Card Deck*.

**1984**   Dalí is severely burned in a fire at Púbol Castle. He is rescued by his friend and collaborator Robert Descharnes. He moves to Torre Galatea, an annex of the Dalí Theatre-Museum, where he lives until his death.

# Timeline of the Life and Art of Salvador Dalí

**1988**  In November, Dalí is hospitalized for heart failure and receives a pacemaker. He meets King Juan Carlos I and gives him a drawing, *Head of Europa*, which turns out to be Dalí's final drawing.

**1989**  Dalí dies of heart failure on January 23 in Figueres. He is buried in the crypt under the geodesic dome of the Dalí Theatre-Museum. His will grants all his property and remaining works that have not been previously donated to the Dalí Theatre-Museum to the Spanish state.

**1991**  The Salvador Dalí Museum acquires *Galacidalacidesoxyribonucleicacid*, a tribute to the double-stranded DNA helix.

**1994**  The Salvador Dalí: The Early Years exhibit travels the world.

**1995**  Gala's castle in Púbol opens as a museum. The Salvador Dalí Museum acquires *Portrait of My Dead Brother*.

**2000**  Reynolds Morse, Dalí's friend and the founder of the Salvador Dalí Museum, passes away. His wife, Eleanor, dies in 2009.

**2003**  The film *Destino*, an animated Disney/Dalí coproduction begun in 1945, is released.

**2011**  The new Salvador Dalí Museum in St. Petersburg, Florida, opens on January 11.

**2017**  Dalí is exhumed on June 26, 2017, for a paternity test that is negative. Dalí's trademark mustache is still intact.

# FURTHER READING

Dawn Adès and William Jeffett, Exhibition catalog to "Dalí/ Duchamp." Royal Academy of Arts/The Dalí Museum, October 2017.

Salvador Dalí, *The Secret Life of Salvador Dalí*. New York: Dial Press, 1942. Reprinted by Dover Press, 1993.

Robert Descharnes and Gilles Néret, *Dalí*. New York: Harry N. Abrams, 2003.

Robert Descharnes, *The World of Salvador Dalí*. New York: Macmillan, 1962.

Robert Descharnes and Gilles Néret, *Dalí: The Paintings*. Cologne: Taschen, 2016.

Meredith Etherington-Smith, *The Persistence of Memory: A Biography of Dalí*. New York: Da Capo Press, 1995.

Fèlix Fanés, *Salvador Dalí: The Construction of the Image, 1925–1930*. New Haven: Yale University Press, 2007.

Haim Finkelstein, *The Collected Writings of Salvador Dalí*. Cambridge: Cambridge University Press, 1998.

Ian Gibson, *The Shameful Life of Salvador Dalí*. New York: W. W. Norton & Company, 1998.

H. Hine, W. Jeffet, and K. Reynolds, *Persistence & Memory: New Critical Perspectives on Dalí at the Centennial*. St. Petersburg: The Salvador Dalí Museum, 2004.

William Jeffett, *Dalí Doubled: From Surrealism to the Self*. St. Petersburg, FL: The Salvador Dalí Museum, 2010.

Gilles Néret, *Dalí*. Cologne: Taschen, 2017.

Robert Radford, *Dalí: Art and Ideas*. New York: Phaidon, 1997.

Ralf Schiebler, *Dalí: Genius, Obsession and Lust*. Munich: Prestel, 1996.

Suzanne Stratton-Pruitt and William Jeffett, *Dalí and the Spanish Baroque*. St. Petersburg: The Salvador Dalí Museum, 2007.

Michael R. Taylor (ed.), *The Dalí Renaissance: New Perspectives on His Life*. New Haven: Yale University Press, 2008.

# NOTES

## 1. Beginnings

1. A notable exception is the catalog of an exhibit that was held at the Salvador Dalí Museum in St. Petersburg in 2007, entitled *Dalí and the Spanish Baroque*, curated by Suzanne Stratton-Pruitt and William Jeffett.

2. Salvador Dalí, *The Secret Life of Salvador Dalí*.

3. Ian Gibson, *The Shameful Life of Salvador Dalí*.

4. Gregori Dalí is noted as a "young labourer" (*jove trebellador*) who married Sabina Rottlens, daughter of a carpenter from the nearby town of Figueres. See Ian Gibson, *The Shameful Life of Salvador Dalí*.

5. Meredith Etherington-Smith, *The Persistence of Memory*, p. 7.

6. Dalí, *Secret Life*, as quoted in Etherington-Smith, *Persistence of Memory*, p. 9.

7. Dalí, *Secret Life*, p. 6.

8. Etherington-Smith, *Persistence of Memory*, p. 4.

## 2. The Early Years: 1922–1926

**9.** Alain Bosquet, *The Great Masturbator: Conversations with Salvador Dalí.* Elektron Books, 2013, p. 291.

**10.** Albert J. Lubin, *Stranger on the Earth: A Psychological Biography of Vincent van Gogh.* Holt, Rinehart and Winston, 1972, pp. 82–84.

**11.** Salvador Dalí, *The Tragic Myth of Millet's Angelus*, p. 74.

**12.** Dalí, *Secret Life*, p. 1.

**13.** Ibid.

**14.** Dalí, *Secret Life*, p. 11.

**15.** Robert Descharnes and Gilles Néret, *Dalí*, p. 7.

**16.** Zoltán Kováry, "The Enigma of Desire: Salvador Dalí and the Conquest of the Irrational," in *PsyArt*, July 29, 2009.

**17.** Ralf Schiebler, *Dalí: Genius, Obsession and Lust*, p. 7.

**18.** Etherington-Smith, *Persistence of Memory*, p. 18.

**19.** Dalí, *Secret Life*, p. 71.

**20.** *The Masterpieces of Raphael.* Gowans & Gray, London, 1909. The publisher produced fifty Gowans's Art Books in total, featuring such artists as Titian (#8), Velázquez (#12), Veronese (#14), Botticelli (#20), Michelangelo (#25), Uccello (#41), De Hooch and Vermeer (#46), and Gozzoli (#49). Leonardo da Vinci is notably absent, arguably because the artist did not produce a sufficient quantity of paintings to fill a book with sixty illustrations. Interestingly, Leonardo's pupil Bernardino Luini did merit a publication (#30).

**21.** Dalí, *Secret Life*, p. 4.

**22.** Bosquet, *The Great Masturbator*, p. 486.

**23.** Dalí, *Secret Life*, as quoted in Descharnes and Néret, *Dalí*, pp. 13–14.

24. See, for example, Sir Charles Petrie, *The History of Spain: Part II from the Death of Philip II to 1945*. New York: Macmillan, 1952; and Peter Pierson, *The History of Spain*. Westport, CT: Greenwood Press, 1999.

25. *Studium* was a monthly magazine published in January and June 1919 by Salvador Dalí, when he was in the sixth grade of high school at the Ramón Muntaner Institute. Dalí edited and published the magazine together with his friends Jaume Miravitlles, Joan Xirau, Juan Turró, and Ramon Reig. It featured illustrations, poetic texts, and a series of essays dedicated to painters like Goya, Velázquez, and Leonardo da Vinci.

26. The collection was declared a national museum in 1990 by the Catalan government, prior to the Barcelona Olympic Games, and since 2004 has been known as the Museu Nacional d'Art de Catalunya. As noted, the museum houses an important collection of Spanish and Catalan Romanesque and Gothic art, as well as works by artists of the *noucentisme* movement.

27. Dalí, *Secret Life*, as quoted in Etherington-Smith, *Persistence of Memory*, p. 21.

28. Dalí, *Secret Life*, p. 81.

29. Dalí, *Secret Life*, p. 124.

30. José de Churriguera, the eighteenth-century architect of the Goyeneche Palace that later became the Madrid Royal Academy of Fine Arts, was so renowned for designing ornate Italianate buildings that in Spanish architectural history, his style is known as Churrigueresque.

31. The formal Spanish title is the *Junta para Ampliación de Estudios e Investigaciones Científicas*.

32. Etherington-Smith, *Persistence of Memory*, p. 37.

33. Dalí, *Secret Life*, p. 71.

34. Dalí, *Secret Life*, p. 160.

35. Mary Ann Caws, *Pablo Picasso*. Reaktion Books, 2005, p. 66.

36. See, for example, Haim Finkelstein, *The Collected Writings of Salvador Dalí*. Cambridge University Press, 1998.

37. Etherington-Smith, *Persistence of Memory*, p. 67.

38. Eric Shanes, *Dalí*. Parkstone International, 1994, p. 26.

39. Etherington-Smith, *Persistence of Memory*, p. 70.

40. Descharnes and Néret, *Dalí*, p. 25.

41. Robert Descharnes and Gilles Néret, *Dalí: The Paintings*, p. 100.

## 3. The Years in the Wilderness: 1926–1929

42. Dalí, *Secret Life*, as quoted in Descharnes and Néret, *Dalí: The Paintings*, p. 119.

43. Nancy Hargrove, "The Great Parade: Cocteau, Picasso, Satie, Massine, Diaghilev—and T.S. Eliot" in *Journal for the Interdisciplinary Study of Literature*, 1998; Vol. 31 (1).

44. André Breton, *First Manifesto of Surrealism*, 1924; as quoted in Hans Werner Holzwarth (ed.), Modern Art. Taschen, 2016, p. 337.

45. Giorgio de Chirico, *The Return of Craftsmanship*, as quoted in Magdalena Holzhey, *Giorgio de Chirico*. Taschen, 2005, p. 60.

46. The interaction between Picasso, Miró, and Dalí was the subject of a special exhibition at Florence's Palazzo Strozzi, which opened on March 12, 2011.

47. Janis Mink, *Miró*. Taschen, 2003, p. 43.

48. Herbert Read, "The Influence of Surrealism," in *A Concise History of Modern Painting*. New York: Oxford University Press, p. 144.

49. Salvador Dalí, *Journal d'un genie*. Paris, 1964.

50. Descharnes and Néret, *Dalí*, p. 26.

51. Dalí, *Secret Life*, p. 207.

52. Jean Rouch, with Lucien Taylor, "A Life on the Edge of Filmed Anthropology," in *Cine-Ethnography*. University of Minnesota Press, 2003, p. 142.

**53.** Dalí, *Secret Life*, p. 212.

**54.** Etherington-Smith, *Persistence of Memory*, p. 108.

**55.** Fèlix Fanés, *Salvador Dalí: The Construction of the Image, 1925–1930*, p. 82.

**56.** Shanes, *Dalí*, p. 52.

**57.** Georges Bataille, "Jeu Lugubre," in *Documents*, no. 7, December 1929.

**58.** Etherington-Smith, *Persistence of Memory*, p. 116.

**59.** Dalí, *Secret Life*, as quoted in Descharnes and Néret, *Dalí: The Paintings*, 2016, p. 149.

**60.** Ruth Brandon, *Surreal Lives: The Surrealists 1917–1945*. Grove Press, 2000, p. 336.

**61.** Edward Rubin, "*The Great Masturbator* in Retrospect," in *NY Arts*, June 24, 2006.

**62.** Salvador Dalí, *Confessions inconfessables*. A: Obra Completa, Textos Autobiogràfics 2. Ediciones Destino / Fundació Gala-Salvador Dalí, Barcelona / Figueres, 2003, p. 463.

**63.** André Lhote, "Les Arts. La Saison de Paris," in *La Nouvelle Revue Française*, Paris, July 1931, p. 214.

**64.** Salvador Dalí and Louis Pauwels, *Les Passions selon Dalí*. Denoël, 1968.

## 4. The *Persistence of Memory*: 1929–1934

**65.** Luis Buñuel, *My Last Sigh*; English translation by Knopf, 1983, p. 115.

**66.** When the Eugenio d'Ors article prompted a scandal in Catalan society, Dalí defended himself by saying, "I need hardly add that this inscription is false and that it reduces the really subversive meaning of this inscription. On the contrary, it is a question of a moral conflict of the kind very like that posed by a dream in which we assassinate someone dear to us." Salvador Dalí, "Posició moral del surrealisme," in *Hèlix*, 10, March 22, 1930.

67. Dalí, *Secret Life*, p. 264.

68. Descharnes and Néret, *Dalí*, p. 28.

69. Daniel Frasnay, *The Artist's World: Magritte*. Viking Press, 1969, pp. 99–107.

70. Jean Bobon, "Contribution à la psychopathologie de l'expression plastique, mimique et picturale: les néominismes et les néomorphismes," in *Acta Neurologica et Psychiatrica Belgica*, Fasc. 12, 1957.

71. Dalí, *Secret Life*, as quoted in Descharnes and Néret, *Dalí: The Paintings*, p. 198.

72. Dalí, *Secret Life*, p. 317.

73. Dawn Adès, *Dalí*. Thames and Hudson, 1982.

74. Salvador Dalí, "La chèvre sanitaire," in *La Femme visible*; Paris: Éditions surrealists, 1930, pp. 23–34.

75. The painter insisted on this explanation in his reply letter to Prigogine, who took it as Dalí's reaction to Einstein's mathematical theory.

76. Robert Radford, *Dalí: Art and Ideas*. Phaidon, 1997.

77. "Les enquestes a la joventut," in *La Publicitat*, December 12, 1928.

78. Radford, *Dalí*, p. 156.

79. F. Serra, "De Comunisme i Sobrerrealisme," in *L'Hora*, 44, November 6, 1931; as quoted in Fèlix Fanés, *Salvador Dalí: The Construction of the Image, 1925–1930*, p. 179.

80. Ibid., p. 160.

81. Shanes, *Dalí*, p. 58.

82. Nathan Schneider, "The Angelus at Work," in *America*, March 24, 2015.

83. Salvador Dalí, "Millet's *L'Angelus*," in the catalog of the exhibition Salvador Dalí: Les chants de Maldodor; Paris, Galerie des Quatre Chemins, 1934; in Finkelstein, *The Collected Writings of Salvador Dalí*, p. 280.

84. Bosquet, *The Great Masturbator*, p. 164.

85. Dalí, *Secret Life*, as quoted in Descharnes and Néret, *Dalí: The Paintings*, p. 190.

86. Dawn Adès and William Jeffett, exhibition catalog to "Dalí/Duchamp," October 2017, p. 16.

87. Dalí, *Secret Life*, p. 325.

88. Dalí, *Secret Life*, p. 327.

## 5. New Horizons: 1934–1945

89. Dalí, *Secret Life*, pp. 329–330.

90. Descharnes and Néret, *Dalí*, p. 104.

91. Descharnes and Néret, *Dalí*, pp. 112–113.

92. Descharnes and Néret, *Dalí*, pp. 114–115.

93. André Breton, *Le Surréalisme et la peinture*, Folio, 1945, p. 24.

94. The Art Institute of Chicago, http://www.artic.edu/aic/collections/artwork/151424.

95. *Art Nerd New York*, February 8, 2016.

96. Descharnes and Néret, *Dalí*, p. 323.

97. In 1999, Walt Disney's nephew Roy E. Disney resurrected the project and produced the seven-minute short based on a "reinterpretation" of the Hench storyboards. The film premiered in 2003 in Annecy, France, and was subsequently nominated for the 2003 Academy Award for Best Animated Short Film.

98. William Jeffett, "Salvador Dalí and the Spanish Baroque: From Still Life to Velázquez," in Suzanne Stratton-Pruitt and William Jeffett, *Dalí and the Spanish Baroque*, p. 73.

99. Bosquet, *The Great Masturbator*, p. 398.

100. Salvador Dalí, "Dalí! Dalí!" Catalog essay, Julien Levy Gallery, March 1939.

## 6. The Atomic Era: 1945–1955

101. Salvador Dalí, *Mystical Manifesto*. Robert J. Godet, 1951, in Finkelstein, *Collected Writings of Salvador Dalí*, pp. 363–366.

102. Radford, *Dalí*, pp. 235–236.

103. As quoted in "Art: And Now To Make Masterpieces," in *Time* magazine, December 8, 1947.

104. André Parinaud. *Comment on devient Dalí: les aveux inavouables de Salvador Dalí*. Laffont, January, 1973.

105. Etherington-Smith, *Persistence of Memory*, p. 336.

106. Jonathan Wallis, "Holy Toledo! Saint John of the Cross, Paranoiac-Critical Mysticism, and the Life and Work of Saint Dalí," in Michael R. Taylor (ed.), *The Dalí Renaissance*, p. 38.

107. Matila Ghyka, *The Geometry of Art and Life*. Originally published in 1947, it was republished by Dover Books in 1977.

108. Gill Davies, "Scotland's favourite painting: Dalí's Christ of St John of the Cross." BBC Scotland, June 23, 2011, http://www.bbc.co.uk/scotland/arts/scotlands_favourite_painting_dalis_christ_of_st_john_of_the_cross.shtml.

109. Salvador Dalí, *Unspeakable Confessions*. Parinaud, 1973, p. 241.

110. Jeff Britting, Ayn Rand. Duckworth Overlook Illustrated Lives Series, 2004.

111. Fiona Macdonald, "The painter who entered the fourth dimension," BBC Culture, May 11, 2016, https://www.bbc.com/culture/article/20160511-the-painter-who-entered-the-fourth-dimension.

112. Salvador Dalí, lecture at the Sorbonne, Paris, December 17, 1955.

113. Descharnes and Néret, *Dalí*, p. 476.

114. Robert Descharnes, *Dalí, L'héritage infernal*. Éditions Ramsay/La Marge, 2002, p. 72.

115. Anna Maria Dalí and Salvador Dalí, *Escenes d'una infancia i joventut*.

116. David Lomas, "'Painting is Dead—long live painting!' Notes on Dalí and Leonardo," in Michael R. Taylor (ed.), *The Dalí Renaissance*, pp. 153–189.

117. For example, the study entitled *Morphology of the cranium of Sigmund Freud according to the principle of the volute and of the snail*, 1942.

118. B. Atalay, "Painting by the Numbers," in *Math and the Mona Lisa*, pp. 26–52.

119. Ibid., unpublished curatorial file.

120. Elliott King, Curator, *Dalí: The Late Work*, in OSV Newsweekly, November 10, 2010.

## 7. The Mystic Universe: 1955–1960

121. William Jeffett, "The Artist and the Dictator: Salvador Dalí and Francisco Franco," in Michael R. Taylor (ed.), *The Dalí Renaissance*, p. 138.

122. A. Reynolds Morse, "Dalí—My One-Man Collection," in *Art in America*, 46, no. 1 (Spring 1958), as cited in William Jeffett, "The Artist and the Dictator: Salvador Dalí and Francisco Franco," pp. 139–140.

123. Gibson, *The Shameful Life*, p. 489.

124. Bosquet, *The Great Masturbator*, p. 295.

125. Lest we don't grasp this double vision, Dalí formally titled the work *Quasi-grey picture which, closely seen, is an abstract one; seen from two meters is the Sistine Madonna of Raphael; and from fifteen meters is the ear of an angel measuring one meter and a half; which is painted with anti-matter; therefore with pure energy.*

126. Transcript, "The Mike Wallace Interview with Salvador Dalí (sic)," April 19, 1958. Retrieved from the Harry Ransom Center at the University of Texas at Austin, July 20, 2018. http://www.hrc.utexas.edu/multimedia/video/2008/wallace/Dalí_salvador_t.html.

127. Suzanne Anker and Dorothy Nelkin. *The Molecular Gaze: Art in the Genetic Age*. Cold Spring Harbor Laboratory Press, 2004, p. xii.

128. *Exhibition Guide to Homage to Crick and Watson*, 1962–1963, The Dalí Museum/Collection of The Dalí Museum Library and Archives.

129. Gibson, *The Shameful Life of Salvador Dalí*, pp. 505–506.

130. Michael Strauss, "New York," *The Burlington Magazine*, 103 (694), January 1961, p. 35.

131. W. Heisenberg, "Über den anschaulichen Inhalt der quantentheoretischen Kinematik und Mechanik," Zeitschrift für Physik (in German), 43 (3–4): 1927, pp. 172–198.

# 8. A Return to the Past: 1960–1968

132. Etherington-Smith, *Persistence of Memory*, p. 350.

133. Robert Descharnes, *The World of Salvador Dalí*, p. 11.

134. Robert Cozzolino, "Why Are Salvador Dalí's 'Late Works' His Most Contentious?" in H. Hine, W. Jeffet, and K. Reynolds, *Persistence & Memory: New Critical Perspectives on Dalí at the Centennial*, p. 145.

135. Elliott H. King, David A. Brenneman, William Jeffet, Montse Aguer Teixidor, and Hank Hine. *Salvador Dalí: The Late Work*. High Museum of Art and Yale University Press, 2010.

136. Antoni Ribas Tur, *Dalí's Greatest Work*, ara.cat, August 21, 2014. Retrieved July 25, 2018 from https://www.ara.cat/en/Dalís-greatest-work_0_1198080352.html.

137. Salvador Dalí, "Temes actuals," in *L'Amic de les Arts* (Sitges), 2 (19), October 31, 1927, pp. 98–99.

138. Salvador Dalí, *Diary of a Genius*, in Descharnes and Néret, *Dalí: The Paintings*, p. 560.

139. The full title is *Gala looking at Dalí in a state of anti-gravitation in his work of art "Pop-Op-Yes-Yes-Pompier" in which one can contemplate the two anguishing characters from Millet's Angelus in the state of atavic hibernation standing out of a sky which can suddenly burst into a gigantic Maltese cross right in the heart of the Perpignan railway station where the whole universe must converge.*

140. Descharnes and Néret, *Dalí: The Paintings*, p. 567.

141. Paul Chimera, "Stolen Dalí Art Makes Dubious Headlines," *The Salvador Dalí Society*. Retrieved July 26, 2018 from http://www.Dalí.com/stolen-Dalí-art-makes-dubious-headlines/.

142. Gibson, *Shameful Life*, p. 540.

143. Leonardo da Vinci, *Treatise on Painting*.

144. Eleanor Morse, "My View," in A. Reynolds Morse, *The Dalí Adventure*; p. xxv. MDJ, vol. I, 1995–1996.

145. Gibson, *Shameful Life*, p. 421.

## 9. The Later Years: 1968–1989

146. Bosquet, *The Great Masturbator*, p. 636.

147. See also Susana Martinez-Conde, "Marvels of Illusion: Illusion and perception in the art of Salvador Dalí," in *Frontiers in Human Neuroscience*, September 9, 2015: DOI: 10.3389/fnhum.2015.00496.

148. André Parinaud, *Comment on devient Dalí*.

149. Descharnes and Néret, *Dalí: The Paintings*, p. 626.

150. Raphael Minder, "Dalí's Wife Was More Than Model and Muse," in *New York Times*, July 30, 2018.

151. Gibson, *Shameful Life*, p. 593.

## Epilogue

**152.** Néret, *Dalí*, p. 85.

**153.** Jeffett, *Dalí Doubled*, p. 267.

**154.** Jeffett, *Dalí Doubled*, p. 272.

## Essay: A New Interpretation of *The Persistence of Memory*

**155.** Jacob Burckhardt, *The Cicerone: Or, Art Guide to Painting in Italy*. J. Murray, 1873, p. 67.

**156.** *Studium* was a monthly magazine published in January and June 1919 by Salvador Dalí.

**157.** Salvador Dalí, "Dalí! Dalí!" Catalog essay, Julien Levy Gallery, March 1939.

**158.** David Lomas, "'Painting is Dead—long live painting!' Notes on Dalí and Leonardo," in Michael R. Taylor (ed.), *The Dalí Renaissance*, pp. 153–189.

## Essay: Illusion and Meaning in Dalí's *The Skull of Zurbarán*

**159.** See Valerie Shrimplin, *Sun Symbolism and Cosmology in Michelangelo's 'Last Judgment.'* Kirksville, MO: Truman State University Press, 2000.

**160.** Bosquet, *The Great Masturbator*, p. 298.

# CREDITS

13   © 2020 Salvador Dalí, Fundació Gala-Salvador Dalí, Artists Rights Society. Photo credit: Robert Descharnes / © photo Descharnes & Descharnes sarl

14   Pantheon Archives

15   © 2020 Salvador Dalí, Fundació Gala-Salvador Dalí, Artists Rights Society

16   © 2020 Salvador Dalí, Fundació Gala-Salvador Dalí, Artists Rights Society

17   © 2020 Salvador Dalí, Fundació Gala-Salvador Dalí, Artists Rights Society

18   Pantheon Archives

19   Pantheon Archives

20   Pantheon Archives

21   © 2020 Estate of Pablo Picasso / Artists Rights Society, New York. Digital image © The Museum of Modern Art / Licensed by SCALA / Art Resource, NY

22   © 2020 Salvador Dalí, Fundació Gala-Salvador Dalí, Artists Rights Society

23   © 2020 Estate of Pablo Picasso / Artists Rights Society, New York. Photo credit: SCALA / Art Resource, NY

24   Pantheon Archives

25   Pantheon Archives

26   © 2020 Salvador Dalí, Fundació Gala-Salvador Dalí, Artists Rights Society

27   Pantheon Archives

28   © 2020 Salvador Dalí, Fundació Gala-Salvador Dalí, Artists Rights Society

# Credits

29    Pantheon Archives

30    © 2020 Salvador Dalí, Fundació Gala-Salvador Dalí, Artists Rights Society. Photo credit: Robert Descharnes / © photo Descharnes & Descharnes sarl

31    Pantheon Archives

32    © 2020 Salvador Dalí, Fundació Gala-Salvador Dalí, Artists Rights Society

33    © 2020 Artists Rights Society, New York / SIAE, Rome. Digital image © The Museum of Modern Art / Licensed by SCALA / Art Resource, NY

34    © Successió Miró / Artists Rights Society, New York / ADAGP, Paris 2020

35    Photo credit: The Philadelphia Museum of Art / Art Resource, NY. Image rights of Salvador Dalí reserved. Fundació Gala-Salvador Dalí, Figueres, 2020

36    © 2020 Salvador Dalí, Fundació Gala-Salvador Dalí, Artists Rights Society. Photo credit: Erich Lessing / Art Resource, NY

37    © 2020 Salvador Dalí, Fundació Gala-Salvador Dalí, Artists Rights Society. © DeA Picture Library / Art Resource, NY

38    Philadelphia Museum of Art. Gift of John Mark Lutz, 1965.

39    Fine Art Images / Heritage Images / Getty Images. Image rights of Salvador Dalí reserved. Fundació Gala-Salvador Dalí, Figueres, 2020

40    © 2020 Salvador Dalí, Fundació Gala-Salvador Dalí, Artists Rights Society

41    © 2020 Salvador Dalí, Fundació Gala-Salvador Dalí, Artists Rights Society. Photo credit: Philippe Migeat. © CNAC / MNAM / Dist. RMN-Grand Palais / Art Resource, NY

42    © 2020 C. Herscovici / Artists Rights Society, New York. Digital image © The Museum of Modern Art / Licensed by SCALA / Art Resource, NY

43   © 2020 Salvador Dalí, Fundació Gala-Salvador Dalí, Artists Rights Society. © DeA Picture Library / Art Resource, NY

44   © 2020 Salvador Dalí, Fundació Gala-Salvador Dalí, Artists Rights Society. Digital image © The Museum of Modern Art / Licensed by SCALA / Art Resource, NY

45   Pantheon Archives

46   Pantheon Archives

47   Pantheon Archives

48   © 2020 Salvador Dalí, Fundació Gala-Salvador Dalí, Artists Rights Society

49   Pantheon Archives

50   © 2020 Salvador Dalí, Fundació Gala-Salvador Dalí, Artists Rights Society. Photo credit: Robert Descharnes / © photo Descharnes & Descharnes sarl

51   © 2020 Salvador Dalí, Fundació Gala-Salvador Dalí, Artists Rights Society. Digital image © The Museum of Modern Art / Licensed by SCALA / Art Resource, NY

52   © 2020 Salvador Dalí, Fundació Gala-Salvador Dalí, Artists Rights Society

53   Pantheon Archives

54   © 2020 Salvador Dalí, Fundació Gala-Salvador Dalí, Artists Rights Society. Photo credit: Robert Descharnes / © photo Descharnes & Descharnes sarl

55   © 2020 Salvador Dalí, Fundació Gala-Salvador Dalí, Artists Rights Society. Digital image © The Museum of Modern Art / Licensed by SCALA / Art Resource, NY

56   © 2020 Salvador Dalí, Fundació Gala-Salvador Dalí, Artists Rights Society. Photo credit: Robert Descharnes / © photo Descharnes & Descharnes sarl

# Credits

57   © 2020 Estate of Pablo Picasso / Artists Rights Society, New York. Photo credit: Art Resource, NY

58   © 2020 Salvador Dalí, Fundació Gala-Salvador Dalí, Artists Rights Society. Photo credit: The Philadelphia Museum of Art / Art Resource, NY

59   © 2020 Salvador Dalí, Fundació Gala-Salvador Dalí, Artists Rights Society

60   Pantheon Archives

61   © 2020 Salvador Dalí, Fundació Gala-Salvador Dalí, Artists Rights Society

62   © 2020 Salvador Dalí, Fundació Gala-Salvador Dalí, Artists Rights Society. Photo credit: The Art Institute of Chicago / Art Resource, NY

63   Pantheon Archives

64   © 2020 Salvador Dalí, Fundació Gala-Salvador Dalí, Artists Rights Society

65   © 2020 Salvador Dalí, Fundació Gala-Salvador Dalí, Artists Rights Society

     Pantheon Archives

66   © 2020 Salvador Dalí, Fundació Gala-Salvador Dalí, Artists Rights Society

67   © 2020 Salvador Dalí, Fundació Gala-Salvador Dalí, Artists Rights Society. © 2000 Disney

68   Pantheon Archives

69   Pantheon Archives

70   © 2020 Salvador Dalí, Fundació Gala-Salvador Dalí, Artists Rights Society. Photo credit: Robert Descharnes / © photo Descharnes & Descharnes sarl

71   Pantheon Archives

72   Pantheon Archives

73   Pantheon Archives

74   Pantheon Archives

75   © 2020 Salvador Dalí, Fundació Gala-Salvador Dalí, Artists Rights Society. Photo credit: Robert Descharnes / © photo Descharnes & Descharnes sarl

76   © 2020 Salvador Dalí, Fundació Gala-Salvador Dalí, Artists Rights Society

77   Photos by Philippe Halsman. © Halsman Archive. Image rights of Salvador Dalí reserved. Fundació Gala-Salvador Dalí, Figueres, 2020

78   Pantheon Archives

79   © 2020 Salvador Dalí, Fundació Gala-Salvador Dalí, Artists Rights Society. Photo credit: Robert Descharnes / © photo Descharnes & Descharnes sarl

80   Pantheon Archives

81   © 2020 Salvador Dalí, Fundació Gala-Salvador Dalí, Artists Rights Society. Photo credit: Robert Descharnes / © photo Descharnes & Descharnes sarl

82   Pantheon Archives

83   © 2020 Salvador Dalí, Fundació Gala-Salvador Dalí, Artists Rights Society. Photo credit: Chris Brown Collection

84   © 2020 Salvador Dalí, Fundació Gala-Salvador Dalí, Artists Rights Society. Image copyright © The Metropolitan Museum of Art. Image source: Art Resource, NY

85   Photo credit: Robert Descharnes / © photo Descharnes & Descharnes sarl. Image rights of Salvador Dalí reserved. Fundació Gala-Salvador Dalí, Figueres, 2020

# Credits

86    Photo credit: Robert Descharnes / © photo Descharnes & Descharnes sarl. Image rights of Salvador Dalí reserved. Fundació Gala-Salvador Dalí, Figueres, 2020

87    © 2020 Salvador Dalí, Fundació Gala-Salvador Dalí, Artists Rights Society

88    Pantheon Archives

89    © 2020 Salvador Dalí, Fundació Gala-Salvador Dalí, Artists Rights Society. Image copyright © The Metropolitan Museum of Art. Image source: Art Resource, NY

90    © 2020 Salvador Dalí, Fundació Gala-Salvador Dalí, Artists Rights Society. Photo credit: Robert Descharnes / © photo Descharnes & Descharnes sarl

91    Pantheon Archives

92    © 2020 Salvador Dalí, Fundació Gala-Salvador Dalí, Artists Rights Society. Photo cedit: Chris Brown Collection

93    © 2020 Salvador Dalí, Fundació Gala-Salvador Dalí, Artists Rights Society. Photo credit: Robert Descharnes / © photo Descharnes & Descharnes sarl

94    © 2020 Salvador Dalí, Fundació Gala-Salvador Dalí, Artists Rights Society. Photo credit: Robert Descharnes / © photo Descharnes & Descharnes sarl

95    © 2020 Salvador Dalí, Fundació Gala-Salvador Dalí, Artists Rights Society. Photo credit: Robert Descharnes / © photo Descharnes & Descharnes sarl

96    © 2020 Salvador Dalí, Fundació Gala-Salvador Dalí, Artists Rights Society

97    Pantheon Archives

98    © 2020 Salvador Dalí, Fundació Gala-Salvador Dalí, Artists Rights Society. Photo credit: Robert Descharnes / © photo Descharnes & Descharnes sarl

99   © 2020 Salvador Dalí, Fundació Gala-Salvador Dalí, Artists Rights Society. Photo credit: Erich Lessing / Art Resource, NY

100  © American Broadcast Companies, Inc. All rights reserved. Image rights of Salvador Dalí reserved. Fundació Gala-Salvador Dalí, Figueres, 2020

101  © 2020 Salvador Dalí, Fundació Gala-Salvador Dalí, Artists Rights Society

102  Pantheon Archives

103  © 2020 Salvador Dalí, Fundació Gala-Salvador Dalí, Artists Rights Society

104  © 2020 Salvador Dalí, Fundació Gala-Salvador Dalí, Artists Rights Society

105  © 2020 Salvador Dalí, Fundació Gala-Salvador Dalí, Artists Rights Society

106  Pantheon Archives

107  Pantheon Archives

108  Pantheon Archives

109  Pantheon Archives

110  Pantheon Archives / Krippelboy

111  Pantheon Archives

112  © 2020 Salvador Dalí, Fundació Gala-Salvador Dalí, Artists Rights Society

113  Pantheon Archives

114  © 2020 Salvador Dalí, Fundació Gala-Salvador Dalí, Artists Rights Society. Photo credit: Robert Descharnes / © photo Descharnes & Descharnes sarl

115  Pantheon Archives

# Credits

116   © 2020 Salvador Dalí, Fundació Gala-Salvador Dalí, Artists
Rights Society

117   © 2020 Salvador Dalí, Fundació Gala-Salvador Dalí, Artists
Rights Society

118   © 2020 Salvador Dalí, Fundació Gala-Salvador Dalí, Artists Rights
Society. Photo credit: bpk Bildagentur / Museum Ludwig. Photo:
Rheinsches Bildarchiv Cologne / Britta Schlier / Art Resource, NY

119   © 2020 Salvador Dalí, Fundació Gala-Salvador Dalí, Artists Rights
Society. Photo credit: Robert Descharnes / © photo Descharnes &
Descharnes sarl

120   Pantheon Archives

121   © 2020 Salvador Dalí, Fundació Gala-Salvador Dalí, Artists Rights
Society. Photo credit: Robert Descharnes / © photo Descharnes &
Descharnes sarl

122   Pantheon Archives

123   © 2020 Salvador Dalí, Fundació Gala-Salvador Dalí, Artists
Rights Society

124   © 2020 Salvador Dalí, Fundació Gala-Salvador Dalí, Artists
Rights Society

125   © 2020 Salvador Dalí, Fundació Gala-Salvador Dalí, Artists
Rights Society

126   Pantheon Archives / Taty 2007

127   Pantheon Archives

128   © 2020 Salvador Dalí, Fundació Gala-Salvador Dalí, Artists
Rights Society

129   Pantheon Archives

130   © 2020 Salvador Dalí, Fundació Gala-Salvador Dalí, Artists
Rights Society

131  Pantheon Archives

132  Pantheon Archives

133  © 2020 Salvador Dalí, Fundació Gala-Salvador Dalí, Artists Rights Society

134  © 2020 Salvador Dalí, Fundació Gala-Salvador Dalí, Artists Rights Society. Photo credit: Robert Descharnes / © photo Descharnes & Descharnes sarl

135  © 2020 Salvador Dalí, Fundació Gala-Salvador Dalí, Artists Rights Society

136  Pantheon Archives

137  © 2020 Salvador Dalí, Fundació Gala-Salvador Dalí, Artists Rights Society

138  © 2020 Salvador Dalí, Fundació Gala-Salvador Dalí, Artists Rights Society

139  Pantheon Archives

140  © 2020 Salvador Dalí, Fundació Gala-Salvador Dalí, Artists Rights Society

141  © 2020 Salvador Dalí, Fundació Gala-Salvador Dalí, Artists Rights Society. Photo credit: Robert Descharnes / © photo Descharnes & Descharnes sarl

142  Image rights of Salvador Dalí reserved. Fundació Gala-Salvador Dalí, Figueres, 2020. Chris Brown Collection.

143  Pantheon Archives. Chris Brown Collection.

144  © 2020 Salvador Dalí, Fundació Gala-Salvador Dalí, Artists Rights Society. Digital image © The Museum of Modern Art / Licensed by SCALA / Art Resource, NY

145  Pantheon Archives

146  Pantheon Archives

# Credits